THE CHALLENGE OF
LANDSCAPE
PAINTING

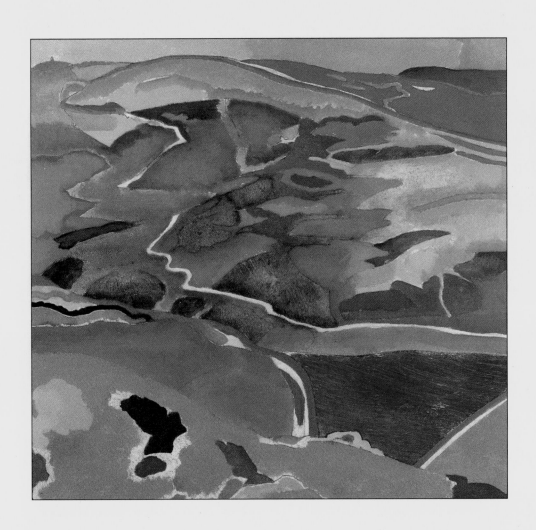

COLLINS

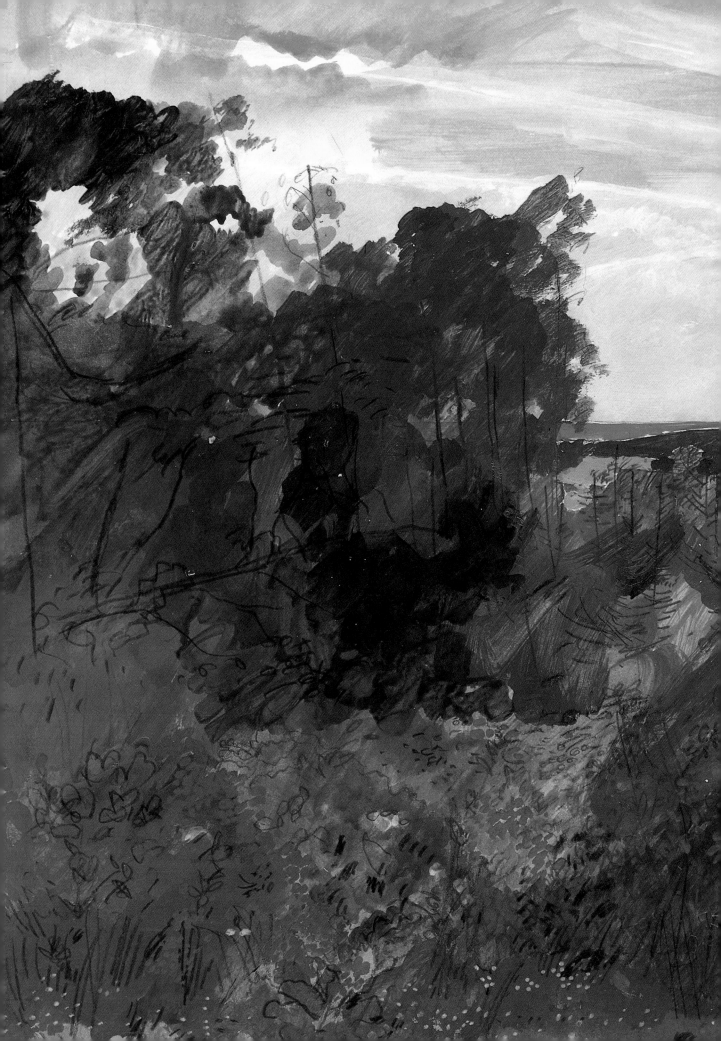

THE CHALLENGE OF
LANDSCAPE
PAINTING

Ian Simpson

Consultant Editor: Laurence Wood

ACKNOWLEDGEMENTS

I am greatly indebted to the artists interviewed for this book, not only for giving me their valuable time but also for their permission to reproduce their work, and in some cases for providing me with colour transparencies. I would also like to thank Cathy Gosling, Caroline Churton and Laurence Wood, not just for their work as editors but because our many discussions during the production of the book had a great influence on its eventual form. I am grateful to Laurence, in addition, for his painstaking work in making a preliminary selection of paintings by contemporary landscape painters, many of them young artists, to illustrate the text. I wish to thank all of them for permission to reproduce their work and for lending either their work itself or colour transparencies. I must also thank Caroline Bach Price for conscientiously typing (and retyping) the script and for her helpful remarks as its first reader.

First published in 1990 by
William Collins Sons & Co. Ltd
London · Glasgow · Sydney · Auckland
Toronto · Johannesburg

© Ian Simpson 1990

A CIP catalogue record for this book is available from the British Library

ISBN 0 00 411573 2

Art Editor: Caroline Hill

Set in Palatino
by Rowland Phototypesetting Ltd
Bury St Edmunds, Suffolk
Originated, printed and bound in Singapore
by C. S. Graphics Pte, Ltd

PAGE 1: **Derek Hyatt,** Grouse Moor, **oil on hardboard, 40 x 38 cm (16 x 15 in)**

PREVIOUS SPREAD: **Ian Simpson,** A Swedish Landscape on Two Days **(detail), acrylic on paper, 49.5 x 118 cm (19½ x 46½ in)**

Contents

'To walk…in the country was to perceive the soul of beauty through the forms of matter.'
(Samuel Palmer, 19th century)

Introduction

When I started to write this book it was intended to help landscape painters improve their work. There are many books available for people who want to start painting, but few for those who may already have some experience of painting and are looking for advice which may make them better artists.

Books on how to improve your painting are generally thought of as being for amateurs, but the distinction between amateur and professional artists is rapidly becoming meaningless. The term 'professional artist' is difficult, if not impossible, to define. There are many who describe themselves as 'professional painters' whose main income comes from sources other than painting, while others, whose dedication, quality of work and time devoted to painting equal, and sometimes exceed, that of their 'professional' counterparts, are classed as 'amateurs'.

Laurence Wood, Scottish Loch, 1987, watercolour, 66 x 81 cm (26 x 32 in). Vast expanses of seemingly featureless water and distant hills present a difficult challenge to the painter. An unpredictable but inspiring start can be made by allowing broad washes of watercolour to intermingle over a large sheet of paper. By exploiting these 'accidental' effects and utilizing the transparent qualities of the paint the artist can convey the sense of light and space

This book has been written for all categories of practising landscape painters, but as it has developed it has also become relevant to another group of readers. From the first, I wanted it to have, as a significant element, interviews with distinguished landscape painters. I chose for these interviews Roger de Grey, Lawrence Gowing, John Piper, Keith Grant, Derek Hyatt, Olwyn Bowey and Norman Adams. As I talked to these artists I realized that what they had to say about their own painting and that of others would also be of interest to those wishing to understand more about painting without necessarily wishing to paint themselves.

If you are a painter this book aims first and foremost to improve your painting. If you are interested in landscape painting but not a painter yourself, it aims to increase your knowledge of how artists work and your appreciation of landscape painting.

The Value of Different Viewpoints

No matter how open-minded and objective an author tries to be, his or her opinions and prejudices inevitably emerge in the text. That is why, in this book, I wanted to counter-balance my own views with those of other artists. I also carried out the interviews before writing most of the book, with the intention that what the various artists said would moderate and influence what I wrote subsequently.

There are many views on art and different opinions on the work of artists. There are also many

ways of teaching art, but I believe that whatever form this takes it should have a strong positive sense of direction, while also reminding students that there are other valid approaches. I firmly believe that anyone can learn to paint. Not everyone can be a great artist, but everyone is a different kind of artist. There are as many ways of painting as there are individuals and this book aims to help you to find your own way if you are a painter, and if you aren't, to understand the artist's individuality.

You won't find just one point of view running through this book. What some of the artists told me in their interviews sometimes contradicts what I have said elsewhere. I did not always agree with what they said but I tried to record faithfully what they told me. Some of those interviewed were interested in seeing what I had written, prior to publication, and so I sent them a copy of my first draft of the interview for their comments or amendment. I haven't, in general, when writing my accounts of these interviews, made any comments of my own on what the artists have said, but I think that a few observations at this point will be useful.

The Artists' Interviews

Although I have attempted to report accurately what each artist said in our discussions, the interviews have in some cases been restructured in writing them. This is because I allowed the artists to talk freely, without pressing them to return to my

Ian Simpson, Coastal Landscape, **oil on board, 91 x 122 cm (36 x 48 in). This painting exploits the patterns and textures of the subject. The simple shapes of the cliffs, foreground and sea were painted in thin colour. These shapes were preserved as the painting developed, with details drawn over them**

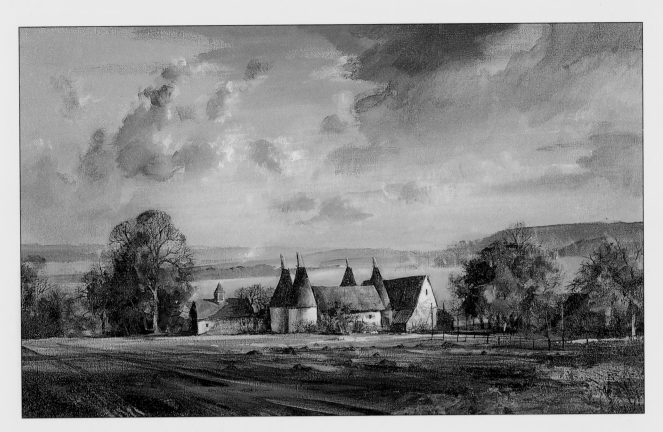

Rowland Hilder, Shoreham Valley, **oil on canvas, 71 x 101cm (28 x 40 in). This painting was made in the artist's studio, using numerous sketches, watercolours and drawings done on location in Shoreham Valley – a favourite, well-preserved stretch of countryside. Over time, however, much has changed there – trees have disappeared, and farms and oast houses have been converted into domestic dwellings – so the artist aimed to capture something of his memories resulting from a long association with this lovely valley**

questions if they went on to talk about other things. Often they made a point and later in the interview returned to it. Sometimes an interview took a direction which I had not intended and one which didn't necessarily follow on logically from the previous topic of our conversation. In writing my account later I have therefore sometimes given some of the interviews a coherence they probably didn't have on the occasion.

One of the things which surprised me was that those artists who read my initial draft of their interview seemed so grateful to me for writing it in a form which they thought explained clearly what they did as painters. I think this is because I approached the interviews in a different way from usual and this may have thrown some new light on how they worked. I didn't ask them about their views on painting, for instance, or what they thought they were trying to say in their work, but about *how* they actually worked. The relationship they have with their subject, their views on art, and their comments on other artists' work emerged naturally from this.

I do not believe everything that the artists told me. That is not to say that anyone was trying to deceive me but to demonstrate what I believe to be a general truth, that no-one is as they think they are. The amount of time artists say they have spent working on a particular painting, or the total time they say they spend working each day, can in fact be a long way from reality. For example, when Francis Bacon worked in a studio at the Royal College of Art

for what in reality were only mornings, he used to think of them as 'days'. When artists express their views on their own work, they have to present them in a way which is compatible with their general views on painting. Where these views on art are well formulated, as can be the case when they have been previously presented in books or magazine articles, it can sometimes be very difficult for the artists concerned to live up to them. They may find that it is not easy to place their own work within the context of their considered opinions on contemporary art.

Some of the interviews contained contradictions and I have deliberately left them in my account of what was said. This is because it is important to realize that artists cannot be completely certain of what they are doing. Francis Bacon's description of what it is like to paint seems to me a very honest one: 'In my case all painting . . . is an accident. I foresee it, yet I hardly ever carry it out as I foresee it. It transforms itself by the actual paint. I don't, in fact, know very often what the paint will do, and it does many things which are very much better than I could make it do. Perhaps one could say it's not an accident because it becomes a selective process which part of the accident one chooses to preserve.' It may not add to your sense of confidence to realize that experienced, distinguished artists are not in complete control of their work, but perhaps after thinking about it, you will find it reassuring!

The interviews reveal a degree of insecurity. Most people, I imagine, believe that others are not as sensitive as themselves, but with such an inexact art as painting it is easy to see why artists are likely to be thin-skinned and insecure. John Piper, after more than fifty years spent painting, admits that he is not sure, on finishing a painting, whether it is good or bad. Roger de Grey stresses that you have to believe your work is good to keep on doing it, but is not alone, among those artists who teach, in admitting that he cannot criticize his own work with the same candour that he uses with students.

James Morrison, *Rain Clearing, Assynt*, 1988, oil on gesso-primed board, 101 x 152 cm (40 x 60 in). Particular atmospheric effects have always inspired this painter. Here the subtle legacy of clearing rain has been captured with watercolour-like washes of transparent oil paint
(The Scottish Gallery, Edinburgh and London)

Attitudes to the Landscape

From the interviews you will find that there is no consensus on painting methods. One point, however, on which there was near consensus surprised me. Most of the artists insisted that the landscape itself was unimportant and merely a starting point for a painting; or, in the case of Roger de Grey, it provided an environment in which he was happiest to work. All these artists have lived (and painted) through a period of time when Modernism has reigned supreme. It has been difficult to remain a 'representational' painter through this period when non-representational painting has been so much in vogue. I suggest that this might account for why some of the artists want to play down the importance of the subject of landscape and why they are so concerned about not being able to paint without reference to it. This inability is sometimes regarded by them as a lack of imagination but obviously it is possible to have imaginative referential painting, just as it is possible to have unimaginative non-referential painting.

The term 'representational painting' can mean different things to different people. I have used it here to describe painting which is not necessarily realistic but which nevertheless contains recognizable subjects. It is possible for representational paintings to be made without reference to nature

and for non-representational (or abstract) paintings to come from the study of nature, but Modernist painting required artists to be both non-referential and non-representational.

Artists differ in their views regarding the distinction between representational and abstract painting. As you will read later, Keith Grant sees no distinction and feels that all painting is abstract. Lawrence Gowing, however, sees representational painting as something separate from abstract painting and claims to have helped to save representational painting from extinction.

The best art teaching takes place, I believe, where a group of informed people express their views and the student draws his or her own conclusions. This book offers strategies for painting the landscape (which are equally valid for painting other subjects) based on my experience as painter and teacher, and these strategies are balanced by the views of other artists, some of them distinguished teachers as well. I hope it will give you new directions for developing your work if you are a painter and that if you don't paint it will give you an increased appreciation of artists and landscape painting.

'Today one can dare anything and, furthermore, nobody is surprised.'
(Paul Gauguin, 1889)

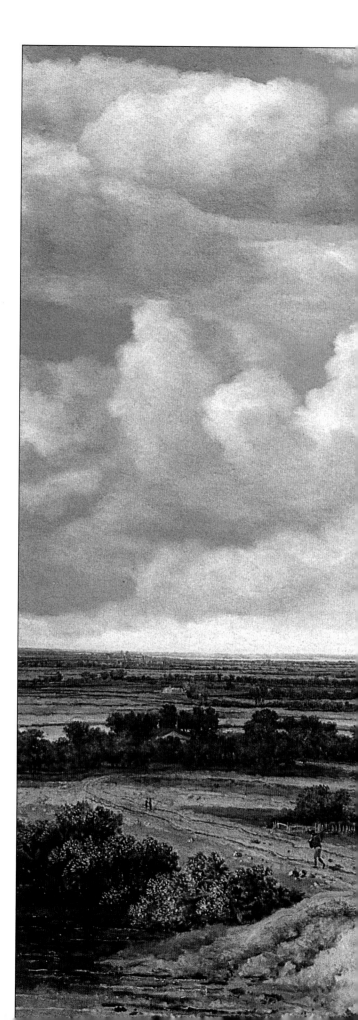

Chapter 1
A Brief History of Landscape Painting

This brief history of landscape painting is not the entirely objective account which might have been written by an art historian. I have written it from my own subjective view, as a painter, and it is intended to provide a context in which contemporary landscape painting can be placed. I am well aware that my regard for particular artists of the past has had a bearing on their inclusion here and it is likely that my own views on what is significant about the present have influenced what I have seen as important in the past. Perhaps, for example, the current renewed interest in the qualities of paint is the reason for my inclusion of Peter Paul Rubens (1577–1640), who is not usually thought of as a landscape painter.

Philips de Koninck, An Extensive Landscape with a Road by a Ruin, **1655, oil on canvas, 137 x 168 cm (54 x 66 in)**
(Reproduced by courtesy of the Trustees of the National Gallery, London)

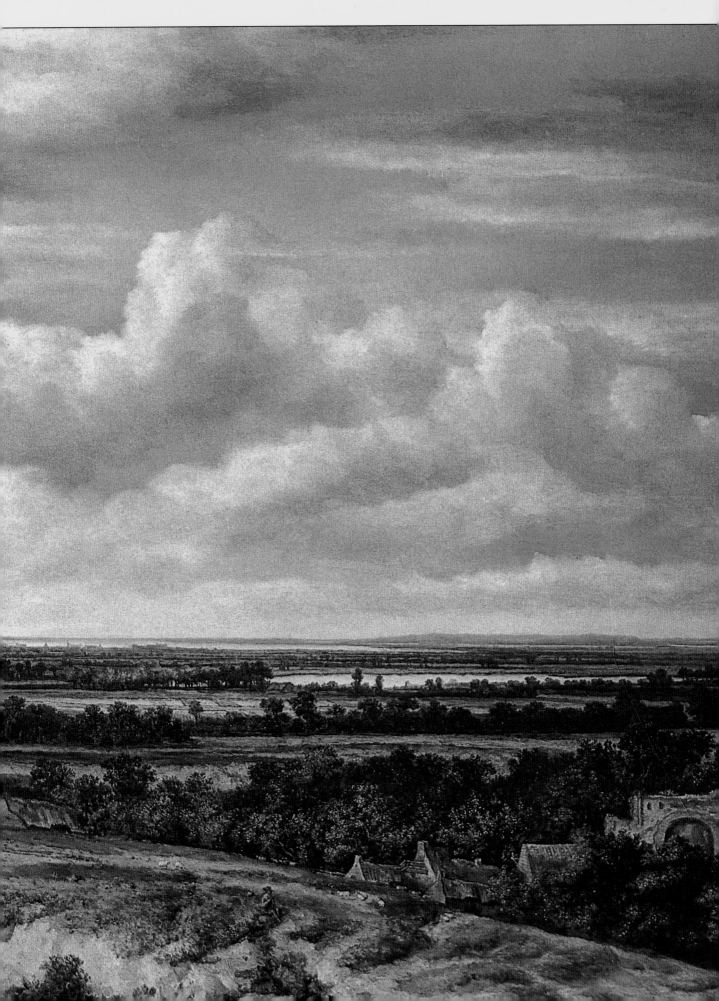

The Challenge of Landscape Painting

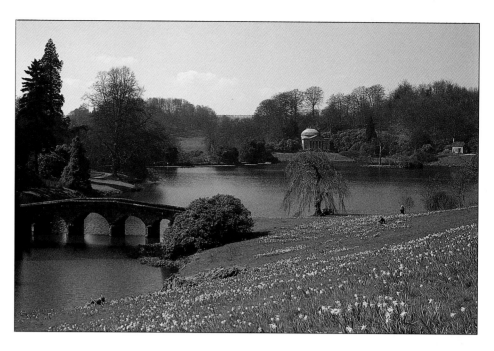

I have illustrated this chapter with paintings by artists whom I consider to be major figures, but I recognize that in addition to Rubens one or two of my choices may be considered somewhat idiosyncratic. Few others, I suspect, would include John Sell Cotman (1782–1842) in such a history, but he is an artist whose work I have always loved and, for me personally, it has stood the test of time. I never fail to be surprised by what could be described as the 'abstract qualities' in his paintings which make his work appear to be much more recent than it actually is He may be only a minor master but for me he had to be included here nevertheless.

Early Landscapes

Landscape painting, as we know it today, has a relatively short history. Probably the earliest paintings of landscapes are among the wall paintings in the ruins of Pompeii, the Roman city buried under volcanic ash from the eruption of Vesuvius in AD 79. These paintings are not views of specific places. They are generalized scenes painted to provide a taste of the country for people living in a city.

There were landscape painters in China in the twelfth and thirteenth centuries but these artists didn't paint pictures of actual places either. They were trained in the skills of painting various features of the landscape, such as trees, rocks and skies, by copying the acknowledged Chinese masters of the time. Once these skills had been acquired they were used, not to depict particular scenes, but to invent landscapes full of spiritual relevance.

Landscape in the Background

The first European painting which includes a real view of a recognizable place is thought to be the painting by Konrad Witz (c.1400–46) entitled *The Miraculous Draught of Fishes*, painted around 1444. He used a view of Lake Geneva as a setting for his portrayal of the Bible story. However, up to this point in history, landscape painting had existed only as a pastoral background against which the main pictorial elements of the painting stood. The chief concern of painting was to tell a story. It was not until the sixteenth century that painting was seen as having representational as well as narrative possibilities, and that artists' descriptive skills began to be admired. Once it had been realized that nature could be re-created in paintings, artists such as the German painter Albrecht Altdorfer (c.1480–1538) were able to produce landscapes which had no figures and were without any story-line.

Masters of Landscape Painting

It took well over 200 years following Altdorfer's death for landscape to be fully accepted as a subject for painting, but there were nevertheless some significant landscapes painted during those two centuries. However, few artists painted landscape exclusively and many paintings, although predominantly featuring the landscape, also included figures.

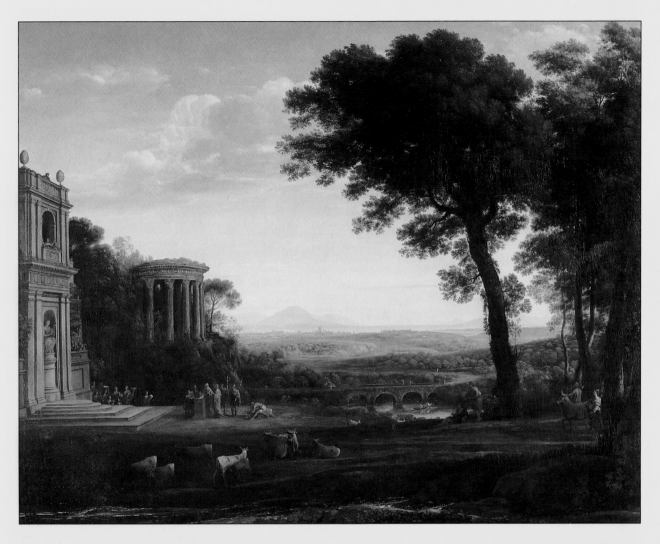

Claude Lorrain, *The Father of Psyche Sacrificing at the Temple of Apollo,* **1663, oil on canvas, 175 x 223 cm (69 x 87¾ in)** (The National Trust Photographic Library)

The Importance of Claude

The French painter Claude, often referred to as Claude Lorrain (1600–82), was the artist who opened people's eyes to the sublime beauty of nature. His pictures had an enormous influence, particularly in Britain. Claude studied and worked in Rome and his landscapes have a strong Italian flavour. Paintings such as *The Father of Psyche Sacrificing at the Temple of Apollo*, with its rolling landscape and classical ruins, made such an impression that a hundred years after his death in 1682, real landscapes were judged against the standards set in his paintings. Even in the eighteenth century his ardent admirers in England were still trying to shape the English landscape into a Claudian view. Claude's representation of nature and his dreams of beauty provided an ideal world with which people could identify. Those who were rich enough made their own gardens like Claude's landscapes. Clear evidence of this can be seen to this day in the landscapes created in the grounds of many English country houses, such as Stourhead in Wiltshire. The garden or landscape evocative of a Claude painting was said to be picturesque – that is, like a picture.

Rubens and his use of paint

We do not automatically think of the Flemish painter Peter Paul Rubens (1577–1640) as a landscape painter. He was a generation older than Claude and like him he studied and worked in Italy. Rubens had probably the most successful career of any artist in the history of painting. Employed as a diplomat as well as an artist, he was knighted by King Charles I in recognition of his achievements.

Rubens brought a new vitality to painting, a new kind of life and vigour. By integrating drawing and colour through expressive brushwork, he made the pictures of his predecessors look like drawings to which colour had been added as an afterthought. His are perhaps the first 'painterly' paintings. His vast output of altarpieces, portraits, hunting scenes, and religious and mythological subjects also included some memorable landscapes. The dramatic *Rainbow Landscape* clearly demonstrates Rubens' ability to use paint expressively not only to re-create a particular scene but also to record a spectacular moment in time.

The Dutch landscape painters

One of the effects of the Reformation was that in northern Europe artists had to look for branches of painting to which objection could not be raised on religious grounds. Portrait painting was the most flourishing branch. However, those artists who did not wish to be portrait painters had to exist, as artists mainly do today, without commissions and so they concentrated on painting particular subjects which

people would want to buy. As a result, artists became specialists, some, for example, painting still life and others ships. In Holland particularly artists became fascinated with the sky, the sea and the landscape. Instead of the dramatic Roman ruins which Claude painted, the seventeenth-century Dutch painters discovered that the windmills and everyday scenes of the flat landscape of their native country could be suitable subjects for painting. The picture by Philips de Koninck (1619–88), entitled *An Extensive Landscape with a Road by a Ruin* (see page 13), is a superb example of this, showing how he makes the most of the low horizon and atmospheric sky. Although painted over three hundred years ago, this panoramic view still looks impressive and ambitious.

Turner and Constable

In spite of the success of Claude, the drama of Rubens, and the atmosphere of the Dutch paintings, artists in the seventeenth century who were exclusively landscape painters were not taken seriously. Landscape painting remained a minor branch of art until the late eighteenth century. Then, attitudes changed and artists were given greater freedom in their choice of subject matter. Landscape painting finally became a subject in its own right and great artists began to turn their undivided attention to developing this form of painting. Two English painters raised landscape painting to a new position of eminence and they did it in very different ways. One was J. M. W. Turner (1775–1851) and the other John Constable (1776–1837).

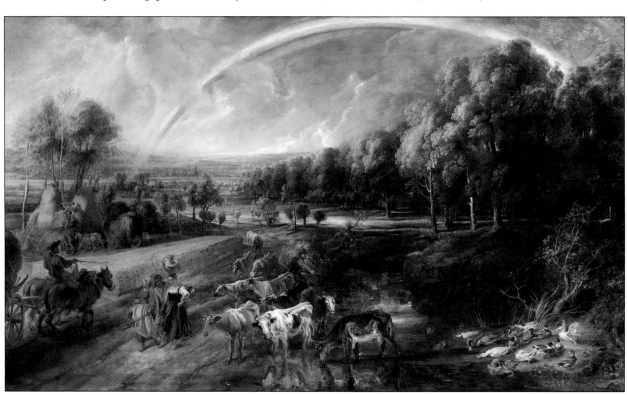

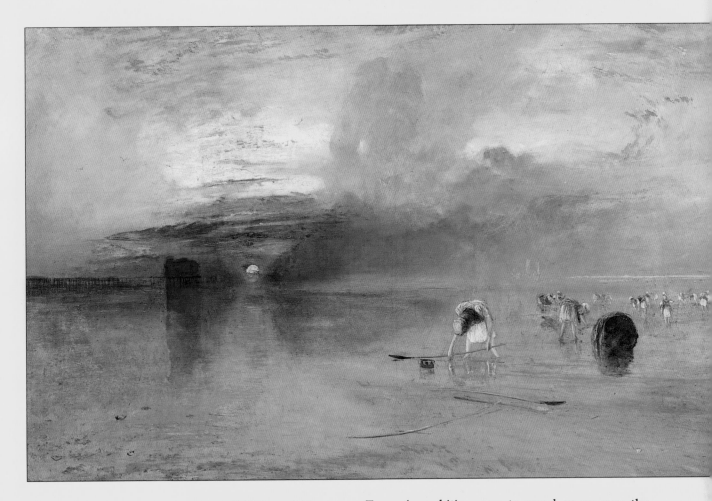

ABOVE: **J. M. W. Turner,** Calais
Sands, **c. 1830, oil on canvas,
73 x 107 cm (28½ x 42 in)**
(Metropolitan Borough of Bury,
Art Gallery and Museum)

LEFT: **Peter Paul Rubens,** The
Rainbow Landscape, **1636-8, oil
on wood panel, 136 x 236 cm
(53½ x 93 in)**
(Reproduced by permission of
the Trustees of the Wallace
Collection, London)

Turner's ambition was to equal or surpass the
famous landscapes of Claude. At his death Turner
left his pictures to the nation, on condition that one
of his paintings must always be exhibited alongside
a work by Claude. If you compare the painting by
Claude illustrated earlier with Turner's *Calais Sands*
you will instantly see that the two pictures are quite
different. Claude painted a dream world where
everything is calm, simple and serene. Turner's
paintings, in contrast, are full of movement. He
looked for the dramatic, like the sunset in this paint-
ing, and painted it with great verve. His colour and
brushwork are daring, striving towards a bold effect
rich in suggestion and never over-stated. Look at the
way he hints at the ripples on the sea and then, with
a few clever brush strokes, creates the figures in the
water.

Constable's approach to landscape painting was
different. He admired paintings from the past but
preferred to paint what he saw with his own eyes,
not through the eyes of Claude. 'There is room
enough for a natural painter,' he wrote to a friend,
and went on to criticize the artists of his day who
painted according to a formula, with a predeter-
mined colour scheme and recipes for painting clouds
and trees. Constable disliked these concocted pic-
tures. He wanted to paint the landscape as he saw

17

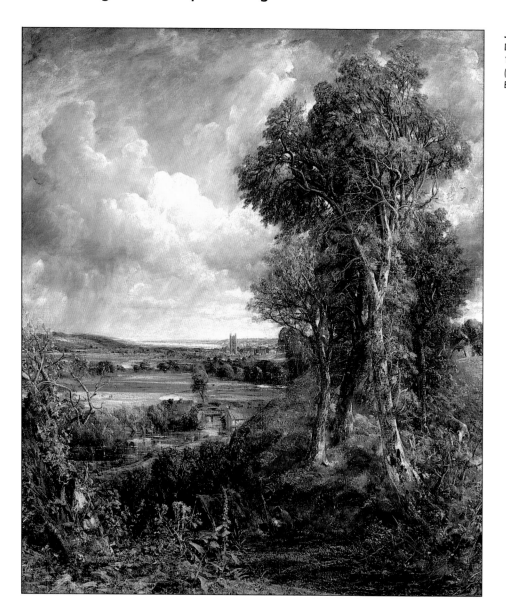

John Constable, Vale of
Dedham, **1828, oil on canvas,
145 x 122 cm (57 x 48 in)**
(National Gallery of Scotland,
Edinburgh)

it, and made sketches from nature which he elaborated in his studio. Often these sketches were bolder and more brilliantly painted than his finished paintings, and in them his truth to nature is unsurpassed.

I remember an occasion when I was a student at the Royal College of Art in London and a distinguished critic came to lecture. He asked us which artist had managed to get nearest to painting how we actually saw things ourselves. Constable was the undisputed choice. *Vale of Dedham* is typical of Constable's finished paintings, revealing him at the height of his powers. This picture was painted with sincerity and restraint; Turner's heightened realism was not for him. Constable wanted simply to show how impressive nature could be. He saw no necessity to dramatize it or to use it as a vehicle for demonstrating his skills as a painter.

From this point in the history of painting, artists could follow the paths opened up by these two great painters, perhaps the greatest Britain has ever

produced. They could either look for the dramatic and try to be poets like Turner, or alternatively they could stick to what they could see in front of them and try to paint it with honesty and determination as Constable did.

Cotman, the watercolour painter

John Sell Cotman (1782–1842) was a contemporary of Turner and Constable. His early and late paintings, while of a high standard, are no more than very good examples of English landscape paintings of the time, but for a period from about 1805 until 1812 he produced some of the finest watercolours ever painted. *Duncombe Park, Yorkshire* is an example of one of these beautiful paintings. Painted in 1805–6, it portrays the delicate balance Cotman achieved between painting nature as he saw it and at the same time translating what he saw into a kind of abstraction, which was highly original. He found a way of explaining complicated masses of foliage, for

example, with an effective silhouette; he interpreted masses as simple abstract shapes. No-one can say where Cotman's remarkable style came from. It anticipated styles of painting which came much later and because of this his watercolours were not truly appreciated until a century after they had been painted.

There has been some dispute about Cotman's working method. In the past it was thought that paintings such as *Duncombe Park, Yorkshire* had been painted outdoors, but it is now believed that they were studio paintings made from sketches. From about 1812 for economic and other reasons Cotman turned from watercolour painting to etching, but it neither secured his future financially nor gave him the artistic acknowledgement he so desired. On his return to painting about thirteen years later he wasn't able to rediscover the vision which had produced his earlier masterpieces. At his best, however, Cotman was a supreme artist of great originality who, in my view, can sit very comfortably beside Turner and Constable.

Monet and Impressionism

My story of landscape painting now moves from Britain to France and to Impressionism and 'plein-air'

19

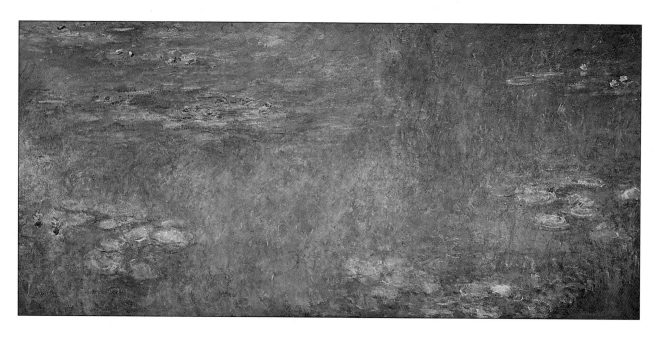

painting. 'Plein-air' painting has two meanings: it can mean the feeling of the open air that a painting can convey, or it can describe pictures actually painted out of doors. Claude may have done some painting outdoors and certainly Constable did, but the practice was not widespread, at least so far as producing finished paintings was concerned, until the development of Impressionism in the latter part of the nineteenth century. A group of French painters known as the Barbizon School painted outdoors in the mid nineteenth century and actually pre-date the Impressionists. They based themselves in the village of Barbizon, in the forest of Fontainebleau, and painted peasant life and rural scenery on the spot. This group may well have created an interest in France in plein-air painting, but it was the Impressionists whose outdoor paintings took art in a new direction.

Claude Monet (1840–1926), the greatest of the Impressionists, was in his late teens when he was persuaded by the painter Eugène Boudin to take up landscape painting. Subsequently Monet visited London in 1871 with Camille Pissarro (1831–1903), where they both studied the work of Turner and Constable. According to Monet, they were not particularly impressed, but something at least of Turner's work seemed to leave its mark on Monet. On his return to France he exhibited in Paris in 1874 a painting entitled *An Impression* at what has now become known as the First Impressionist Exhibition. The title of this painting was used derisively to name the movement which Monet headed as 'Impressionism'.

The Impressionists painted directly from nature. They were fascinated by effects of light and believed in absolute fidelity to their visual sensations. Monet remained true to these principles longer than any

other members of the movement and his last series of paintings, *Water-lilies*, shows this approach developed to the point where his pictures are abstract shimmering pools of colour. Painting the magic of light had become more important to him than describing the landscape itself.

The actual waterlily pond which Monet painted was in an elaborate garden that he had constructed for himself at Giverney and many now claim that these paintings were the starting point for a form of twentieth-century abstract painting known as Abstract Expressionism.

Sisley: Impressionism and representation

Impressionism is not only important to the development of twentieth-century painting in general, it is also where landscape painting, as we know it today, really begins. Not all the Impressionists in their attempts to paint light dissolved landscape forms into pools of colour like Monet did. Alfred Sisley (1839–99) was born in Paris of British parents and was almost exclusively a landscape painter. His paintings are clearly Impressionist but you can see in *The Bridge at Sèvres* that he was much more concerned with representing the subject than Monet was in his later paintings. These two contrasting approaches to painting the visual sensation are reminiscent of the differences between Turner and Constable; Monet's approach, like Turner's, was more poetic, while Sisley's interpretation of nature, like Constable's, was less expressive.

Cézanne: Impressionism and structure

Although their styles of painting are quite different, Monet and Sisley both remained Impressionists, but not all the French artists of the period were content to work within this movement. Paul Cézanne

LEFT: **Claude Monet,** Water-lilies, **c. 1916, oil on canvas, 200 x 426 cm (79 x 168 in)** (Reproduced by courtesy of the Trustees of the National Gallery, London)

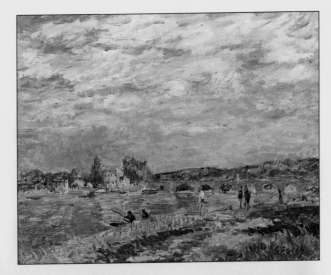

Alfred Sisley, The Bridge at Sèvres, **1877, oil on canvas, 381 x 460 cm (150 x 181 in)** (The Tate Gallery, London)

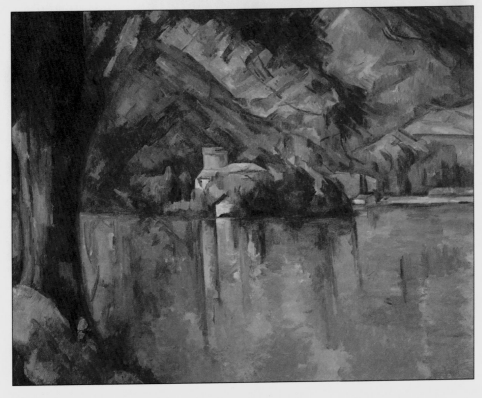

Paul Cézanne, Le Lac d'Annecy, **1896, oil on canvas, 65 x 81 cm (25½ x 32 in)** (Courtauld Institute Galleries, London)

(1839–1906) was dissatisfied with what the art historian Ernst Gombrich has referred to as the 'brilliant but messy' paintings of Impressionism. Cézanne, who described Monet as 'only an eye, but my God, what an eye!', wanted to make Impressionism into 'something more solid and durable'. He wished his paintings to have depth and solidity without having to sacrifice colour, and he also wanted to organize what he saw into a balanced design. In order to achieve this, he was prepared to allow objects to become distorted in his paintings. His indifference to 'correct drawing' was as significant to future artists as Monet's 'pools of colour'.

Cézanne's aims in painting seem quite contradictory. On the one hand, he wanted to paint what he could see in front of him, in a similar way to the Impressionists, but on the other, he regarded their paintings as lacking organization and he wished to restructure what he saw so that his pictures had a simple underlying framework. He achieved these aims by an infinitely prolonged analysis of his subjects. He painted his landscapes on the spot, day after day, and the agonizing process of careful adjustment that went into the production of his paintings took so long that many of them were left unfinished. Le Lac d'Annecy shows a landscape which has been carefully studied and reconstructed in the painting. Everything has been considered and nothing left to chance. There are no accidents and no gestures with the brush to create illusionary effects.

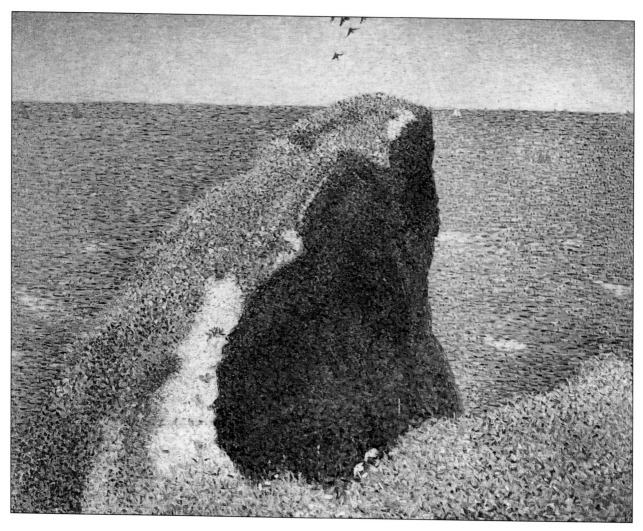

Towards the twentieth century

It was primarily from Monet and Cézanne, therefore, that the landscape painting of this century developed. Before we leave history and turn to the present day, however, I want to show how the development of landscape painting was taken a stage further, again by two very different artists, one working from his sensations like Monet, and the other, like Cézanne, more interested in the formal qualities of painting.

While Cézanne was struggling in Provence with the problem of how to structure Impressionism, a younger man, Georges Seurat (1859–91), was tackling the same problem in Paris, in a different way. Seurat's approach was through science. He studied the colour theories of Chevreul, who first wrote about them in 1859. He also studied the ideas on colour which were presented in the diaries of the French painter Eugène Delacroix (1798–1863), as well as the aesthetic theories of a group of scientists writing about visual phenomena, published in 1890. From these sources Seurat developed a system of painting using small dots of colour, which became known as Pointillism or Divisionism. This system

ABOVE: **Georges Seurat,** Le Bec du Hoc, Grandcamp, **1885, oil on canvas, 65 x 81 cm (25½ x 32 in)** (The Tate Gallery, London)

RIGHT: **Vincent van Gogh,** Landscape near Montmajour, **1888, pen, 49 x 61 cm (19 x 24 in)** (British Museum, London)

was based mainly on the theory that if the appropriate primary colours were applied to a painting as tiny blobs of colour, closely grouped together but not mixed, this would produce brighter secondary colours than could be obtained by colour mixing. With Pointillism the mixing takes place in the viewer's eye, or to be more accurate, in the brain.

This system of painting discouraged the artist from painting detail and the simplification in some of Seurat's pictures is even greater than in Cézanne's. Seurat became less interested in depicting visual appearances and more concerned with emphasizing the rhythms running through his paintings. His compositions, which feature very precise positioning of horizontals and verticals, are masterly. The painting illustrated above, *Le Bec du Hoc, Grandcamp*, shows his compositional skills and his pointillist painting system clearly. All his finished paintings were painted in the studio from drawings and studies made on the spot.

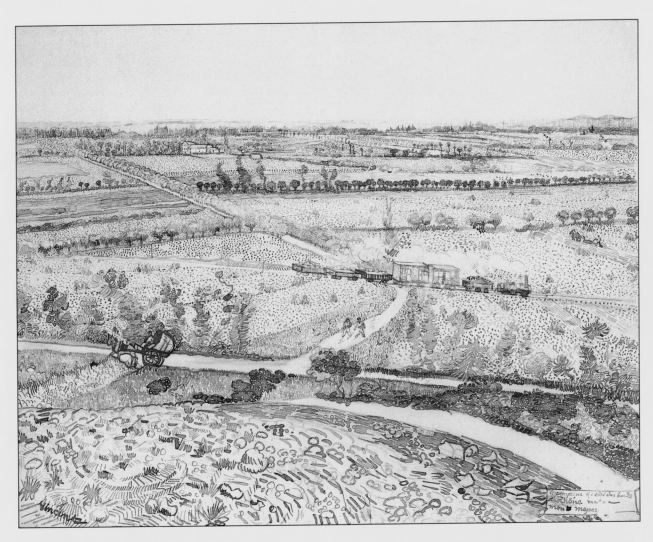

At the same time that Seurat was painting *Le Bec du Hoc*, Vincent van Gogh (1853–90) had already reached the half-way mark in a painting career which lasted only eight years. They were a highly charged few years during which he worked under tremendous emotional pressure and produced over 800 canvases. He was also a prolific draughtsman. Even though many of his drawings were lost or destroyed, there are over 1600 remaining from his brief life as an artist. *Landscape near Montmajour* is a brilliant drawing made after van Gogh left Paris in 1888 to work in the South of France, in search of intense light and colour.

Van Gogh drew and painted in a frenzy of creation. In a letter to his brother he described how he worked: 'The emotions are sometimes so strong that one works without being aware of working . . . and the strokes come with a sequence and coherence like words in a speech or a letter.' You can imagine *Landscape near Montmajour* being drawn in much the same way as someone else might write. The marks made with the quill pen demonstrate how van Gogh responded to this view. You can feel vividly his excitement about the vastness of the landscape divided by lines of trees and roads and with a train traversing the middle distance.

It is worth noting, however, that the drawing is not simply a display of emotion. Van Gogh, though largely self-taught, had studied the work of numerous artists and he had learned how to organize what he saw. As a result, the drawing is beautifully composed with lines curving, crossing and running to the horizon. The difference in the scale of the textures made by his pen strokes has the effect of making the foreground project and the background recede.

Although there are big historical leaps in my brief history of landscape painting, the background I have provided will set the scene for my comments on the landscape painting of this century. I hope it also provides a context for my interviews with present-day artists which feature in this book. All these artists refer to painters of the past, and in the interview with Roger de Grey which follows he refers particularly to Cézanne's *Le Lac d'Annecy* and working methods.

23

Interview

Roger de Grey

'You have to live in a state of thinking your painting is good or you couldn't do it.'

R oger de Grey is considered as primarily a painter of landscapes and he spends much of his time painting outdoors. Yet, surprisingly, he is adamant that describing the landscape is not his motive for painting. He paints landscape, he says, basically because he needs to work outside. He maintains that he doesn't go out-of-doors to paint trees or views but because he wants to work in what he believes is his natural environment. In fact, the landscape often gets in the way of what he is trying to paint. 'I have no subject,' de Grey explains. 'I am not a naturalist wanting to paint the landscape.'

De Grey has had what he describes as a 'life-long love affair with being in the open air' and wishes he had been born in some Mediterranean country where he could have lived his ideal life, out-of-doors. He paints in England and in France, and usually in places that he knows very well. His dream of an ideal life sometimes includes an ideal landscape, for which he searches. When the weather makes it difficult to paint outside he sometimes dreams about where he will go to paint at a later date, but often when he goes to the imagined spot he finds himself disillusioned. Reality doesn't match the dream and this compels him to search for a more suitable subject. It can be a fortnight before he is able to return to the place where the disillusionment set in, even though this may be a favourite painting spot of his.

He described one of his favourite painting locations, on the sands of an estuary. The main feature of the spot is a huge bridge which, curiously, has never featured in any of his paintings started there, except in the form of a shadow. Whenever he returns to this place he is happy and contented. It is like returning home.

In spite of this strong emotional pull to a particular place and although de Grey needs the landscape to make a start to his paintings, he feels that his pictures have little to do with actual appearances. He says people are astonished when they see him painting. They look at the landscape in front of him and then at his painting to try to identify his subject. If he is working in amongst the trees he describes the sensation he experiences as being 'surrounded by those strange colours and things which enclose the whole of your vision'. If he is working in some other environment he says he has to create the same sensation from nothing.

De Grey finds it difficult to explain to his satisfaction the relationship between artists and their subjects. Cézanne, he says, must surely have made his painting of *Le Lac d'Annecy* with his back to it, because if you study the painting and then go to the place itself, the painting bears no relation to what would normally be thought of as reality. Cézanne's vision, de Grey is convinced, was of something quite different from the landscape in front of him.

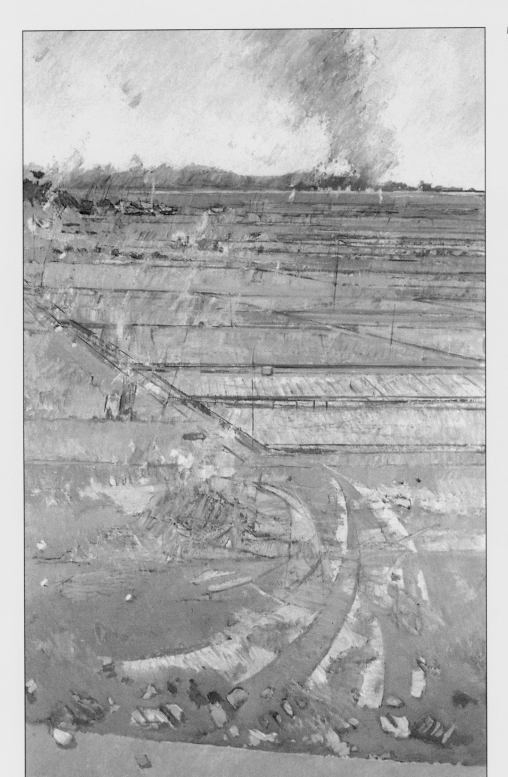

La Tremblade, **oil on canvas,**
152 x 91 cm (60 x 36 in)

The Influence of Euston Road Painting

Lawrence Gowing was a powerful influence on de Grey when they were both teaching at King's College in Newcastle-upon-Tyne (then part of Durham University). He introduced de Grey to the Euston Road concept of landscape. Gowing was aiming at a kind of studied, measured accuracy in his painting and talked at this time of clamping his head in a fixed position so that he could place points in his paintings with great precision.

This severely disciplined concept of painting from observation was new to de Grey, working in Newcastle in the late 1940s and early 1950s, though

he had seen Euston Road paintings just before the war in 1939, while a student at Chelsea School of Art. He hadn't much liked the paintings then and in particular had disliked William Coldstream's work, which to him appeared to be the key to the whole concept of painting in this studied way. It seemed inconceivable to him later that at Newcastle he had found the approach so absorbing, but perhaps it satisfied, in part, his desire to paint with geometric precision.

De Grey claims he learned a great deal from Euston Road painting but after a time had to break away from its constraints. He had always drawn fluently without plotting his way across the paper in the way that Gowing's influence had taught him to do in his paintings. He found, therefore, that his drawing and painting were developing separately and independently. His drawings were open, direct and responsive, in contrast to the constrained formality of his paintings. This, he decided, had to be changed and he managed to make the transition during the 1960s.

Working Methods

Over the years de Grey's working method has altered significantly. He used to believe that paintings had to be completed on the spot and that working on them while removed from the objects demonstrated a 'lack of integrity'. Now he might work for a fortnight or so on a painting outside and then put it to one side in his studio. In the winter, when painting outside becomes impossible, he revises in his studio the paintings started earlier outdoors. Occasionally he starts a new canvas with an idea taken from a painting made on the spot, but more usually he paints over the picture started out-of-doors.

When he revises a painting he starts by changing some part of the picture and then follows where this leads. Each change of colour, tone or shape initiates adjustment of other elements of the painting. This 'knock-on effect' becomes a very absorbing activity and through it, de Grey believes, his paintings gain another dimension. With a touch of humour he also describes this overpainting as accounting for the 'unacceptable surface' of his paintings. 'Other people's paintings,' he says, 'seem to have been painted in one go.' His, on the other hand, become 'a concoction of different layers and thicknesses'. On reflection he feels that perhaps the evidence in his paintings of not having been done at one particular point in time helps to give them a timeless quality, something he admires in the work of other artists.

Once he has started a painting his initial idea begins to be obstructed by new things which engage his interest. It could be that a tree trunk presents a particular painting problem and in tackling this problem the painting develops in a way which was not originally foreseen.

Choosing painting subjects

De Grey paints trees frequently. He finds them 'baffling things to work with' and difficult to paint. In an effort to resolve the problems they present he sometimes makes drawings of them akin to 'those painful drawings' which Constable made. He spends hours trying to make trees in his paintings seem to grow out of the ground properly. He compares the balance of a tree to the balance of a standing human figure, considering it to be just as precise. Evidence of the search for this correct balance is clearly revealed in his paintings, where the direction of a tree trunk may show signs of having been changed several times in order to satisfy what de Grey feels is its correct thrust.

When he is talking of grappling with the problem of painting a tree, the subject itself seems important to de Grey. Yet he rejects this, believing he should really be a geometric abstract painter. He has tried to paint abstract pictures in the past but reckons that they require a degree of imagination and invention

Interior/Exterior, **oil on canvas,
152 x 91 cm (60 x 36 in)**

LEFT: La Tremblade, 1989, oil on
canvas, 127 x 101 cm
(50 x 40 in)
(Royal Academy of Arts, London)

which he claims he doesn't possess. He loves abstract painting, however, and feels his life is really deeply concerned with it. Nevertheless, when people identify an element of abstraction in his work, he has to explain that he is very powerfully hooked on the visual world, too. He wishes he 'could have made abstract paintings into the visual world' but has not been able to do so. He very much admires painters who he feels have managed to do this, and gives Jackson Pollock (1912–56) as an example. He considers that those painters whose work derives from Monet rather than Cézanne, the two artists considered by many as the most important in the development of twentieth-century painting, are those who have been able to make abstract paintings out of visual experiences.

De Grey is very interested in the effects of light. 'My whole life depends on sunlight,' he says. He doesn't like painting on grey days, though sometimes he has to. He describes 'the conflict between light and shade' as the essence of what interests him in painting. He sees light and shade as revealing or destroying what he is looking at and he remains captivated by this conflict, which has fascinated him

all his life. Effects of light change rapidly and so, like the Impressionists, he does not paint for very long on any one painting, perhaps for two and a half hours at a time. After this the light has changed too much to continue. He returns to the location on another day, when the light is as it was when he started his painting.

Although de Grey plays down its importance to him, the choice of landscape as a subject is deliberate. He doesn't want to paint factory chimneys or introduce anything into his pictures that represents the present. To make his point more strongly he says that he is perfectly happy to work with his back to a nuclear power station, painting the sea in front of him. The modern man-made aspect doesn't distract him. 'I am deeply interested in the present,' he says, 'but I'm only interested in painters who have disregarded the present of their time.' He admires Claude, who he feels could have painted at any time in the history of civilization, and also Salvator Rosa (1615–73). Closer to home he respects Constable and, to a large extent, Turner, though he confesses to not being so interested in Turner's theatrical Italianate paintings.

Interior/Exterior, **1989, oil on canvas, 127 x 150 cm (50 x 59 in)** (Royal Academy of Arts, London)

RIGHT: Interior/Exterior, **oil on canvas, 182 x 101 cm (72 x 40 in)**

Equipment and Techniques

Providing you discount his car, which he says he relies on, at least to the extent that Pissarro relied on his little cart, for transporting his painting paraphernalia, de Grey has no elaborate equipment for painting outside. He uses a Winsor & Newton sketching easel which he bought in 1939 when he was twenty-one. He describes it as 'the only really satisfactory collapsible easel that has ever been made'. It has three legs and a sliding brass fitting, with a long arm to hold the canvas in place. The legs have holes for pegs, which de Grey has replaced over the years with nails. The easel will take a 152 cm (60 in) canvas at its fullest extent.

De Grey generally uses the same colours each time he paints, set out on his palette in the same way. Sometimes, to give himself a jolt, he changes his palette, but he says that changing the colours doesn't really make much difference to the eventual painting. He uses a cool palette with no cadmium red. He prefers cadmium orange for his warm colours and also has rose madder on his palette, but he seldom uses this. He uses black only for special things, although he used to use it more generally. He mixes browns rather than having the earth colours on his palette. If browns are mixed, he considers them to have hidden resources. He does not find earth colours very satisfactory; they are not

vibrant colours and the last thing to confront a ploughed field with, he warns, must be a palette with earth colours on it.

Nobody taught de Grey much about techniques, he says, and he has tended to use the methods of the Impressionists, not least because his early life was to an extent built around Impressionism. His uncle was the painter Spencer Gore (1878–1914), who had been in contact with the Pissarro family, and words of wisdom on painting were therefore handed down. 'Never varnish a picture,' he was told, and he never has. From hearsay and from reading Camille Pissarro's letters to his son Lucien, de Grey discovered that the Impressionists considered manufactured oil paints to be so full of oil already that they needed only turpentine to reduce them in consistency, so he too uses only turpentine.

So far as size is concerned de Grey paints large pictures for one who works outside. They are sometimes 182 or 213 cm (72 or 84 in) high, though he confesses to feeling fear when a painting exceeds 182 cm (72 in). He used to be able to paint quite small paintings but now has no patience, he says, with sizes much below 127 x 101 cm (50 x 40 in).

One reason why he paints large, de Grey says, is to differentiate his paintings from those of other artists with whom he is frequently grouped. These include naturalistic painters who he feels have a very different approach from him.

Deciding on the right shape of canvas is also complicated for de Grey. Basically, he observes,

Teaching and Painting

Most of de Grey's life has been spent in education. After King's College in Newcastle he taught at the Royal College of Art in London and he is at present Principal of the City and Guilds College as well as being President of the Royal Academy. He says he has always preferred to teach by implication rather than by being direct, but he has grown to feel that students don't like this approach, preferring something more positive. He thinks, however, that this requires a teacher to be too obtrusive.

He finds he cannot confront his own painting in the way he may criticize a student's work. He hasn't got the courage, he says, because he 'lives on a knife edge between thinking my painting's marvellous and thinking it's dreadful. And when I think it's dreadful, I can't work at all.' He only has to see something which he considers bad in his painting to think that everything he does is dreadful. He says he rarely sees a painting of his without wishing he could repaint it. 'You have to live in a state of thinking your painting is good or you couldn't do it,' de Grey observes. 'No matter how many successful things happen to you, you still have to build up your own confidence and try to protect yourself against humiliation.'

De Grey's concern about the humiliation of artists leads him to object strongly to the current world of art criticism. It has, he believes, become too abusive and he doesn't think that artists can take that kind of demolition. It may, he suggests, amuse the general public or the critics, but the criticism is often characterized by an absence of any appreciation of the artists' intention. 'People don't paint for the hell of it. It's a deeply seated thing – a preoccupation – the whole of one's life.'

In spite of his many rôles de Grey usually paints on four days each week. He has a rule (rarely broken) of always painting on Friday, Saturday and Sunday. 'It's difficult to paint every day,' he says, 'and people who say they do, probably don't; it's a very demanding thing.' De Grey regrets that the pattern of his life prevents him from seeing as many exhibitions as he would like, but actually painting is more important to him than looking at paintings.

De Grey feels alien to the present fashion for intuitive, expressive painting. He admires it, but the more he sees of it, the more he comes back with real excitement to the idea of very simple geometry. He says he can never be an expressive, romantic painter. He respects romantic artists, but feels he has little in common with them. Even when he was at school he knew that the romantic approach to landscape was not his approach.

there are only three shapes: a vertical rectangle, a horizontal one and a square. For a time he found it so difficult to choose which of the first two to use that he decided to paint only on square canvases. He still likes the look of square canvases and finds their shape satisfying. He likes other people's square paintings, too, and feels it is again something to do with the fascination of geometry, which continues to haunt him.

De Grey has also made a dozen or so composite paintings. He described in our interview how these paintings originated. Sometimes he has been in a position where, if he turned very slightly to the left or right, he could see new material for the same idea. He found that he might then make two or three paintings from the same spot, and it occurred to him that he could join these together. These paintings, which are later placed adjacent to each other, are not consecutive and cannot be put edge to edge exactly, because they are never painted very close to each other in time.

'For me, a landscape does not exist in its own right, since its appearance changes at any moment.'
(Claude Monet, 1890)

Chapter 2

The Landscape
Past and Present

It is probable that at the present time there are more pictures of landscape painted, exhibited and sold, than of any other subject. We even see landscape images where they are not the artist's intention. Totally abstract paintings are often said to evoke landscape, for example, and in our desire to see the merest mark depicting reality, a single line drawn across a sheet of plain paper is usually imagined to be the line of the horizon.

There are doubtless many reasons for our close relationship with landscape. Most of us are compelled to live in towns or cities, and pictures of the undulating planes and organic forms of the countryside provide relief from the hard horizontals and verticals of the urban scene. Through landscape painting we are brought closer to nature and are reminded of the changing seasons and the varying light of each day.

Alan Welsford, Evening Landscape, Broughton Astley, **1982/3, oil on board, 122 x 152 cm (48 x 60 in). Here the cloudy sky is observed as a series of receding, overlapping layers. The light emanates from beyond the horizon**

Ian Simpson, Landscape, Cornwall, **oil on board, 76 x 91 cm (30 x 36 in). The main interest here is in the dramatic foreground rock shapes, silhouetted against the blue-green sea, with the coastline beyond. The great difference in scale between foreground and background helps to create a feeling of space, while the repetition, in the background, of the foreground triangular shapes integrates both areas of the painting**

Landscape painting tends to invoke in us a deeply felt nostalgia for the country and for rural life. The fact that we respond so readily to landscape images is well recognized in the world of advertising: the powerful association of rural life with things that are natural, wholesome, honest and durable is used to promote all kinds of products ranging from bread to motor cars.

From the artist's point of view, however, this love of the landscape does not necessarily make the landscape painter's life an easy one. I have used the word 'nostalgia' already in describing our feelings for the landscape. The love of landscape often takes the form of a longing for an environment and way of life which no longer exists. Landscape painting today, however, has to be about how we see the landscape of the *present*; as with all forms of art, the subject must be interpreted in a way which is relevant to the present but which also takes account of the legacy of the past. It can be difficult to get the balance right, but I am certain I am correct to emphasize seeing the landscape in this way.

As artists, we must see the landscape as it really is and decide what is important to us, taking on trust that we have the capability of saying something original about it because we are all individuals. In any case, however much you might admire Cézanne, for example, you cannot see through his eyes or paint as he did. Since he died in 1908 the landscape has changed, the way we see it has changed, and the way artists paint has changed as well. Trying to make paintings which use the vision and methods

of the present but which also assimilate the influence of landscape paintings of the past is therefore the first part of what I have called the 'two-fold challenge' of landscape painting. The second part of the challenge relates to the subject of landscape itself – coming to terms with the practical difficulties of painting complex organic forms in infinite space and with constantly changing light.

The Challenge of History

I surveyed the landscape painters of the past in Chapter 1. Even though you yourself might have chosen different artists on which to focus attention, this would not have altered the main lesson which history teaches us. There is undoubtedly a thread which runs through landscape painting linking the different artists and periods, but there is no consistent view of what the concerns of landscape painting should be. This is equally true of other branches of painting. Not only has each generation of artists changed the nature of painting but the speed of change itself has reached a point of frenzy. Since the end of the nineteenth century, at any one time individual artists can be going in quite different directions. This diversity has been a dominant feature of the art of this century and it has made many artists uncertain and insecure. This is revealed in the interviews with artists in this book.

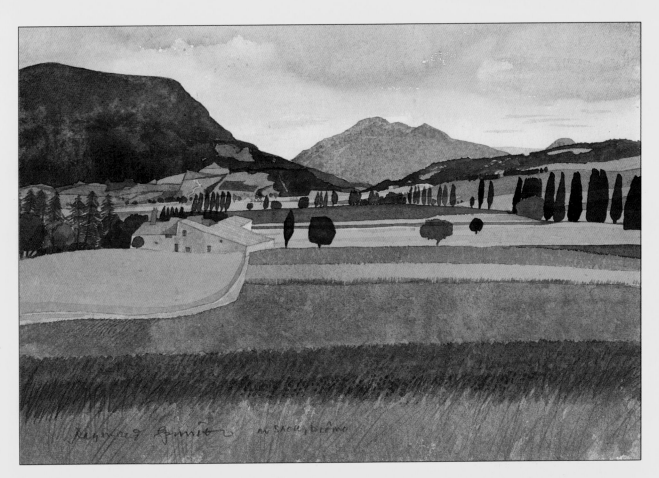

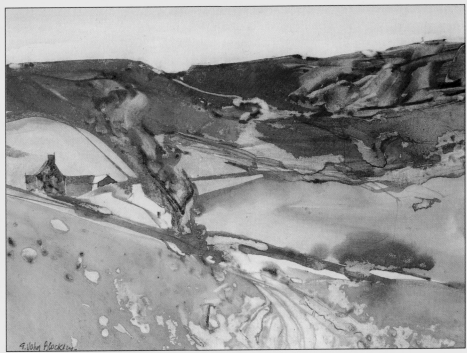

ABOVE: **Raymond Spurrier,** Near Saou, Drôme, **1981, watercolour, 26 x 37.5 cm (10¼ x 14¾ in). In this straightforward landscape mountains contrast with cultivated land, horizontals with verticals, and the colour of wheat with lavender**

RIGHT: **John Blockley,** Powys, Mid-Wales, **1988, watercolour, 20 x 28 cm (8 x 11 in). This painting is concerned with the movement of the landscape: its gentle, sweeping curves, suggestions of half-hidden footpaths, indications of trees blending into the patterned hillsides. The buildings offer a positive statement of fact within the overall interpretative nature of the painting; but their shapes also echo some of the directions of the brush strokes in the landscape, so that buildings and landscape integrate**

Indirect and direct influences

It is not only artists who change the directions of art but also critics, commentators, museum curators, gallery owners and private collectors. The ambitions of most painters working at present are to have a one-person exhibition in a prestigious gallery, to be favourably reviewed by the influential critics, and to have work purchased by a national museum or an important collector. No matter how strongly artists may insist that they are painting for themselves,

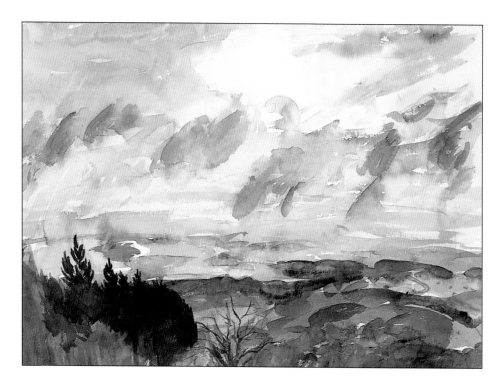

Laurence Wood, *Moving Clouds*, **1988, watercolour, 40 x 56 cm (16 x 22 in). Here the artist painted rapidly, responding positively to the unpredictable, accidental behaviour of the medium. Invention was the key in this situation. The unexpected shape formations together with the colour mixing, caused when wash after wash was applied to wet paper, were harnessed to create this atmospheric study**

their desire for approval makes it highly likely that these indirect pressures influence their work.

Sometimes the external pressure is intentional and direct. Since the late 1950s the major influence in art has come from the USA. Some American critics have seen their rôle to be not only one of judging what artists have done, but also of telling them what they should do. The American writer Tom Wolfe, commenting on the New York art scene of the 1960s and 1970s, considered the critics to have been overwhelmingly powerful in determining what artists did. He suggests a future where the art of this period is exhibited in the form of the critics' words, enlarged and displayed, with small versions of the artists' work placed beside this text merely as illustrations.

To give an example of the way critics of the 1960s tried to influence painting we need only turn to the famous American critic Clement Greenberg. He said that artists should 'insist exclusively' on paint and the shape and flatness of the canvas, and that subject matter should be 'avoided like the plague'. Greenberg writes in a form of art language which is only meaningful to those who are conversant with it; put simply, he was saying to painters that pictures should be abstract and that artists should not be concerned with creating an illusion of space. Many painters went along with these ideas and Greenberg encouraged (and some would say created) an international movement in painting. This emphasis on the abstract, formal qualities of painting and the rejection of the subject became, for more than a decade, synonymous with the only contemporary painting believed by most art experts to be worthy of serious attention. It left landscape and other

representational painters feeling anxious, to say the least. Some changed their ideas to fall in with the prevailing doctrine of what painting should be like; others went on as before but not without being affected by Modernism, as it was later named.

The return to realism

In the last ten years the pendulum has been swinging away from abstraction towards a form of expressionist realism. By this I mean that although representational, the paintings exaggerate or distort in order to create a dominant emotional impact, often reinforced by vigorous handling of the paint. This return to realism has produced a revival of interest in a number of artists, not necessarily expressionists, who have been neglected for more than twenty years, such as Eric Ravilious (1903–42) and Laura Knight (1877–1970), and has drawn fresh attention to representational painting.

Artists and freedom

Having raised the question of the influence of art critics, I am not saying that it is necessarily wrong for artists to be given guidelines for their work, or even told exactly what to do. Patrons in the past must always have influenced what artists did and some of the greatest art has been work which has been commissioned. There is nothing to say that freedom to do anything one pleases produces great art and perhaps it is impossible in any case for artists ever to be entirely free. The romantic idea of the artist in the ivory tower, insulated from everything except his own creativity, is a recent concept. It does not square with history and is based more on fiction

than on fact. Even if you choose not to exhibit your work and decide deliberately to avoid the minefield of the 'art scene', you cannot avoid some of the pressures, particularly the weight of the past.

Painting any subject poses identical problems of looking, selecting and translating into paint, but in landscape painting there are what I have described as 'practical difficulties', concerned specifically with this subject, which add to the universal painting problems. First of all, the landscape is outside; you can't bring it into the studio. As a subject it is vast and it changes all the time. Many of the features of the landscape are changing daily and during the course of a day the light alters constantly. Also, at least in northern Europe, the weather is unpredictable. I have often abandoned paintings because the original subject changed dramatically while I was painting it.

Working from direct or indirect observation

In my opinion, landscape painting, more than any other subject, poses the dilemma of whether to paint from direct observation or whether to work from studies, drawings, photographs, or from memory. Working outdoors, even setting aside for a moment the problems which can be caused by the weather, is for most artists inconvenient and needs to be carefully planned. Yet, painting from direct observation has several advantages. If you paint outdoors, constant stimulation is provided by the landscape. All the information which the subject offers is right there in front of you. The changing light, the uncer-

tainty of the weather, and the limited time you can spend outside all compel you to work quickly; this may seem to be a disadvantage, but speed of working imposed by such restrictions usually gives pictures painted on the spot a vitality and spontaneity which are not otherwise easily obtained.

There are opportunities in this book to compare paintings made outdoors and in the studio by several artists and you can decide whether or not the outdoor paintings have greater vitality. Studio painting has its own advantages. It removes the pressure of having to work quickly and it is therefore likely that a studio painting will be more controlled, better composed and possibly a more carefully considered statement than one painted on the spot.

The diversity of the landscape

Another aspect of landscape as a painting subject which causes a particular problem is its diversity. Landscape subjects can present enormous differences in scale. The actual distance from the foreground to the background can be considerable. Painting by the sea, for example, offers the challenge of re-creating vast distances and accommodating great differences in scale. In *FE64 Fishing Tackle* this contrast is fully exploited.

Landscape subjects may also contain moving, changing forms, such as waves, clouds and effects caused by the wind. These can be difficult to identify and equally difficult to translate into paint. A blustery showery day can produce the most astonishing transformations in the sky. Clouds move quickly, altering shape and colour as they travel. Patches of blue sky appear and vanish unexpectedly. Grey sheets of rain are swept aside by wind, allowing brilliant light to break through. To sit and try to translate this into paint is a formidable and exciting experiment in control and invention. Natural forms,

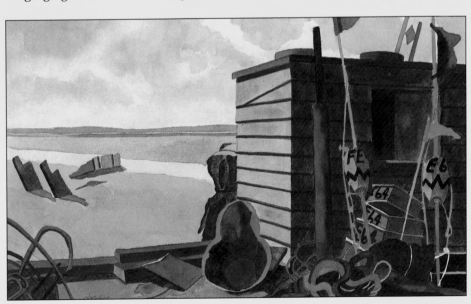

Lesley Giles, FE64 Fishing Tackle, **1987, watercolour, 33 x 51 cm (13 x 20 in). Here the scale of the foreground objects invites us to stand amongst them and then look beyond, across the featureless water to the thin strip of distant hills**

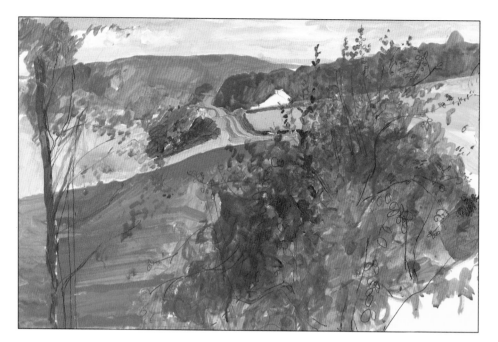

Ian Simpson, Swedish Landscape, Bjorketorp, **acrylic on paper, 40 x 58 cm (16 x 23 in)**. This was painted from an upstairs window and the contrast in scale between the foreground trees and the road and house in the middle distance gives a strong sense of space to the picture. The paint has been used thinly to describe the texture of the trees and fields, and the road winding over undulations in the landscape has been given special prominence

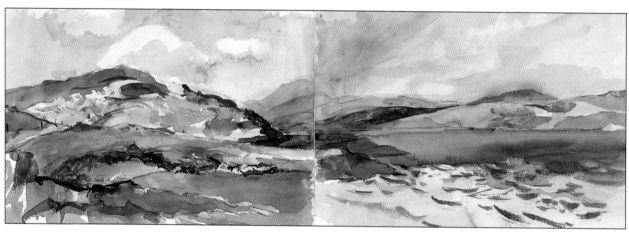

ABOVE: **Laurence Wood**, Loch Scridain, 1988, **watercolour, 35 x 101 cm (14 x 40 in)**. This was painted outdoors. The undulating rhythms of hills, clouds and waves flow across two sheets of paper. The light changes constantly as we follow the artist's eye across the loch on a breezy day

LEFT: **Ian Simpson**, Swedish Lake, **acrylic on paper, 40 x 58 cm (16 x 23 in)**. The colour of the water and the shapes of land and trees against this subtle blue-green were the starting points for this picture, made on the spot. The vastness of the lake and something of the sombre nature of the particular day have emerged in the painting, although its primary concern was for interlocking shapes and patterns

such as trees, shrubs and plants, can be very elusive objects to paint, too. Their forms are often indistinct and they may appear to be a mass of detail.

Landscape can offer a variety of subjects, ranging from the back garden, where forms are contained in a clearly defined space, to the open panoramic view where the space stretches beyond the distance you can see. When confronted by an extensive, open view we are acutely aware of the great space all around us. The sky, for instance, is not a flat screen perched on the horizon, but is a spacious dome, stretching into the distance, high above our heads. Our field of vision is surprisingly wide. Even a slight sideways movement of our head or eyes extends this further. For example, you could never see the view in *Loch Scridain* through a fixed-position viewfinder.

Landscape paintings may also be concerned with the more obviously man-made landscapes of parks and farmland; or they might explore those places where man's effect is less obvious, such as moorland, hill and mountain country, as well as those landscapes which feature water in the form of rivers, lakes, ponds, waterfalls, or the sea.

A focal point or a general statement

Despite the inexhaustible diversity of landscape subjects, almost all of them pose a fundamental problem: what should be the focus of attention? Should the painting have a particular focal point, such as the island and lighthouse in *Godrevy*, or should it make a statement about the landscape as a whole, as in *Bellrope Meadow, Cookham*? If a painting is to have a

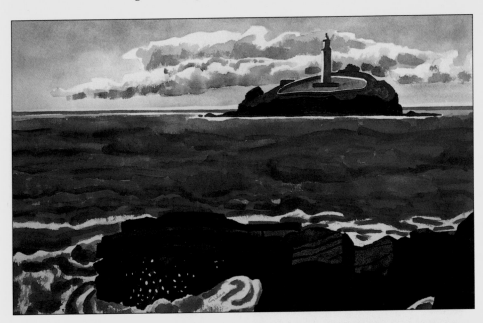

Lesley Giles, Godrevy, 1987, watercolour, 33 x 51 cm (13 x 20 in). Here the clouds, as if held by some invisible force, hover behind the island, which is the focal point of this painting, and hold our interest. The dark, rich colours of sea and foreground rocks knit the picture together and make a dramatic contrast to the white surf and pale sky against which the island stands. Our attention is focused, yet the overall effect of the picture is not depleted

Stanley Spencer, Bellrope Meadow, Cookham, 1936, oil on canvas, 66 x 130 cm (26 x 51 in) (Rochdale Art Gallery, Lancashire)

ABOVE: **Tom Rickman**, Coppice, 1987, oil on canvas, 74 x 124 cm (29 x 49 in). Although the title of this picture describes the distant trees, the canvas is dominated by the sky. This is often the case with extensive flat landscapes, when the sky is packed with ever changing cloud shapes, light effects and beautiful shadows

main feature, this need not, of course, be an object. It could, for example, be the sky, which can be used very effectively to give a painting a particular mood, as in *Coppice*. A landscape painting may, however, focus attention entirely on the ground plane, to the extent that the sky is completely excluded, as can be seen in *Garden at Plönninge*.

Landscape painters sometimes use figures or buildings, for example, as features in their pictures. One of the artists interviewed for this book, Olwyn Bowey, is particularly interested in using architecture, animals and figures in her landscapes, but in the main I have restricted my definition of landscape to 'pure' landscape. However, within this I have included paintings which are more about atmospheric effects, such as the mood of a particular day or the kind of weather, than the topographical landscape itself. This adds further to the almost endless list of subjects under the overall heading of 'landscape', also introducing another dimension to the challenge of the subject itself.

BELOW: **Ian Simpson**, Garden at Plönninge, **oil on board, 51 x 61 cm (20 x 24 in)**

The question of 'place'

I have said that the landscape subject itself presents a particular challenge, first by being outside so that we have to choose how to paint it, and second by its great diversity. There is a third problem posed by the subject which to an extent affects all painting subjects but most pointedly concerns landscape. This is how to deal with the question of 'place'. Is the depiction of a specific place important, and if it

ABOVE: **Ian Simpson**, Buildings and Docks, **oil on board, 51 x 76 cm (20 x 30 in). This** view, looking down over docks and beyond them to the sea, makes good use of the patterns of the water and the sharp contrast between its blue and the red of the foreground huts. The eye is drawn from these huts out across the angular shapes of jetties and buildings towards the sea, giving a feeling of space and desolation

RIGHT: **Ian Simpson**, Figures on a Beach, **acrylic on paper, 38 x 56 cm (15 x 22 in). Made** entirely on the spot, paintings of figures like this are a real challenge. Getting their relative scales right and the relationship between figures and environment is difficult when the figures are moving all the time. It is necessary to look hard, memorize what you can, and work very quickly. The figures in this painting are integrated with the landscape and give a sense of scale and distance to the picture

is, can it best be revealed by taking one particular viewpoint, or might a sense of 'place' be best re-created by showing it from several viewpoints, as in *L'Hospitalet du Larzac, Aveyron*? If a sense of place is not regarded as important – and from the interviews in this book you will understand that it is not of importance to all artists – then a number of different experiences of a landscape can be brought together to make a painting which does not depict an actual view at all, such as *Moorgreen Colliery*.

ABOVE: **Raymond Spurrier,** *L'Hospitalet du Larzac, Aveyron*, **1981, watercolour, 27.5 x 37 cm (10¾ x 14½ in).** **This painting is an attempt to create the slightly 'stagey', dream-like feeling of a French village in the silent midday heat. The buildings and trees are used less for their own sake than to define and articulate the empty space, while the formalized sky emphasizes the sense of unreality**

Laurence Wood, *Moorgreen Colliery*, **1985, oil on canvas, 122 x 152 cm (48 x 60 in). This large painting was composed from a number of studies made on site at a disused colliery. The intention was to fuse together viewpoints, features, objects and experiences from all over the site into one atmospheric painting that would convey the 'essence' of the place**

However, this raises, at any rate for me, the further question of whether there is any limit as to how far an artist may depart from a subject before the painting ceases to be about the landscape at all and becomes an independent invention.

My Own Position

In presenting the dual challenge of history and subject I have tried to show the range of problems that confronts the landscape painter. Each artist has to take a particular position in relation to this challenge and it would be unfair if I did not attempt to explain my own, because this must influence the way I present the information in this book.

Already, almost without realizing it, I have put all painting into two broad categories. Perhaps the work of van Gogh best epitomizes one of these. Writing to his brother, he said: 'There is something intimate about painting I cannot explain to you – but it is so delightful just for expressing one's feelings.' One of my categories, then, is 'paintings expressing feelings' and the other is 'paintings based on seeing'. The two are not, however, as separate and as exclusive as I am making them sound here.

Nevertheless, painting to me is predominantly about seeing, even though it is about feeling as well. The two for me are inextricably entwined, as I suspect they are for most artists. When I paint, I am trying to identify and translate into paint a visual sensation. I'm not always sure of what it is and I don't always manage to get near what I have seen and experienced, but the starting point of every painting is seeing something that makes my pulse quicken.

The British painter Graham Sutherland (1903–80) eloquently described seeing something which inspired one of his landscapes: 'I see something – some conjunction of forms – which dominates all others. There is a sudden recognition that in what I have been looking at there is contained a unique series of rhythms A shiver down the spine arrives to prove the validity of such an encounter.' This description comes very close to my own experience.

The 'place' is important to me because the visual encounter, which for me gets the painting process started, is closely related to the place. There is a story which was told by a famous artist (I believe it was the German painter Max Ernst). He recounted how his father, also a painter, always included in his pictures everything he could actually see. This devotion to his subject presented him on at least one occasion with a terrible dilemma. He was working on a painting which he realized could be improved if a particular tree was removed from it. He was unable to change his painting, however, because the tree was nevertheless a part of the actual landscape that was the subject of his picture. As a result it had to be included. After much soul searching he made up his mind what to do. He sawed down the real tree and then he was able to remove it from his painting!

When I say that the place is important to me, I do not mean it is important in this literal way, yet while I select from what I see, I do not change the basic elements very much. To change things drastically would be to leave behind the point of painting for me and move into what I describe as 'picture making', which doesn't interest me at all.

Lawrence Gowing, the next artist to be interviewed in this book, is a painter who always paints from direct observation. A distinguished art historian and writer, as well as a painter, he describes the way he has responded to the challenge of painting over the last half century. Apart from references to them in the interviews, the problems posed by landscape painting, outlined in this chapter, are systematically considered in the other chapters of this book, beginning in Chapter 3 with the dilemma of whether or not to take your easel out and paint on the spot in the way that Gowing does.

Ian Simpson, *Swedish Landscape*, oil on board, 51 x 61 cm (20 x 24 in). This picture was made entirely on the spot over several days. It was painted from the porch of a house, with a column supporting the porch roof used as a strong, three-dimensional foreground object against which the fields beyond could be contrasted. The textures of grass and corn were created by painting areas of green and yellow and then drawing into these areas while they were still wet with a small brush and, on some occasions, with its wooden handle

PHOTO: JORGE LEWINSKI

Interview

Lawrence Gowing

'There have been times when I have found it easier to express what I have seen in the landscape in words rather than in paint.'

Lawrence Gowing has always painted landscapes and although he has also painted portraits and other subjects in the past, he regards himself now as a landscape painter.

He is also, however, a distinguished writer, lecturer, broadcaster and curator, who has held several important academic posts, including that of Professor of Fine Art at University College, London. He lays justifiable claim to having helped, through his critical writing, to save figurative painting when in the 1960s and 1970s it was in danger of disappearing. In 1956 he recorded in his diary the alarm he felt at the way his colleagues at King's College in Newcastle-upon-Tyne (then part of Durham University), who included Victor Pasmore and Richard Hamilton, rejected any painting that was not obviously imaginative. For them the only place for representational painting was in an elementary introduction to art.

Gowing has had no real formal art training. His basic training, he says, took place in his general education. He did, however, attend the Euston Road School, a short-lived institution founded in 1937 and closed when the war began in 1939. Here he met Coldstream, Pasmore and Graham Bell (1910–43), who had a powerful influence on him. He regrets the form this education in art took because he feels that instead of having an experience of 'opening out' he was in a sense indoctrinated by the Euston Road School. 'Measuring' was its basic principle, and measuring the precise position of key points was used to encourage a detached, objective appraisal of the subject. Gowing feels that this rigorous, disciplined and impartial approach to painting has left him with little imagination as an artist.

Gowing has been interested all his life in the subtle relationships that exist between objects, which he likens to the essence of a Chardin painting. The direct observation of these relationships, he believes, is too important to be lost and he sees figurative painting as a valid and vital thread through the history of painting which will continue, probably forever.

One of the artists who has particularly interested Gowing, and about whom he has written a book, is the seventeenth-century Dutch painter Jan Vermeer (1632–75). Gowing regards the kind of relationship that Vermeer had with the subjects he painted as so intense that it cannot be dismissed and nor can his pictures be considered, as they have been by some artists and writers, merely descriptive. The great figurative painters such as Vermeer, Gowing says, may not be imaginative in the sense that his academic colleagues in the 1950s thought artists should be, but their imagination is nevertheless presented in the personal selection they make after contemplating and engaging with the subject.

Four Trees in a Wood, **1987, oil on canvas, 58 x 66 cm (23 x 26 in)** (Royal Academy of Arts, London)

Subjects for Painting

Gowing's own pictures are painted entirely on location. He lives in London but he paints mostly in Sussex where he has a cottage. He makes paintings sometimes from the windows of his cottage but more usually he paints in a wooded area nearby. He also thinks that there are views through the doorways of his London home which provide a similar visual experience to his landscape subjects. He intends to make some paintings of these interiors, which he describes as 'reconstituting a primeval visual experience.'

There is one particular place in Sussex he returns to time and time again to paint. He describes it as a grove of tall ash trees, with branches reaching up to touch, like the columns of Gothic arches, in 'a cathedral of trees'. His landscapes are often concerned with a ceiling of leaves, making an enclosed space, which leads through to a bright area. This is similar to a view from a room, looking out through a doorway to a lighter room beyond. Gowing thinks

ABOVE: Trees over Stream, 1984, oil on canvas, 40 x 51 cm (16 x 20 in) (Royal Academy of Arts, London)

that a painting of this kind of subject is read by the viewer as 'a way through life'. He finds that any painting of his which depicts this 'way through life' leading along a path to a bright clearing in the distance will sell easily. In contrast, if a painting presents an impenetrable wall of foliage no-one wants to buy it.

He never paints from drawings; he regards the small 'sketch' paintings he makes as rehearsals for larger paintings. He feels that whenever he has tried working in the studio on paintings which he started outdoors he has never managed to improve them and so he always aims to complete his landscapes on the spot.

Gowing feels that he has a close affinity with the landscape he knew when he was growing up and that other landscapes have never had the same fascination for him. When he lived in the north of England he found neither the landscape nor the light right for him. He has found some French landscapes much more to his liking, but because he does not feel for them the affinity he feels for the Sussex landscape, to him his paintings of France are not entirely successful.

RIGHT: Within the Wood, 1986, oil on canvas, 43 x 66 cm (17 x 26 in) (Royal Academy of Arts, London)

Working Methods

He always paints in oils, only occasionally using watercolours to make a colour note in a drawing. Sometimes he makes small paintings on boards measuring 35 x 25 cm (14 x 10 in), which are held in a panel holder, suspended round his neck, while he paints. Larger paintings are made on canvas. For these he uses a sketching easel with a brass canvas tilter, which he says is very similar to the kind of easel Cézanne used for painting outdoors in Provence.

Gowing puts a wide range of colours on his palette. They are arranged in the order of the spectrum, from red to violet, with violet placed on the right. By always arranging his colours in the same order he can paint almost without needing to check into which colour he dips his brush.

Gowing has a clear idea of what he intends to do when he starts a painting. He has described this as wanting 'to paint the scoop of space without losing the flatness of the painting surface'. The 'scoop of space' refers to the enclosed, enveloping woodland space which is one of his favourite subjects. He does no preliminary drawing on the painting surface, working in areas of colour from the start. He plans the design of the picture as he paints. He normally paints on a white ground but on some occasions he stains it, before he begins painting, by rubbing in a single colour with a rag.

When he paints he tries to forget what the objects are. He wants 'to receive the totality of information', but he does not wish to paint a description of the landscape nor try to re-create the atmosphere of the place. His interest lies in seeing the objects simply as three-dimensional forms in space and he wishes to paint the precise relationships of these forms both to each other and to himself. In spite of this objective approach to painting, Stephen Spender has claimed, in the introduction of the catalogue of a retrospective exhibition of Gowing's work, that his portraiture is a psychological interpretation of character. Gowing does not agree with this view, saying that he has never tried to get character into either his portraits or his landscapes.

Although he has a clear intention when he starts to paint, Gowing feels that, for him, there is always a risk of losing sight of his initial concept. He thinks that, on occasions, he can be lured by the subject into matching the greens he can see in the landscape with greens in his painting. In order to avoid this happening, he sometimes excludes all green pigment from his palette so that the greens in his picture have to be deliberately mixed from blue and yellow. This, he feels, compels him to work to a colour scheme, rather than merely copy what he can see. He believes that a colour scheme has to be devised

Study at Rook's Nest, **1989, oil on canvas, 51 x 58 cm (20 x 23 in)** (Royal Academy of Arts, London)

for each painting and that what he sees has to be translated to suit this predetermined scheme. He cites William Hogarth (1697–1764) and Rembrandt (1606–69) as two artists who have worked in this way. Both these painters, he says, would work out a predetermined colour scheme for a figure painting, with perhaps a carnation pink or apricot pink identified from the start as a key colour for the flesh.

There have been times when Gowing has found it easier to express what he has seen in the landscape in words rather than in paint. He has often painted during the day and in the evening made diary notes, putting down in words his day's visual experiences. At times he has thought that the notes and the paintings should be exhibited together, but more recently he does not seem to have written his 'painting diary', the evenings after a painting session being taken up with other forms of writing.

Like many artists who rely on the external visual world as a stimulus, Gowing seems to be concerned that he finds it necessary to paint from a subject. The twentieth century has encouraged the belief that art based on observation is merely copying and that true art comes from within the artist. Gowing seems very ambivalent on this point. He is strongly committed to landscape painting and thinks there are many kinds of landscape space waiting for artists to explore, but he seems also to have a desire to be a different kind of artist. He has painted abstracted versions of his landscape 'scoop of space' which explain in a diagrammatic form the enclosed space

that he finds so interesting. He has also experimented with large-scale paintings of nudes, sometimes using photographic references. He now sees these 'body paintings' as being totally misconceived.

Writing and Other Activities

When Gowing retired from his post at London University he promised himself that he would devote all his time to painting and write only when he felt compelled to. He had not foreseen the offers that would be made to him. He accepted an invitation to go to Washington, in a professorial rôle, to oversee the research staff at the National Gallery of Art. He then continued his stay in Washington as curatorial chairman of the Phillips Collection. This was followed by work for television and as a curator for important exhibitions such as 'Cézanne: the Early Years', organized for the Royal Academy. Although these activities have pulled him away from becoming a full-time painter, perhaps writing and painting are now inseparable aspects of his way of life.

Many artists are compelled to take up activities other than painting in order to maintain a reasonable life style, and like others who have spent a major part of their life in academic administration Gowing has, in a sense, become 'institutionalized'. He finds it difficult to shake off the security which results

Cherry Copse at Stock Close,
**1951, oil on canvas,
90.5 x 69.5 cm (35½ x 27½ in)**
(Reading University)

from belonging to a large institution. He is a little afraid of existing without an office and a secretary. His published written work has often been first dictated to his secretary and to an extent he has relied on her response to give him an appreciation of how clearly his message could be understood.

Gowing is a Royal Academician and now mostly exhibits his work in the annual Royal Academy Summer Exhibition. He feels that on the large walls of the Academy, paintings smaller than 91 × 71 cm (36 × 28 in) tend to be lost, so in future he intends to make his paintings larger.

He talks warmly of his painting in the 1950s, when he was producing a much larger and more consistent body of work. He clearly would like to work in the same way now. He has decided not to paint portraits again and to concentrate on landscape painting. The interiors which he says he may also paint are really seen as extensions of his landscape painting, as explained earlier.

When someone's life has been so concerned with the historical and critical study of painting and also with teaching, you might expect that the same rigorous analysis used in these activities would be applied to his own painting. However, Gowing says that he does not attempt this, relying on his eyes to reveal the relationships between the objects he paints and himself, the method which he has used (with a few digressions) throughout a career spanning more than forty years.

Lesley Giles, Cairngorm, 1987, watercolour, 33 x 51 cm (13 x 20 in). In the mountains the atmospheric conditions change very quickly. Here, through the use of 'damp' rich colours we can sense the passing storms that leave the earth and air heavy with moisture

Focus

Painting Mountains

Perhaps the word 'landscape' brings to mind first a view of undulating fields leading to distant hills or mountains. Often this kind of landscape is predominantly green, leaving few obvious colour contrasts and usually compelling the artist to make the maximum use of colour temperature to create a feeling of space in the painting. The foreground greens have to stress the warmth of the particular colour, with colder blue-green in the background.

John Blockley, Mountain Landscape, 1988, watercolour, 16 x 21 cm (6¼ x 8¼ in). This subject is seen very much in terms of pattern and directional movement. The reddish-brown area in the foreground zig-zags towards the distant white-capped mountain, and this movement is echoed by the path-like passage of bleached colour passing within it. Areas of colour, located in diagonally opposed positions, also echo each other. It is important when designing these relationships that they do not appear obvious and contrived

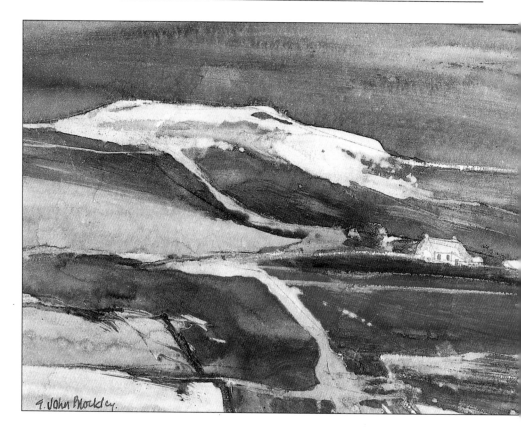

ABOVE: **Raymond Spurrier, Cretan Hillside II, 1986, watercolour, 24.5 x 34.5 cm (9¾ x 13¾ in). This painting shows the abstract design imposed upon a mountain landscape by the varied surface pattern of cultivation and scrubland**

Ian Simpson, A Landscape in Brecon, **oil on board, 51 x 61 cm (20 x 24 in). This subject, painted on the spot, provided the interlocking foreground and background shapes which so many of my paintings seem to be concerned with. The larger foreground shapes give the painting a sense of space, and the contrast of greys, blues and greens creates a feeling of airiness and vitality**

49

'Painting is a science and should be pursued as an enquiry into the laws of nature.'
(John Constable, 1836)

Chapter 3 _____

Painting Directly from the Landscape

I said in Chapter 1 that contemporary landscape painting began with the Impressionists, who believed in painting outdoors so that they could experience, at first hand, the play of light on objects and surfaces. We take Impressionist paintings for granted now, but it was a very different story when the first Impressionist paintings were exhibited in Paris in 1874. The Impressionists knew that our eyes are capable of understanding the merest suggestion of an object, but others failed to understand this and saw only confusing daubs of paint.

Laurence Wood, Parkland, **1987, ink and watercolour, 43 x 51 cm (17 x 20 in).** In this lively, on-the-spot sketch of autumnal parkland, painted between showers, the initial colours were poured freely onto the paper. Sepia ink was then used to draw into this base before it was completely dry, in places bleeding out into the colours. By working to beat the next fall of rain the artist was forced to produce an innovative translation of the subject

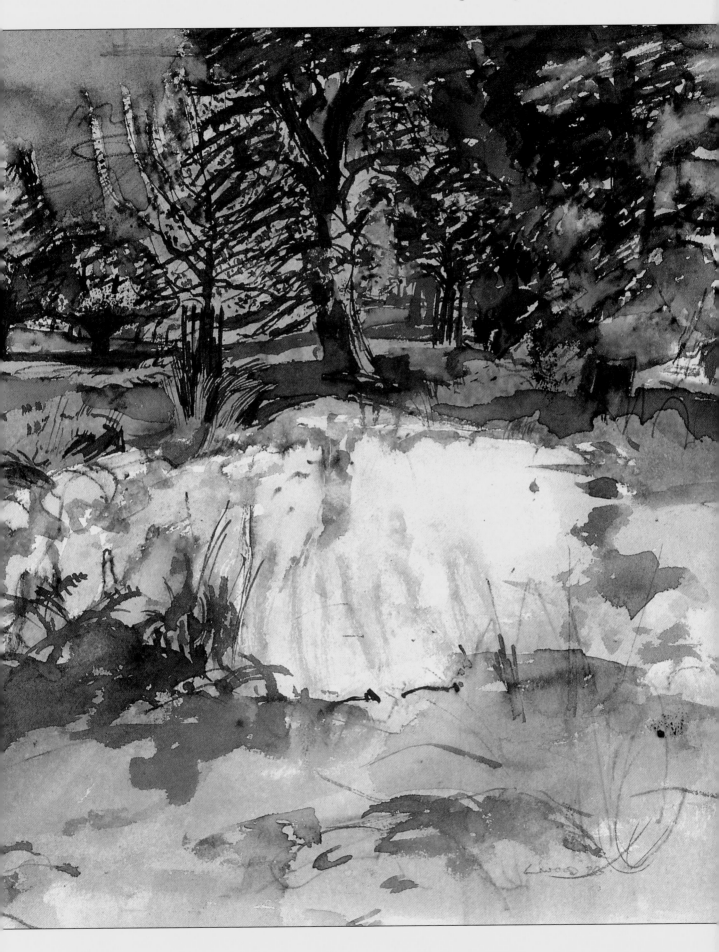

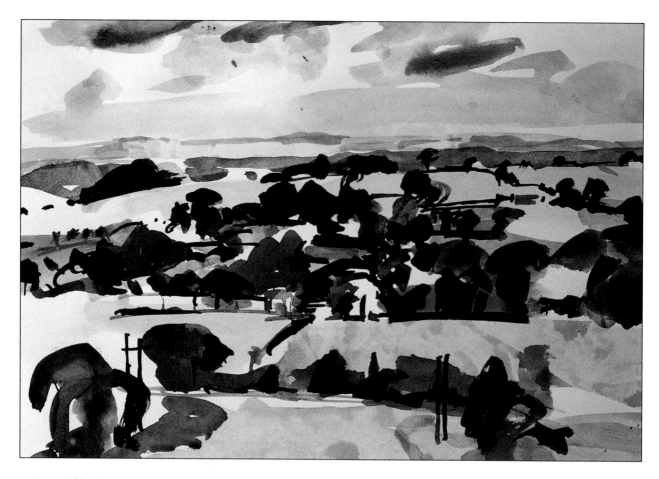

It is difficult for us today to appreciate just how these Impressionist paintings outraged both critics and public alike when they were first exhibited. The Impressionists believed that their paintings were scientifically accurate renderings of natural appearances, but the loose brushwork and blurred outlines in their paintings meant nothing to a public unused to looking at pictures of this kind. It took a considerable time before people learned that Impressionist paintings had to be seen from a distance. Once they discovered this, the confusion of brush strokes and patches of broken colour suddenly and miraculously fell into place.

Impressionist paintings demonstrate the advantages of vitality and spontaneity which can be gained from painting outside. When artists such as Monet, Sisley, Pissarro and Renoir were painting directly from the landscape, this close contact with the subject imbued their work with liveliness and a sense of fresh discovery. However, although their work gained from this, it also suffered, because painting outside made it extremely difficult to produce a firm, well-structured composition. You don't necessarily have to paint in the Impressionist style when painting outdoors, but the speed at which you need to work makes it likely that your painting will lack some of the careful organization that a slowly developed studio painting can have.

For and Against Outdoor Painting

Personally, as I have already confessed, I have found the question of whether to paint outdoors or in the studio an impossible one to answer. For a long period of time I always painted landscapes in the studio from drawings. *Coastal Landscape* is an example of a studio painting made from a drawing done on the spot, also illustrated here. Later, I alternated between painting from drawings and working outdoors. Then there followed a long period when all my landscape paintings were made on the spot and more recently I have returned to working from drawings and studies in the studio – but without having abandoned occasional sessions when I go outdoors to paint.

I find that the spontaneity generated when painting on the spot – how the paint is applied and the way drawing and colour fuse together in an unself-conscious way – is not possible to the same extent when painting in the studio. When working between showers, for instance, the artist has little time to consider composition and structure, and must therefore be positive and gestural. But, achieving a well-constructed painting when working outdoors is a problem. It can also be difficult to select

LEFT: **Michael Hoar,** Landscape, **1984, watercolour, 30 x 46 cm (12 x 18 in). All the vitality and spontaneity of working outdoors with watercolour can be seen in this painting. Broad washes have been quickly yet carefully manipulated to explore the variety of tree forms, the limited colour range and the striking image. The unpainted areas are just as important as the painted ones, skilfully explaining the undulations of the land as we cross one field to another**

Ian Simpson, Coastal Landscape, **pencil drawing with watercolour, 40 x 58 cm (16 x 23 in)**

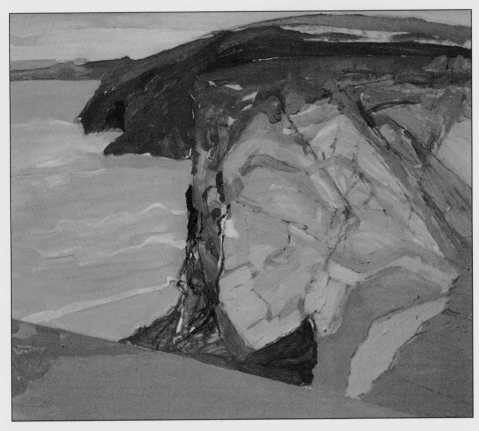

Ian Simpson, Coastal Landscape, **oil on board, 76 x 91 cm (30 x 36 in)**

from the landscape only the elements that the painting requires; it is easy to be seduced into painting everything you can see, regardless of whether it helps the painting.

The worst aspect of painting outdoors is that it is so inconvenient. When you think of carrying an easel, canvases or boards, and painting materials across fields or down cliff paths, only to reach a place where the light changes constantly, the wind tries to blow over your easel, insects bite you and spectators gape at you, you wonder why you do it. And that is on a good day! It can also rain so that you get nothing done at all. The painter Ford Madox Brown (1821–93) kept a diary and recorded during September and October in 1854 the progress of a painting

of a cornfield. He writes a vivid account, which to me rings true, of the difficulties of working from nature. On 4 September 1854 he wrote: 'About three out to a field, to begin the outline of a small landscape. Found it of surpassing loveliness. Cornshocks in long perspective form, hayricks, and steeple seen between them – foreground of turnips – blue sky and afternoon sun. By the time I had drawn in the outline they had carted half my wheat: by today all I had drawn in was gone.'

Perhaps this description of something that everyone who has painted outdoors must have experienced gives us one golden rule about painting on the spot. You have to ask yourself the question, 'Is anything here likely to be changed in the course of

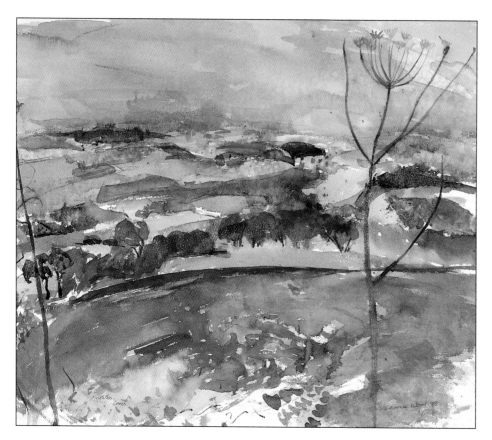

Laurence Wood, *Lancashire Plain, Rain*, 1988, watercolour, 46 x 56 cm (18 x 22 in). Two hours into this watercolour and the heavens opened. The rain that fell onto the image before it was hurriedly protected mottled and muddied some of the colours. Once the rain had passed, the artist resumed work and, rather than discard the painting, exploited and incorporated nature's adjustments

RIGHT: **Ian Simpson**, *Coastal Landscape*, **oil on board, 76 x 91 cm (30 x 36 in).** Dramatic foreground shapes and high viewpoints are features of many of my paintings. This one was made on the spot in a single painting session. The paint is quite thick in places and the vitality which comes from working very quickly is revealed in the brush marks. Although it was the drama of the contrasting shapes which fascinated me, the atmosphere of the day and menacing sea have crept into the painting as well

my painting?' If it is, then either you should make a drawing (or painting) of that element of your subject, for future reference, or you must complete that part of your painting immediately, hoping you can make it compatible with the rest of the picture as it develops. Unless you plan to complete your painting in one session, you may well be advised to choose another subject to paint.

Even the best-laid plans do not always work out, however! Recently I started a painting in a quiet wooded area only to find when I returned a few days later, that for no apparent reason a tree had fallen right across the spot where I had been working. This disturbance had so changed the subject that I found it impossible to continue my painting. However, there are occasions when a chance occurrence can be turned to the artist's advantage, as can be seen in *Lancashire Plain, Rain*, a highly atmospheric painting of a cold winter day with heavy raining skies.

The fact that painting outdoors is so fraught with difficulties and yet still appeals to artists must indicate that at least to some it is an important activity. Of the landscape painters interviewed for this book Lawrence Gowing and Olwyn Bowey always paint on the spot and generally complete their landscapes outdoors. Norman Adams paints his landscape watercolours outdoors, and while his larger more complex paintings are studio works, they are often inspired by his outdoor work. Derek Hyatt starts his

paintings by drawing in the main landscape shapes from direct observation and Roger de Grey paints outside, although he does frequently change the pictures later in his studio. John Piper makes paintings or mixed-media studies in colour on the spot from which he then develops larger studio paintings. Only Keith Grant finds painting on the spot 'almost a waste of time'.

I find painting outdoors exciting because in the hurry to paint what I feel to be important all kinds of things happen. These may be pure accidents, or spontaneous responses, who knows; but often I find on returning home that the picture contains sections I cannot imagine having painted myself. Painting outdoors is a form of landscape painting which must not be rejected lightly. The direct contact with nature provides you with a constant stimulus and the speed at which you have to work to capture a particular effect, before the light changes it completely, often makes you paint with a fluency that can surprise you. Working rapidly on the spot usually allows the paint, as Francis Bacon described earlier (see page 10), to do things more readily than is possible when you are working in the studio, where most people tend to work more carefully and with greater control. If you have previously been unsuccessful when painting outdoors, I hope that you will be inspired to try to explore this form of landscape painting again. Painting a landscape on the spot can offer a painter a very intense visual experience.

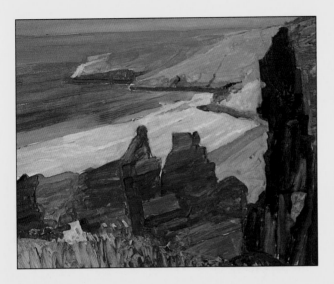

together with my brushes and paints. The bending and stretching which painting then involves may be good exercise, but I would not recommend it as a good painting method! If you want to sit down to paint, a stool or a folding chair is obviously essential.

I always take out the colours and brushes I use in the studio and put exactly the same basic colours on my palette indoors or out. It can be useful to make a list of things to take out painting – preferably not just before going out, but perhaps on your return from an outdoor session when you will have fresh in your mind the items you might wish you had taken with you. Turner always made a list of the things he needed to take out painting. After paints, sketching easel and so on, he used to write 'Self', heavily underlined!

Equipment for Painting Outdoors

The artists interviewed in this book who work outdoors all take out different items of equipment. Olwyn Bowey takes a variety of stretchers and a radial easel with her. To get all she needs to the place where she intends to paint usually requires two trips. In general, she paints near where she lives, but nevertheless many would be deterred at the thought of taking so much equipment, even for a short distance. At the other end of the scale, Norman Adams takes only watercolours, board, paper and a stool (which soon gets discarded).

Clearly, what artists take out with them when they paint is very much a personal choice. Like Roger de Grey and Lawrence Gowing I have a sketching easel which I have had since my student days. It is of a very simple kind, made of wood by a manufacturer who no longer exists. There may well now be better portable easels, but I wouldn't want any other. Its familiarity matters to me more than any deficiency it might have.

I always try to decide before I set out whether I will be making a drawing or painting in oils, acrylics or watercolours. I don't want to carry unnecessary materials but I usually end up taking too much in my fear of being short of something which will prove vital once I start to paint. Even if I carry my equipment by car, to a point near where I am going to paint, I still like to make only one trip from the car to my painting spot. This sometimes means that I leave my folding stool behind, telling myself that it won't be necessary. However, I always stand when I paint outside, usually resting my palette on the stool so I am obviously handicapped without it. Unless I can find a convenient place for my palette, such as a low wall, it has to go on the ground

Outdoor Painting Problems

I find the two main problems of painting outdoors are the weather and, to a lesser extent, people. Even in Britain it is possible to paint outdoors for most of the year. The cold is not usually the ultimate deterrent, but rain can make it impossible to paint and I find windy days extremely frustrating. I always paint on hardboard and even a light wind can make the painting wobble, or even blow the easel over. I always take a length of cord out with me so that I can use it to suspend something heavy (a brick or a large stone) from the easel to weight it down. If I can't find a suitable brick or stone nearby I use my sketching bag as a weight.

I don't think there is any solution to the problem of the wind blowing the painting, except to be extremely careful about the position you choose to paint from. It can be difficult sometimes to foresee what can happen during the course of a day's painting and I have often been driven to distraction by having chosen a painting spot which eventually caught the wind. Standing in the sun all day can also be disastrous, as can not having enough space to be able to stand back from your painting in order to see it from a distance.

Even if you have to compromise a little on the precise spot you choose to paint from, this is preferable to being constantly distracted by being uncomfortable. We have seen how difficult the Impressionists found it to paint outdoors and maintain concentration on the composition of their paintings, and certainly if you are trying to make finished pictures outdoors you must arrange everything so that the painting can have your undivided attention.

The other main distraction when working outdoors can be other people. Olwyn Bowey told me

55

Laurence Wood, *Venetian Lagoon*, 1986, watercolour, 22 x 32 cm (8½ x 12½ in). As a relief from the busy summer crowds in Venice, the artist set off across the lagoon. Travelling light with just a small watercolour block and a few paints, he captured the placid, restful atmosphere of this undisturbed location

BELOW RIGHT: Ian Simpson, *Swedish Landscape with Yellow Field*, acrylic on paper, 40 x 58 cm (16 x 23 in). I was intrigued by the vast expanses of green rolling fields in this landscape, contrasted with the patch of yellow and the red of the farm in the middle distance. The painting was made on the spot and I deliberately simplified the landscape to a few basic shapes and colours

that even though she works in a rural area off the beaten track, she prefers to paint outside on weekdays when the chance of meeting people will be less. Sometimes, though, an ideal painting spot is in a place where you can't be hidden away and then you can easily become the focus of attention. Spectators don't seem to realize that painting requires great concentration – perhaps they believe that pictures are produced without much effort – but it is most important not to let any interruptions spoil your concentration.

I try to avoid working in places which are too public. I have painted in St Mark's Square in Venice, but I started at 6 a.m. and finished before the tourists were about. If I find a perfect subject in a very public place I generally work quickly in watercolour or acrylic on paper. I don't use an easel, which is too conspicuous, but paint sitting on a stool with my drawing board resting on my knees. Painting in this way is also useful when it is windy, or when the weather is unpredictable and you are unsure about the wisdom of starting a larger painting in oils.

Wet oil paintings

Returning home or back to your car with a wet oil painting can be difficult, and again windy days exacerbate this problem. The painting can catch the wind like a sail and can be blown against you to ruin all your hard work, and your clothes as well. I find that a piece of board the same size as the canvas or board on which I am painting can be useful for protecting a wet painting. I use this in conjunction with canvas pins, which can be bought from artists' materials shops. These are plastic-bodied pins with a steel point on each side and are used as spacers. When pressed into the corners of the wet painting,

the protecting board can then be placed over the picture without damaging the paint surface. I then tie the painting and the protecting board securely together with string.

Sizes of Paintings

The size of painting an artist makes will depend on a number of factors. So far as selling work is concerned, particularly in Britain, there is a widely held view that only small paintings sell easily. In fact, large paintings (say, 122 x 91 cm/48 x 36 in) can enhance the feeling of space in small rooms; but your chances of selling a painting 35 x 25 cm (14 x 10 in) are much greater. This latter size is one which Lawrence Gowing likes, but he has drawn attention to another problem relating to the size of paintings: if you take part in mixed exhibitions in large galleries, your paintings can look lost unless they are fairly large. He considers 91 x 71 cm (36 x 28 in) to be a size which would be noticed.

The size of a painting has to be just right for its subject, but with landscapes particularly, where the subject stretches away in all directions, it is not possible to be very precise about how this general rule can be applied. The relationship between the size of your picture and the scale of a prominent tree or a foreground field is a matter of judgement, but in theory the subject should determine both the size and the proportions of the painting. In practice, however, as the interviews with artists reveal, it is often the predetermined size of the painting that dictates the limits of the subject. Roger de Grey has

said that he wants to paint as large as possible outdoors and he finds subjects to fit these large canvases. Derek Hyatt later in this book says how he likes to paint on boards which are nearly square. The dimensions of his paintings are quite small, but again the square format is decided before the subject is chosen. I find that I have become familiar with working on boards of a particular size – for example, 61 x 51 cm (24 x 20 in) and 91 x 76 cm (36 x 30 in) – and that I tend to see my subjects in these sizes.

It is obviously difficult to paint very large pictures on the spot (and in any case, working outdoors on a small scale can produce the most beautiful concentrated images) but looking at the dimensions of the paintings by the artists interviewed in this book, it is interesting to note the wide range of sizes and proportions. Although we usually think of landscape paintings as being considerably wider than they are high – and, indeed, this shape of rectangle is often described as having 'landscape'

proportions – many of the landscapes do not conform to this format. Roger de Grey's paintings, for example, are often much taller than they are wide.

One way of making large paintings out-of-doors is to paint the picture in two or more sections. A particularly wide landscape, for instance, can be painted as several separate paintings placed next to each other. This is a way of working which has particularly interested me and also some of the other artists featured in the book.

The Perfect Subject

Setting out to find 'the perfect subject' can be a disastrous undertaking. Somehow, if you go out intent on finding a place to paint, nowhere seems quite right. Roger de Grey has already described this

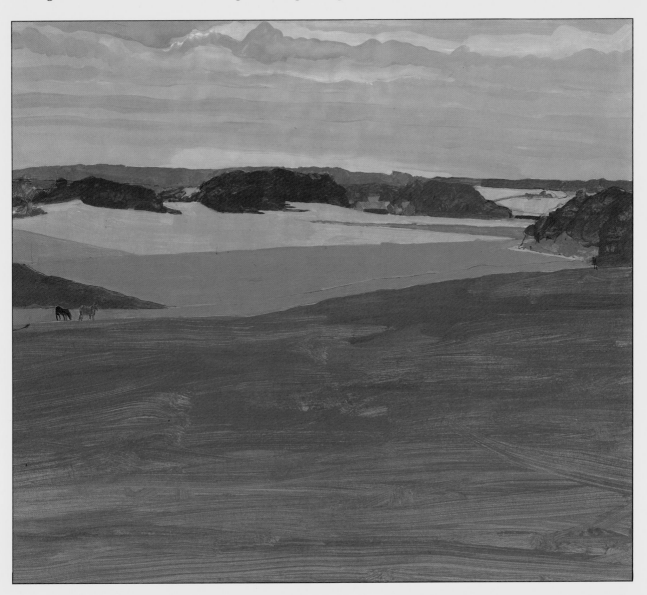

Ian Simpson, *Wimbledon Park I*, **charcoal pencil, pencil and watercolour drawing on paper, 16.5 x 35 cm (6½ x 14 in)**

Ian Simpson, *Wimbledon Park II*, **charcoal pencil, pencil and watercolour drawing on paper, 23 x 42 cm (9 x 16½ in)**

unsuccessful search and how he frequently returns to paint in the same place time after time. There are fascinating things to paint all around you, wherever you are. Sometimes, in a place so familiar that you hardly look at it anymore, you find in a flash the subject for a painting. The British painter Carel Weight, who often makes paintings of suburban London streets and gardens, describes this sudden recognition thus: 'You pass the spot each day. You know and love every brick and tree. Suddenly, in a moment, everything is changed.'

Sometimes you can be out walking when you spot something that interests you. When this happens I find that it is important to make a note of what I have seen there and then. I may subsequently come back and make a more complete drawing of it. These notes are extremely important as they are the basis of the final painting and they have to be made quickly to catch the moment of seeing. If you fail to record the moment of recognition, it may be useless to return to the subject later, because when you do it will have disappeared. In reality it is still there, of course, but the flash of recognition will have gone and I find it cannot always be recaptured.

Sometimes, however, you find an interesting subject quite differently, by slowly searching out those things which will make an interesting painting.

These might only emerge as the painting develops. It can sometimes be a revelation to set up your easel at any convenient place in the landscape and just paint what, by chance, you can see in front of you. Once you start to look properly you can frequently see subjects which didn't seem to exist a few moments previously. The two drawings of Wimbledon Park were both made by chance while sitting on a seat in the park. Although they look completely different they were in fact made while I was sitting in the same place, on the same day. I simply turned my head slightly to obtain the changed viewpoint.

Using a viewfinder

I find that using a viewfinder can help to pick out suitable painting subjects. I use a piece of card measuring 10 x 7.5 cm (4 x 3 in) with a 6 x 4 cm (2½ x 1½ in) rectangle cut out of it. Looking at the landscape through this viewfinder can help to isolate areas of the whole and suggest possible subjects for painting. Sometimes there is so much to see in the landscape that we are unable to focus on a manageable area of it and therefore fail to find a good subject. On these occasions I find the viewfinder can be a very helpful device to get me started. Once I have decided on the area to paint I then put the viewfinder aside and paint directly from the subject.

Preliminary sketches

The best way of testing out whether a possible subject will enable you to make a successful painting is to make a quick sketch of it. The preliminary sketch is very important and is helpful in a number of ways. It can give you confidence in your initial idea and even before you start to paint it can help determine what is significant in the subject. The sketch should be a kind of rehearsal for the eventual painting. By trying out the composition you can find the best shape to contain the subject. This sketch should give you a preliminary idea of what the painting might be like and should record your first impressions of the subject, which otherwise may be easily forgotten as the painting develops. Sometimes, after making this first drawing, you might decide that the subject isn't as good as you had first thought and you may then discard it. I made the drawing *Seafront at Applecross* very quickly, using pencil and watercolour, but having 'tried out' the idea, I was not sure that I could make a painting from this subject and it was abandoned at this stage.

Often, once your first sketch has satisfied you that you have found something to paint, you can leave it and start your painting. However, I sometimes find that I need to develop what starts as a sketch into a more finished drawing, before I am sure about the shape of the eventual painting and its contents. The drawing *Cliffs and Sea* started as a quick sketch to try out the subject, but I found I needed to extend the drawing as my ideas about the composition changed. I was still unsure about how I might organize the colour, so I added colour to the drawing before I became convinced that I was ready to put it to one side and start to paint. How much you work out in the preliminary sketch and how much you decide on when you paint can vary from subject to subject.

Different artists use preliminary drawings in different ways. Later in this book Derek Hyatt explains how he may make twenty or thirty sketch variations on a single idea. Olwyn Bowey always starts by making a detailed drawing in which she tries to decide how her painting will look. Although this drawing usually provides the initial idea for a painting, this can nevertheless change radically once the painting is in progress.

Composing Your Painting on the Spot

It can be exciting (but risky!) to paint on the spot without making preliminary studies. I do this more when painting on paper than on board. I start on a large sheet of paper and don't decide even the shape of the painting until it is well advanced, eventually cutting the paper down to the size I want.

ABOVE: **Ian Simpson,** Seafront at Applecross, **pencil and watercolour drawing on paper, 40 x 58 cm (16 x 23 in)**

Ian Simpson, Cliffs and Sea, **pencil, ink and watercolour drawing, 40 x 76 cm (16 x 30 in)**

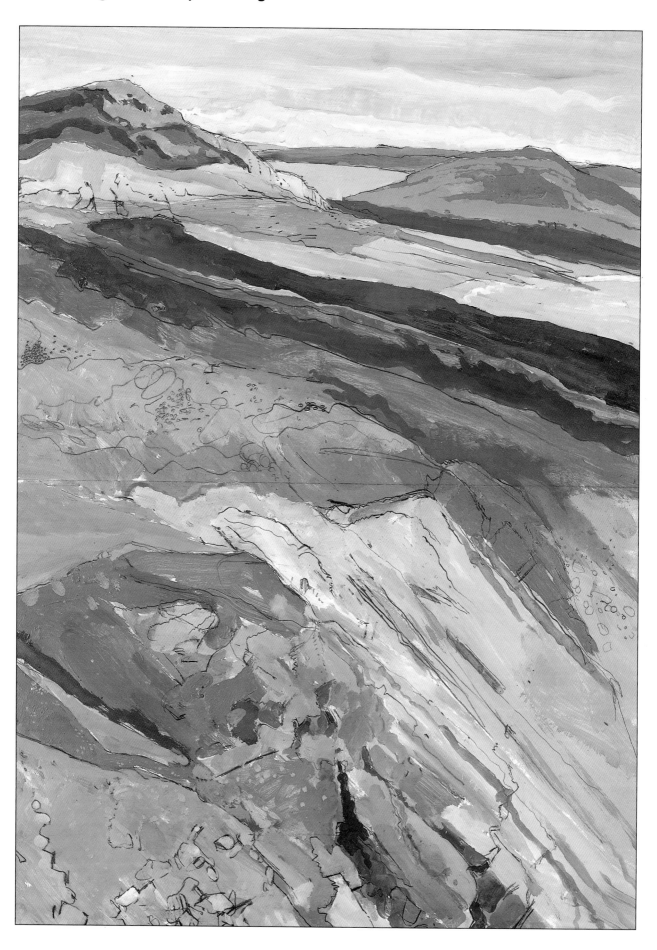

LEFT: **Ian Simpson,** Landscape, Mumbles, **acrylic on paper, 76 x 56 cm (30 x 22 in)**

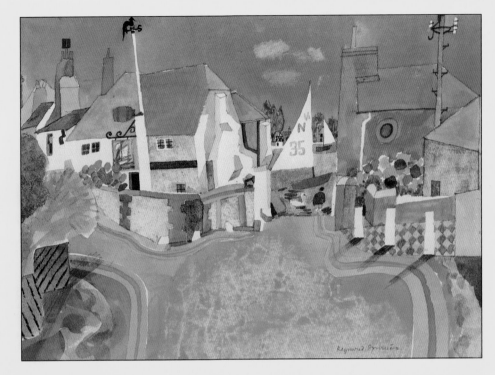

Raymond Spurrier, Holiday Harbour, **1982, watercolour, 24.5 x 34.5 cm (9¾ x 13¾ in). This painting was an intuitive response, using pattern, texture and bright Fauvish colours to create the sparkle and excitement of a little sailing village: what it felt like to be there rather than what it looked like**

When working on paper you can also easily increase the size of the painting by joining sheets together, if the subject proves to be larger than you had first envisaged. I do this frequently when working in acrylics on paper, but it is not generally possible when using watercolour because the join shows too prominently. The painting *Landscape, Mumbles* had its height extended to twice the original size as I realized that it was important to make much more of the foreground than I had originally intended.

If you paint on the spot without preliminary drawings you have to 'block-in' rapidly the main shapes of the subject and then be prepared to change them later if the painting doesn't look quite right. If you are painting on board or canvas you can always reduce the size of your painting, but it will be practically impossible to increase its size, so you may need to make significant changes to the painting in its early stages if the arrangement of shapes in it proves unsatisfactory.

A Painting in One Session

Before the nineteenth century artists used to build up their paintings slowly by elaborate methods of underpainting. Completing a painting in one session, in full colour, often called 'alla prima' painting, is a technique that has been widely used since then and is a particularly useful one for painting on the spot.

I find that in order to complete a painting in oils or acrylics in one session, apart from working quickly and continuously, I have to begin to work in opaque paint almost from the start. Because acrylics dry rapidly it is possible to overpaint when using them; but with oils, any overpainting, except over a very thin stain of colour, inevitably means applying new paint to paint which is already wet. I prefer working in this way to painting over dry paint. Painting wet-in-wet has become one of the features of oil painting and it is a technique which can enable very subtle transitions to be made from one colour to another. Even with acrylics I try to paint so quickly that I can work wet-in-wet as much as possible.

It can, however, be difficult to change a colour completely when working in this way with oil paints. Either the new colour has to be mixed on the painting, thus modifying the existing colour by adding another one to it, or you have to take the unwanted colour off the painting surface and apply a new colour in its place. I do this by carefully scraping off the paint with a painting knife and blotting off any paint that remains with either newspaper or an absorbent paper like kitchen paper. Sometimes I find it useful to remove the paint only partially (you may know this technique as 'tonking'), again using newspaper or absorbent paper pressed lightly onto the wet paint, and then modify what remains. As general advice for painting on the spot in oils or acrylics, and particularly where you are trying to complete a painting in one session, Camille Pissarro's guidance in a letter to an aspiring young painter still holds good: 'Make a choice of subject. See what is lying at the right and the left, then work

61

Ian Simpson, *Winter Landscape, Sweden*, **watercolour,** 40 x 58 cm (16 x 23 in)

on everything simultaneously. Don't work bit by bit, but paint everything at once by placing tones everywhere, with brush-strokes of the right colour and [tone] value, while noticing what is alongside. . . . The eye should not be fixed on one spot, but should take in everything. . . . Work at the same time on sky, water, branches, ground, keeping everything going on an equal basis. . . . Cover the canvas at first go, and then work on until you see nothing more to add. . . . Don't be afraid of putting on colour . . . paint what you observe and feel. Paint generously and unhesitatingly, for it is best not to lose the first impression.'

Watercolour paintings are frequently made in one session. This was the case with *Winter Landscape, Sweden*. Norman Adams says that he can paint as many as five or more in one day. I use watercolours much less than I do oils or acrylics and so my use of them is almost certainly influenced by the way I use the other mediums. I always work on a drawing board or large sketchbook on my knee (never on an easel), so that I can lay the painting flat to stop the wet paint running uncontrollably. I work almost entirely with the paint wet. Outside, in the summer, this can be difficult as it dries quickly. Plenty of clean water, large brushes and a sponge are therefore needed to keep the painting wet.

Artists who make greater use of this medium often work outdoors applying layers of colour over each other. Each layer is allowed to dry before the next is applied and because the colour is transparent every layer modifies any colour it is painted over. You can, of course, combine the layering method with the wet-in-wet technique and direct painting. Occasionally something of the layering method gets into my system of working by chance. Indeed, chance may well play a greater part in outdoor watercolour painting than it does if you are working with oils or acrylics. I believe that any opportunities that occur in this way should be seized and not regarded as a disadvantage. Because watercolour paint is transparent it is difficult to change any 'mistakes'. You can't just paint over them but you can often exploit them. What may at first seem like mistakes can lead you in unpredictable directions and produce surprising results.

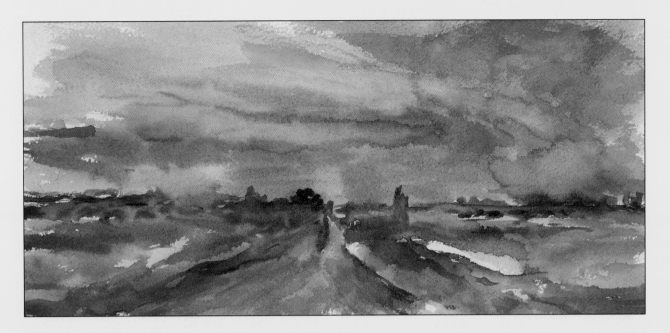

In *Dusk, North Amsterdam* the relaxed wet-in-wet washes of watercolour were allowed to mix together naturally. This produced a sensitive translation of the muted colours and softened forms of the subject. The flat plane of land blends perfectly with the sky as falling dusk obscures details, fusing the landscape into a whole.

The technique of building up layers of washes can be advantageous when painting outdoors as the image can be allowed to crystallize slowly. Initial forms are painted in pale washes, with further layers adding richness and strength. The slow build-up and slight adjustments of form result in the first tentative washes co-existing alongside the final brush marks. In *Seine, Paris* this creates a luminous shimmer, totally in keeping with the subject, full of reflections and ambient light.

Julia Hope, Dusk, North Amsterdam, **1987, watercolour, 15 x 33 cm (6 x 13 in)**

BELOW: **Julia Hope,** Seine, Paris, **1988, watercolour, 20 x 47 cm (8 x 18½ in)**

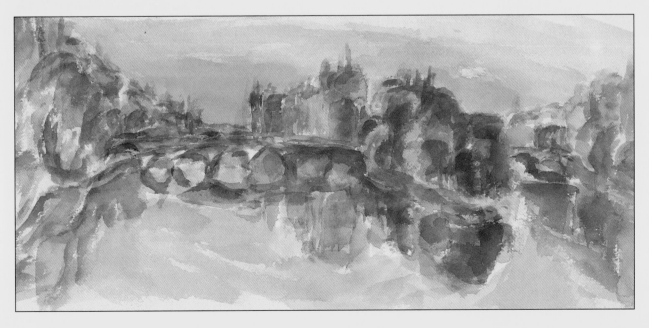

Developing a Painting Over Several Sessions

Of course you may not want to complete a painting in one session. This could be because you prefer to work by building up the paint gradually, or it may be because you are trying to capture a particular fleeting effect that only exists for a very short period of time each day and must be observed and painted on a number of occasions. There are advantages in working in a slower, more considered way, but there are disadvantages as well. I have mentioned already the criticism levelled at Impressionist painting; that its speed of execution, so well described by Pissarro earlier, leads to a lack of structure in the paintings. They are inclined to be imprecise, with weaknesses in their composition; yet it doesn't necessarily follow that outdoor paintings have to be painted so quickly that this is the result. In general, the Impressionists sacrificed care in order to catch a fleeting impression, but Cézanne painted directly from nature very slowly and with unbelievable conscientiousness.

Working on a painting over a number of days can certainly result in it having more detail, more structure and a better composition. *Coastal Landscape, Cornwall* was painted carefully over a period of four days. This gave me time to reconsider colours, introduce more detail, and change and reorganize the composition. However, this more considered approach to painting may mean that the pictures lack some of the spontaneity and bravura that are characteristic of those painted more quickly. It can also be difficult to sustain the initial idea in a painting continued over several days.

Some paintings, for a variety of reasons, take longer to paint than others. The subject may have some features which need to be painted very carefully and in order to do this it may be necessary to use a layered painting method, allowing each layer to dry before the next is applied over it. Although this sounds like the watercolour method I mentioned earlier, I am referring in this instance to oils and acrylics. With these mediums the layers of paint will usually be opaque but they are applied so that some of the underpainting shows through. Alternatively thin glazes of colour might be used.

The painting *Stefan's Garden* is a fairly small picture but it took me much longer to paint than many larger paintings, requiring several painting sessions. The white framework of the greenhouse and the white pattern of the fence, table and chairs had to be painted carefully, and in order to translate the lawn and flowerbeds it was necessary to paint areas of colour, allow them to dry and then overpaint. I find that with frameworks such as those in this painting you can't simply paint the fence, table and chairs over the background. For the painting to look right, you have also to paint the background round the framework itself. I find this equally true when painting other similar 'frameworks' such as the branches of trees against the sky. When the sky is painted first and the trees are painted on top the result usually looks unsatisfactory. The superimposed branches do not appear to be properly positioned in space until the sky has been painted again between them. More often than not, this process of painting has to be repeated several times before the branches look right against the sky.

Painting on Coloured Grounds

When painting on a conventional white ground it is difficult to get a real idea of what the picture will eventually look like until all the white has been obliterated. It is always exciting to apply

FAR LEFT: **Ian Simpson,** Coastal Landscape, Cornwall, **oil on board, 76 x 91 cm (30 x 36 in)**

LEFT: **Ian Simpson,** Stefan's Garden, **oil on board, 51 x 61 cm (20 x 24 in)**

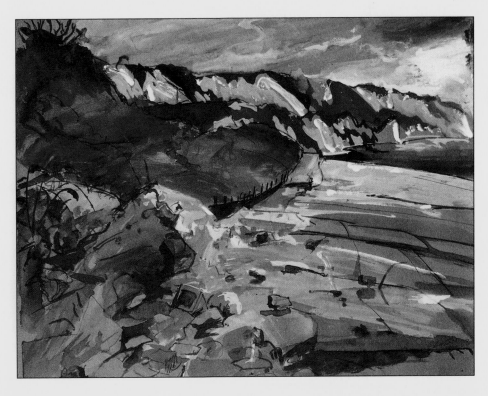

RIGHT: **Laurence Wood,** Near Folkestone, 1987, **ink and gouache on paper, 40 x 46 cm (16 x 18 in). Grey paper was chosen as a support for this outdoor sketch using ink and gouache. The pale tones of the sunlit cliffs stand out brightly on the coloured paper**

areas of clean colour to a white painting surface because seen against white each colour looks so brilliant, but it is difficult to assess whether the colours are right in relation to each other until the whole painting is blocked in. So working on a coloured ground, particularly when you are intending to produce an oil painting in one session, can be very helpful. A coloured ground gives the painting an early unified colour scheme and helps you to check whether your initial idea looks likely to be successful. Even if the picture is painted over several sessions, making a start on a coloured ground can enable you to see how the painting might develop.

I find a warm mid-tone green a good ground for landscape painting. I apply this paint thinly to the white board and allow it to dry before I take the board outdoors for painting. Mid-tone browns can also make useful grounds. Straw board and some other similarly coloured boards are excellent colours in their natural state. They do not need priming if you are going to use acrylics, but for oils they should be made less absorbent by being primed with one or two thin coats of size.

Holding on to the Initial Idea

With any painting the artist is always faced with the difficulty of holding on to either the idea which inspired the painting in the first place, or one which emerged in its early stages. To some painters 'the flash of recognition' is all-important. Other artists are much more prepared to change their painting at any point in its development if a new idea occurs to them. It would be unusual to alter a painting radically if you are working on the spot, but particularly when you paint over several sessions you may well completely change your idea about the subject. Each time you return to it, for instance, it can look different. This might be because of the effects of particular kinds of light on different days or it might also be because you yourself see the landscape differently.

You may do as Olwyn Bowey does and start by making a drawing which will fix the initial feeling for the subject firmly in your mind. You might work more speculatively, allowing the picture itself to determine the directions it will take. Clearly, in most paintings a compromise has to be reached. If you merely attempt to paint your first idea very rigidly, it is likely that the painting will look mechanical and lifeless, so to an extent it must be allowed to have a life of its own. If, however, you constantly change the painting you may never be able to achieve a conclusive statement, and the picture can easily look overworked. Occasionally, when something strikes you anew about your subject, it is better to start a fresh painting than to try to incorporate the new idea in the existing one.

John Piper, whose interview follows, has drawn and painted from direct observation throughout his long career. For him, creativity is entirely dependent on the intensity with which he sees.

Interview

John Piper

PHOTO: GEORGE NEWSON

'I see no thread running through my work; I simply get on with my life and my painting.'

John Piper is simply an amazing man. My interview with him took place only a short time after he had had a major operation. He had lost 12.5 kg (2 stone) in weight from an already very spare body. He greeted me with an apology that his most recent paintings, with which he had been extensively engaged for the last three months, had just been collected for exhibition. And he is now eighty-six!

His studio was still full of his work. There were paintings in progress and amongst the other pictures were a number of prints of his architectural paintings, four of which were placed on the black wall at the end of his studio in front of which he paints. They looked as if they were put there as references even though his most recent paintings have been of flowers. I was particularly interested to see on another wall of his studio a watercolour painting showing three landscapes at Scotney Castle in Kent. These views are positioned one above the other in a single frame. They are dated 1976 and intrigued me for two reasons. First, because I had myself painted at Scotney Castle in 1973 and it is always interesting to compare your own painting of a subject with paintings of the same subject by someone else. Second, because while painting at Scotney I had been shown some earlier paintings made by Piper which were completely different from the one painted in 1976. The earlier paintings were pale, misty, atmospheric and larger in scale, as I remember them. The more recent paintings were richer in colour and much less ethereal

It is easy to make quick, sweeping assumptions about an artist's work, but looking at the intense colour in the work around the studio – not all of which was current work but which was relatively recent and which Piper was pleased with – I thought that possibly his painting had moved over the years away from Turner's vaporous tinted steam towards the vibrant colour areas of Matisse.

Still astounded by his productivity, I began by asking him about his work pattern and whether he painted every day. He thought that no-one could work every day; that there are things other than painting that had to be done; and that one had to be sociable and talk to people. Generally he sounded pretty pleased with his life and achievements, but thought it pointless to look back. He is happy to look forward and let things happen almost without noticing. Piper believes that one's whole nature should be prepared for constant change. To anyone who suggests that for an artist this chameleon-like approach could be interpreted as dishonest, Piper asserts that it would be dishonest to behave in any other way. Writing in 1937, he stated that one must 'change one's spots or stripes or other outward markings according to the influences one truly experiences within oneself'.

Subjects for Painting

Many parts of Britain, France and Italy have provided subjects and inspiration for him. He has also painted a number of pictures of his own garden, having lived in the same house in the country near Henley for fifty years. I would not choose to define precisely what constitutes landscape painting, but the flower paintings Piper was working on when I visited him seem to me to relate more to the landscape genre than to still life painting, which is the category in which flower paintings are usually placed. He appears to be equally content discovering new places to paint or in painting familiar places, and talked particularly enthusiastically about painting in Venice. He said that he is happy to continue exploring the places he knows already, but does not feel he wants to go to new parts of the world now. He has never been in an aeroplane and, although he wishes he had seen earthworks from the air and particularly Stonehenge, he is not keen to fly. It is not that he has a fear of flying but rather that, as is to be expected of someone who 'lets things happen', this is simply one of the things that just hasn't happened in his life. It is interesting to speculate on the pictures Piper might have painted had he seen the landscape from the air.

Blenheim Palace, **1954, coloured chalk, Indian ink and wash on paper, 28 x 56 cm (11 x 22 in)** (Waddington Galleries, London)

Working Methods

He works in watercolours with which he combines pastels, and also in oils on canvas. The oil paintings are developed from his watercolours or from other drawings or studies, which are all made from direct observation. He never paints in oils on the spot. Many paintings are started which do not develop into anything special. Piper firmly believes in learning from experience and doesn't indulge in self-analysis, convinced that too much introspection is bad for an artist. He told me he sees no thread running through his work; he simply gets on with his life and his painting. He enjoys painting at home in his studio but equally he enjoys going away so long as this is not for too long a period and he can take with him his 'toys', as he describes his painting materials.

Clearly Piper's long experience of painting makes him take for granted much of his working method. A feature of his watercolour paintings from the beginning of his career has been his use of wax. Drawing with wax (either a candle or a crayon) produces lines or areas which resist later applications of watercolour and can create beautiful translucent passages in a painting. It is a technique which is very difficult to control as once the wax has been applied it can't be removed. It is hard to believe that Piper may not have had problems in controlling this resist technique in his early days, but clearly he now knows what he wants to do and wax crayons are used with unerring accuracy.

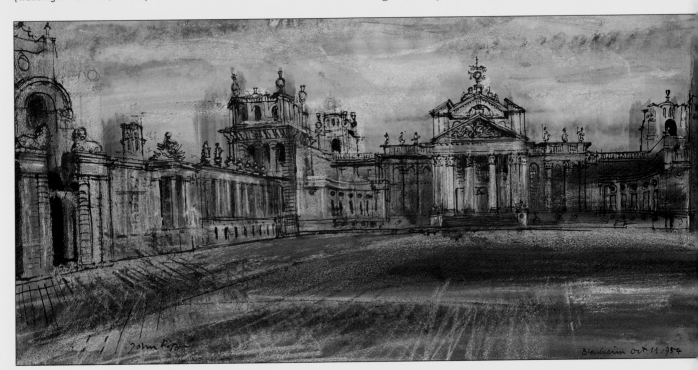

Piper has discovered Atlantis Pastel Paints recently and is very enthusiastic about them, particularly for providing the brilliant colours of the flower heads in his current paintings. The tables on which he keeps his working materials are neatly organized, with the pastel paints sitting tightly and vertically (drawing tips uppermost for easy identification) in a deep cardboard box. He uses a wide range of these pastel paints and although I didn't count them there must have been forty or fifty colours. In contrast, for his oil paintings, where he has a very clear idea of the colours he will use, he may need to put only three or four colours on his palette. He paints in oils on white stretched canvases. He couldn't understand why many artists now paint on unstretched canvas, stretching it only when the painting is completed.

Piper reinforced my view that he is very sure of what he is doing by taking me over to look at the prints that have been made from some of his architectural paintings. He drew my attention to a picture of a church tower. The church, he told me, was in Langport in Somerset and it had been the warm sandstone of the tower against the blue sky that had captivated him. He had used only three colours in the original painting, which had been produced, working from a drawing and a photograph, in about thirty-five minutes. It is a painting which pleases

him a great deal. I felt it was displayed in the painting area of his studio both to encourage him and as proof that even if some paintings get bogged down, it is possible nevertheless with others to paint with clarity and spontaneity and achieve the desired result very quickly.

He also showed me paintings that hadn't gone well and where the production had been difficult. He works on a number of paintings at the same time, putting on one side pictures which are giving problems and returning to them later. One painting had been worked on over several months. He showed me a painting of flowers, now completed and framed, and described how the painting had been nearing completion but had not in the end been right. He had tried introducing blue on both sides at the bottom of the painting and this had made the painting work. Yet the blue certainly wasn't there in the subject, he said. He wasn't sure why it worked but it did.

For all the chance elements in Piper's work, however, his experience has brought great control. When I talked to him about the problem I had of painting with the same spontaneity in the studio as when working directly from a subject outdoors he told me that he had trained himself over many years to retain this spontaneity when working away from the subject.

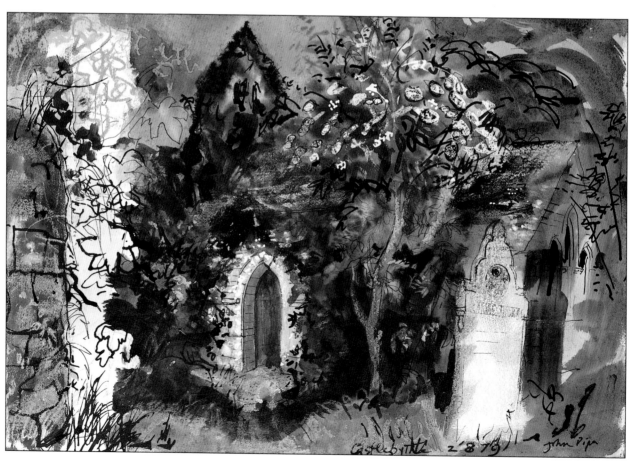

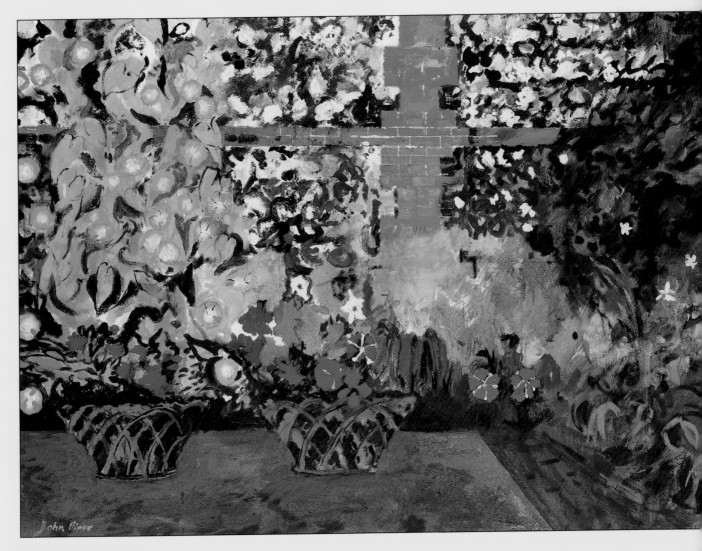

ABOVE: Morning Glories on the
Terrace, **1987, oil on canvas,
91 x 122 cm (36 x 48 in)**
(Waddington Galleries, London)

LEFT: Castlebythe, **1979, mixed
media on paper, 39 x 58 cm**
(15½ x 23 in)
(Waddington Galleries, London)

Piper may work on one painting from twenty
studies, ranging from a few scribbles to detailed
drawings. The drawings may be in sketchbooks or
more usually on small pieces of paper. He also takes
photographs, which he finds useful for details but
more helpful for getting the relationships of scale
right. His watercolour paintings are mostly around
51 x 38 cm (20 x 15 in) and his oil paintings 122 x
91 cm (48 x 36 in). He thinks his oil paintings might

perhaps be a little larger, to advantage. He has
always moved from small scale to large scale, seem-
ingly with relative ease, as he has worked on designs
for tapestries, stained glass windows and stage sets,
as well as making paintings.

Piper readily admits to being no theorist of paint-
ing and his answers to questions about his work are
refreshingly honest, modest and sometimes disarm-
ing. We talked about drawing ability. Piper said that
he didn't think there were any absolute standards of
drawing, no classical ideal of drawing ability against
which artists could be measured. Artists, he con-
sidered, have to be able to draw in a way that is
appropriate to the way they want to paint. When I
pushed my notion that nevertheless there is a skill
required in drawing the figure which landscape
painters need not necessarily possess, Piper told me
that people often ask him why his paintings have
no figures in them. 'I tell them that I don't choose
to put them in or that when I have made my draw-
ings or paintings there haven't been any figures
around. I've just never tried figures.' But he added
that he was aware that these were all unsatisfactory

answers to the questions and that there must be more to the absence of figures in his work than he fully realized.

Piper's production is remarkable. In part, it stems from the importance he places on 'doing' as opposed to self-analysis and assessment. Embodied in his belief that you can't judge immediately whether a painting is successful is also the view that in moving on to the next painting you draw automatically on the experience gained from previous work.

On Other Artists

Piper is generally regarded, I think, as a very English painter. I'm sure he likes to be English but the label 'English painter' he finds harder to accept. He reckons there have been few English painters of quality and mentions only Turner. He feels he owes a debt solely to him and to Matisse, but he talks with admiration of other artists and particularly admires the watercolours of Emil Nolde (1867–1956). He thought the Raoul Dufy (1877–1953) exhibition at the Hayward Gallery in 1983/4 the best

exhibition of work by one artist that he could remember. On reflection, there are some similarities between the work of Dufy and Piper, particularly in the way they use a combination of line drawing and freely painted areas of colour in their painting.

Piper possesses some work by other artists but has not been a collector. He has exchanged work with a few, notably his great friend Ivon Hitchens (1893–1979) and Ceri Richards (1903–71). The Richards painting has since been given to a gallery in Wales. Piper has a beautiful Matisse line drawing of a nude which he acquired many years ago. This drawing was given by Matisse to its original owner and then acquired by Piper indirectly through the sale of one of his own paintings, so the drawing has never changed hands for money.

ABOVE: Fawley I, **1989, oil on canvas, 91 x 122 cm (36 x 48 in)**

RIGHT: Pear Tree and Wall, **1988, oil on canvas, 122 x 91 cm (48 x 36 in)** (Waddington Galleries, London)

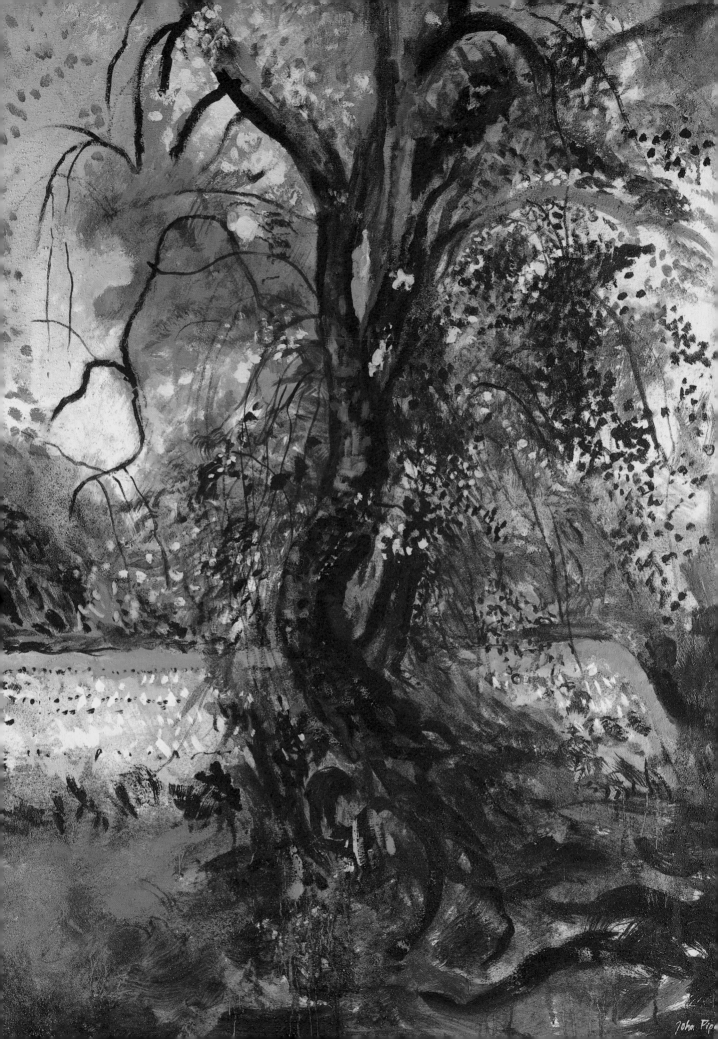

John Piper

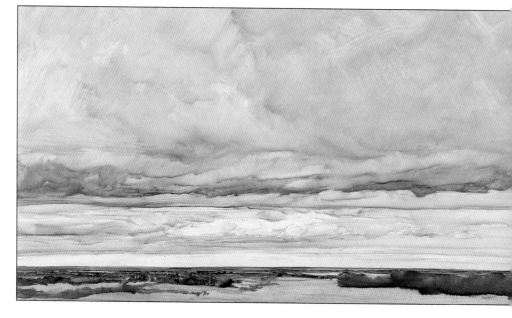

James Morrison, Prairie
Landscape, **1987, oil on gesso-
primed board, 85.5 x 150.5 cm
(33¾ x 59¾ in). Skies are not
flat like a theatre backdrop.
When we stand in an
extensive flat landscape the
sky envelops us like a great
dome. The layering of clouds
in this picture helps to convey
this three-dimensional aspect**
(The Scottish Gallery, Edinburgh
and London)

Focus

Painting Skies

*Skies do not have to be relegated to a supporting or
incidental rôle in a painting; they make a powerful
subject in their own right. One of the long-standing
great challenges to the painter has been to convey
the transparent, weightless and yet three-
dimensional quality of the sky.*

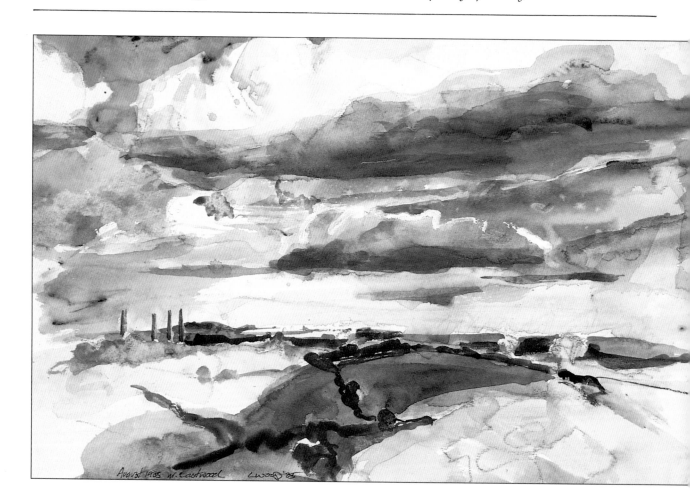

Sally Hargreaves, March Cloud, 1986, oil on board, 25 x 30 cm (10 x 12 in). With great skill the artist has conveyed the monumental scale of the clouds within the edges of a small painting. The low horizon allows 90 per cent of the picture to be devoted to the sky and that is dominated by one huge cloud

Rowland Hilder, First Snow, watercolour, 22.25 x 28 cm (8¾ x 11 in). This sketch was made from memory and from rapid notes jotted down on location following a fall of snow. The painting captures the fleeting moment when the sun suddenly broke through an overcast, wintry sky. The artist was fortunate to be able to take advantage of this 'happy accident' and record the striking effect on the landscape

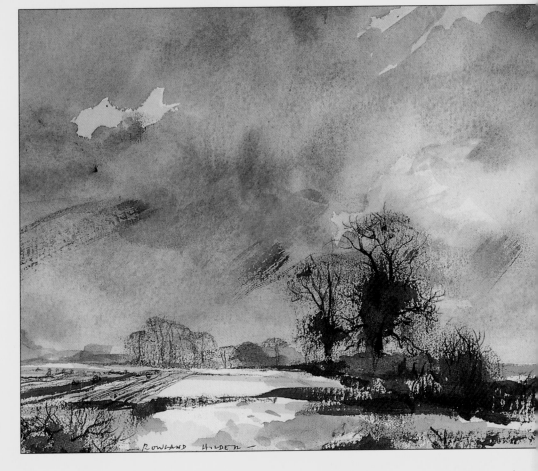

LEFT: **Laurence Wood**, Cloud Study, 1985, watercolour, 40 x 51 cm (16 x 20 in). Though apparently weightless, clouds cast shadows like other objects, but often on a massive scale. Here a large shadow moves across the landscape, creating a dramatic stripe and dwarfing trees and hedges

'Claude Lorrain...was convinced that taking nature as he found it seldom produced beauty.'
(Joshua Reynolds, 1771)

Chapter 4

Painting Landscapes in the Studio

I f you have an exceptional visual memory, or a vivid imagination, you may be able to paint landscapes in your studio 'out of your head'. I am always surprised when I encounter the widely held belief that this is how most artists work and that they produce paintings out of the air rather like doing conjuring tricks. Few artists have ever done this; in any case, when they work in this way the memory and almost certainly the imagination will be based on things previously seen. John Piper has said that 'creation is an indirect result – in fact, the only result – of looking. The more intensely you look at things the more intense will be the work. And, after all, intensity is all that matters in painting.'

Joy Girvin, Italian Spring, **1988, oil on canvas, 51 x 63 cm (20 x 25 in). It is easy to be too careful or methodical with the paint when working in the studio. Here the artist has worked with vitality all over the canvas. The broken colour and rhythmical brush-work both contribute to a fresh and vibrant painting**

John Blockley, *Industrial Landscape*, 1988, watercolour, 23.5 x 23 cm (9¼ x 9 in). Here the artist was attracted by the silhouetted church and the hint of surrounding buildings and chimneys in the misty industrial haze. Detail is confined to the distant buildings to help draw the eye to this part of the painting. The large empty foreground occupies two thirds of the painting and is important in conveying a sense of empty desolation

My own studio landscape paintings are the re-creation of visual experiences and in this chapter I will be describing my method of working. I will also be considering the merits of the different ways of making drawings and studies from direct observation which can be developed into paintings in your studio.

Painting landscapes in the studio has the obvious advantages of eliminating the discomfort of painting outside and protecting you from the vagaries of the weather, but there are other advantages as well. Working from drawings or studies allows you to analyze the subject in a number of different ways. You can, for example, look first at shapes, then tones, and perhaps make a colour study, before you commit yourself to the more complex activity of painting. You might go on to work out the composition of your picture and then, in the comfort of your studio, review all the information you have included in these preliminary studies before starting your painting. This is a much more analytical way of painting than is generally possible when working directly from your subject, although it is worth reiterating that Cézanne's prolonged investigation of landscape was made while painting on the spot.

Some artists (Roger de Grey is one example) start their paintings on the spot and then work on them later in the studio, changing elements of the painting and returning to the subject only if they feel they need more information. I do not intend to describe these working methods here. Rather, I wish to focus on those artists who work entirely from references of various kinds.

Painting from Drawings

There are two main ways in which artists can approach making a drawing. The first is to consider the drawing as an end in itself. The second is to treat it as being a means to an end. The first kind of drawing will possibly be exhibited as the artist's complete statement, but the second kind is a 'working drawing' from which something else is going to be developed. This could be any kind of art or craft work but here I am concentrating on working drawings which are made on the spot as information for landscape paintings.

Ian Simpson, *Landscape in Holland*, **pen drawing, 10 x 15 cm (4 x 6 in)**

BELOW LEFT: **Glyn Morgan**, *Celtic Landscape*, **1987, oil on canvas, 81 x 91 cm (32 x 36 in)**; BELOW: **Glyn Morgan**, *The Black Mountains*, **1986, oil on canvas, 63 x 76 cm (25 x 30 in). These two paintings were both based upon numerous small drawings, inventively combined to produce a colourful amalgamation of viewpoints and features**

There are few artists who do not use drawing as a first step towards making a more significant work in another medium. Drawing is particularly useful for this purpose because it is so direct and so quick. A few lines, drawn in as many seconds, can effectively conjure up a first idea of a landscape. The drawing of fields and trees in *Landscape in Holland* was made in a matter of moments from the window of a rapidly moving bus. It was produced faster than I could have taken a polaroid photograph and it is of much more use to me as information because in order to draw it, I had to decide very quickly what was significant and commit it to paper. In a split second I had to see everything and make something of it. The act of drawing compelled me to look intensely and in a way that I do not believe is possible through the viewfinder of a camera.

Drawing is very important because it is the quickest way to respond to a visual idea. Because working drawings are not intended to be works of art they are rarely seen. Some artists are not keen to show the ideas behind their paintings, preferring their pictures to speak for themselves. With others, the working drawings may be of no great merit in themselves and used by the artists simply as a kind of *aide-mémoire* to jog the memory into recalling the visual incident, rather than actually representing it.

Many artists find making drawings from which they can later paint a difficult activity. I am not convinced that I have always found the best way to translate the most significant features of my drawings into paint; looking back on work done some years ago, I feel that the initial drawing was often merely enlarged in the painting, with colour added. The structure of the painting was provided by lines drawn in thin paint which reproduced what may have been pencil or ink lines in the original drawing.

With me, lines have been the problem. Drawing is mainly about using lines and the art of drawing is a very subtle one. We are so familiar with the vocabulary of drawing and the way lines are used to describe the visual world, that we often forget there are virtually no lines in nature. We usually draw a line to show where one object ends and another comes into view, but it can be extremely difficult to translate this interpretation of a visual experience into two areas of colour which meet to produce the same effect. Nevertheless, in some way, you have to use the features of drawing, its linear and tonal qualities, and above all its directness and

Ian Simpson, Coastal Landscape, Durham, **watercolour, pencil and crayon study**, 40 x 76 cm (16 x 30 in)

speed, to produce information from which you can paint. To do this, you must think all the time you draw, not so much about the drawing itself, but about the next stage – the painting.

A drawing from which you intend to develop a painting should be first an investigation of the subject, testing its potential for painting. It can be considered as a kind of rehearsal. All the time you are drawing, the marks made by pencil or charcoal should anticipate the marks that you think you will make with your brush when you paint. You have to limit yourself to recording the information from which you can later paint, and not concern yourself with whether the drawing is beautiful in its own right. I find that sometimes I create an effect which looks perfect in the drawing but which I know will be impossible to reproduce in paint. On other occasions I am unsure whether something (say, the rough texture of a field) will be needed in the painting and I am tempted to leave it out if the drawing looks all right without it. In situations like this you have to be prepared to ruin the sketch in order to have enough information from which you can later paint. Often I paint from one single study made on the spot in which I have recorded information about shapes, tones and colour, as in *Coastal Landscape, Durham*. Sometimes, however, I find it better to make separate studies of shapes, tones and colours and use all three as references for the painting.

Drawing shapes

Once I have decided on my subject and started drawing, my first interest is usually in the main shapes I think will be useful when I paint. If, after my first attempts, I feel that the drawing is not large enough to include all the shapes I consider to be

Ian Simpson, From the Dining Room, **pen drawing**, 40 x 58 cm (16 x 23 in)

important, I extend it by joining additional pieces of paper where necessary. I do not let the original sheet of drawing paper dictate the outcome of the drawing, even if this means ending up with a drawing larger than my board. Pencil, charcoal, ink or a fibre-tipped pen are ideal for this first drawing. *From the Dining Room* is a line drawing in ink of a landscape seen through a window. I wanted to record the shapes of the objects on the table in relation to the landscape outside. When making drawings like this, I try to fit together all the significant shapes, rather like interlocking the pieces of a jigsaw. I don't usually decide where the edges of the picture will be until I am ready to start painting.

Tones and brush marks

I still find that the best way to identify tones is the method commonly taught – half closing your eyes, so that the colour is partially eliminated and the lightest and darkest contrasts in the subject become more apparent.

Any medium can of course be used for making a tonal drawing. Watercolour, diluted ink, or a monochrome painting in acrylics can provide useful studies, as shown in *Wimbledon Common*. I personally don't find pencils much use (unless they are charcoal pencils or similar) because they are so limited in their tonal range and do not create areas of tone easily. Producing large areas of pencil shading is tedious and, it seems to me, pointless when there are so many better ways of making tonal drawings. Pencil drawings with a narrow range of soft grey tones might look good, but they often prove extremely confusing when you try to translate them into paintings.

Charcoal, chalk, and conté crayon are very effective for making tonal drawings. These mediums can be used broadly to re-create the tone pattern in the subject and I aim to use them in a similar way to how I anticipate using my brushes when I start to paint. I try to sense the space between the objects and use the medium to describe both this space and the form of the objects. In the drawing *Woodland*, where objects are round in form, I have attempted to express this roundness in the way I have used the conté to describe them. Again, if necessary I would enlarge the drawing if I thought this would provide a better tonal pattern for my painting. A finished tonal drawing may eventually include more than the earlier drawing of shapes, because by this time I might have seen possibilities in the subject which I hadn't noticed before.

I draw in part using a logical approach and in part by a process of trial and error. Having put in the initial shapes, I then decide which are the tonal limits in the subject – which area is the lightest and which the darkest. Next I decide how many tones to have

Ian Simpson, Wimbledon Common, **ink and wash**, 16.5 x 18 cm (6½ x 7 in)

Ian Simpson, Woodland, **conté drawing, 29 x 34 cm** (11½ x 13½ in)

between these limits. There may in fact be a great number of slightly different tones, but I usually find it is necessary to simplify these, reducing them to two or three, so that there is an adequate balance between harmony and contrast. Once I have established this tonal framework I then experiment with the tones and change them if they don't look right.

Colour studies

You have to see colour everywhere. Pierre Bonnard (1867–1947), a great colourist, recorded in his diary, 'There is vermillion in the orange shadows and violet in the grey ones.'

A colour study could be made in any medium but I find it difficult, in the studio later, to translate the transparency of watercolour into the opaque colour of oil paint. Acrylic paint is excellent for making colour studies on the spot, and oils can also be used. Oil sketching paper is particularly good if you want to make rapid colour studies.

I like my colour studies to catch the 'colour feeling' of the subject, as can be seen in *French Garden* and

Flowers in a French Garden. I ask myself whether the overall colour has a particular quality. Is it predominantly warm or cold? Is there a dominant colour? I usually paint on a white ground and I try to cover it as rapidly as possible, leaving no white paper or board showing between the areas of colour. Although small patches of white ground between colours can give a painting an initial vitality, they give a very false impression of how the colours will

FAR LEFT: **Ian Simpson**, French
Garden, **oil on board,
25 x 15 cm (10 x 6 in)**

LEFT: **Ian Simpson**, Flowers in a
French Garden, **oil on board,
25 x 15 cm (10 x 6 in)**

BELOW LEFT: **Keith Grant,
sketchbook drawing, pencil,
15 x 20 cm (6 x 8 in). This
swiftly made drawing shows
clearly what the artist consid-
ers to be the most important
elements of the landscape.
Grant supplements sketch-
book drawings with an
excellent visual memory when
he paints in his studio, but this
drawing already has some of
the atmosphere of the
eventual painting**

Ian Simpson, Trees Through a
Window, **pencil, charcoal and
watercolour, 67 x 66 cm
(26½ x 26 in)**

react with each other as the painting develops. I don't usually make a detailed description of the subject, but try to see the colour as vividly as I can without worrying too much about drawing accuracy.

Developing a shorthand

Drawings and studies made with painting in mind are not often seen, and if they were, they might mean very little. This is because artists develop their own individual ways of putting down information, in a form which they will be able to use later when they paint. Through experience they learn which information they can retain in their memory and which they have to record. Often they develop a personal system, a kind of shorthand for recording this information.

A quick method of recording information is valuable for two main reasons. It enables you to note something which might soon change. This could be a particular atmospheric effect, such as the sun emerging from a bank of cloud, or it might be an object, such as a pile of logs in the corner of a field,

which may be moved at any time. It also allows you to draw in inconvenient places, where speed is of the essence – on precarious river banks, maybe, or near a busy road. It is only through experience that you will develop a speedy way of drawing, but there are well-tried ways of quickly recording information on tone and colour.

The importance of sketchbooks

Drawings, studies and notes can be made on separate sheets of paper or board but it is often more convenient to use a sketchbook. Ideally, two sketchbooks are necessary: a small one, which will go in a large pocket, and a bigger one (A2 size or 42 x 59 cm), which is still a manageable size and will enable quite a large drawing to be made.

The importance of always looking and searching for painting subjects and noting them in a sketchbook cannot be stressed too much. It is this constant looking and recording that is likely to produce something unusual or unique. *Trees Through a Window* started as a view seen through a single section of

the window. Paintings through three more sections were painted one at a time and then all the paintings were joined together.

Graham Sutherland always took a notebook with him when he was out walking because, as with many artists, even though most of his work was done in the studio he had to start outside with an actual subject. Deliberately looking for painting subjects can be non-productive so it can be useful to go for walks with no particular preconceived idea and then come on one by chance. I take a very small notebook whenever I go out and if I suddenly see something that interests me I make a note of it.

Making notes on tones and colours

Written notes, alongside drawings or on the drawings themselves, can be useful reminders when you paint, not only of tones, but of anything which you consider to be important when you have the subject in front of you and which you feel you will have difficulty in recalling later. Making colour studies on the spot can sometimes be particularly difficult and landscape painters often write colour notes on their working drawings. This can be an effective way of working, but unless it is carried out with the eventual painting clearly in mind, the information can prove useless.

I find that colour notes have to be very personal reminders. If I simply label an area of my drawing 'blue', for instance, it will probably mean absolutely nothing when I start to paint from it perhaps a month later. To be effective, a colour note has to tell me, months or even years after making it, what I need to know to make a painting from it. I don't want to have to write a descriptive essay about each colour but I do need to provide myself, in a few words, with a reminder of the kind of colour I saw and its significance to the subject. 'Warm blue' or 'purple blue' would be better colour notes than just 'blue', and 'prominent warm blue' or 'receding purple blue' would be even more informative. The blue might remind me of a colour very familiar to me. It might be the blue of an old sweater and if so I would record it as such. The words to describe colours have to be your own words, with a precise meaning for you and able to describe both the individual colour and its relationship with other colours, just as if you were actually painting them.

Working from Photographs

It is possible to make paintings from photographs but, surprisingly perhaps, most artists find photographs more difficult to work from than painting directly from the subject. None of the landscape artists interviewed in this book makes any direct use of photographs.

There are a number of reasons for this. Photographs do not contain the detail that we often imagine they do. They are themselves two-dimensional and it is not easy to re-create in paint the photographic illusion of space. But possibly the most serious limitation of photographs is that they do not record what we see ourselves with the naked eye. If identical objects are at different points in space, but not too distant from each other, a photograph will show them with the same relationships of scale as

Ian Simpson, photo collage, 1988, 20 x 25 cm (8 x 10 in)

we see them. When we look at more distant objects, however, a factor called scale constancy comes into operation. What happens, in effect, is that we see distant objects larger than they appear in the photograph. Our brain makes an adjustment. Cameras can't do this and this factor, plus the distortion caused by most lenses, means that a drawing of a place and a photograph taken of the same spot look very different. If you haven't ever made the comparison, try it!

Another drawback with a camera is that it 'sees' from one fixed point, whereas when artists draw a landscape they never keep their heads in one position and as a result their drawing is usually made up of a number of different views fused together. By taking several photographs, using a camera with a standard 50 mm lens, I have found it possible to join the prints together so that they provide information similar to that in a drawing. The photo collage illustrated on the previous page was made from four prints. I extended the use of the photographs by also making some drawings in the same places. These photographs, together with drawings and a colour study made on the spot (illustrated right), were used to make the painting *Suffolk Landscape in Snow*.

If you use photographic information, don't accept the composition of the photograph as necessarily being the best possible one for a painting. You may find that you need to extend the photograph by adding a drawing of a section of the landscape to one side of it, or you may need to mask off part of the photograph and use only a section of it for your painting.

Projected images

Some artists use slides to project a photograph of a landscape onto their painting surface and then trace the projected image to start their painting. It is also possible to print an enlarged photographic image on paper, board or canvas and paint over this. In addition, by projection or printing, a drawing can be enlarged and transferred to a painting surface. All these methods are used by artists, but even though they may seem attractive as useful aids to painting, they will only be effective in very experienced hands. Between each step in the production of a painting, from seeing something which interests you, through the various studies, to the successive stages of developing the painting, there must be scope to make alterations and to allow the painting to change direction. When starting a painting, in the struggle to draw the images accurately on a larger scale, effects are often created by chance which are worth preserving. Mechanical means of transferring and enlarging the images to an extent deny these possibilities and I would advise you to stick to relying on your eye and your drawing skill.

Ian Simpson, watercolour and charcoal study, 1988, 58 x 40 cm (23 x 16 in)

Ian Simpson, Suffolk Landscape in Snow, **1988, oil on board,** 76 x 91 cm (30 x 36 in)

Enlarging Drawings and Photographs

Often when you paint from drawings, and almost always if you work from photographs, the images have to be enlarged at the painting stage. Some artists do not want to stick too closely to the original studies. They use them only to start their painting which is then developed independently. Other artists, however, wish to transfer to their painting, very accurately and in enlarged form, the images in a drawing or a photograph. In this case they generally use the system known as 'squaring-up'. I use this system myself, but rather than draw squares over my working drawings and studies I have two other alternatives. I either stick pins (ordinary dress-making pins are best) at appropriate intervals round the edge of my working drawing and stretch thread across between them to make a grid of squares; or I lay a sheet of clear Perspex over the drawing and rule the squares on that. Once a grid of lines has been drawn on the Perspex with a Chinagraph pencil (or certain types of fibre-tipped pens), it can be used over and over again for similar-sized drawings and photographs.

Building Up a Painting

Painting in the studio allows a more methodical approach to painting than when you paint out-doors. The painting can be built up in stages, with the paint left to dry between each stage if required. Although I don't believe that paint textures should be artificially created, but should grow out of the natural development of the painting, studio painting does give time for the paint surface itself to be developed.

As a general strategy I find that the best way to build up a painting is to draw in the main shapes in thin paint and then block these in with thin colour, as in *Swedish Landscape*. After this stage I am able to see whether the painting needs major changes in the overall arrangement of these shapes, or in its general composition. If I have squared-up the painting, the grid of lines will still be showing through this first underpainting. I continue to transfer the information from my drawings and studies until I feel that the painting is no longer dependent on them. The painting must be allowed to develop in its own way and should not simply copy the working drawings. At some point in its development the drawings and studies must be set aside and the painting considered solely on its own terms.

One of the greatest difficulties in studio painting is keeping the paint fresh and lively. Because you can work more carefully in the studio there is a tendency for the painting to look too measured and methodical. The solution to this problem must be that you regard the drawings and studies as 'the subject' and you paint directly and spontaneously from them, as you would the real landscape if you were painting outside. John Piper feels that he has quite consciously taught himself to paint in the studio as spontaneously as he does outside.

As a painting develops it is always difficult to decide how far it is permissible to depart from the original concept. From the interviews in this book you will see that some artists are prepared to make radical changes. I do not like to change my original idea significantly. I try to paint a translation of something I have seen. This may require me to eliminate a great deal of superfluous information, but as I explained in Chapter 2 a feeling for the actual place, even the actual view, is important to me. This is not true of all landscape painters, of course. The extent to which the painting is predetermined and how far it changes as it progresses depends on the individual.

The Impressionist painter Alfred Sisley wrote in a letter: 'The motif must always be set down in a simple way, easily grasped and understood by the beholder. By the elimination of superfluous detail, the spectator should be led along the road that the artist indicates to him, and from the first be made to notice what the artist has felt.'

It is not easy to say when a painting is finished. It may not take much time or require much detail to be complete, or it may take literally years, with layer upon layer of paint. Once you cease to make new statements and find yourself repeating or tidying up shapes and forms you have already painted, this is the time to ask yourself whether you should stop.

When painting, not only is it hard to know the point at which to stop, it is also difficult to decide whether what you have done is good or bad. As you will read in the artists' interviews, even very

LEFT: **Ian Simpson,** Swedish Landscape, **oil on board, 35 x 53 cm (14 x 21 in)**

Ian Simpson, The Medway at Chatham, **oil on canvas, 51 x 61 cm (20 x 24 in). Here the high viewpoint and the river sweeping away behind the foreground buildings take the eye into the background and give this painting a feeling of space. The sombre colours and geometric shapes of the buildings contrast with the brilliant blue and green of the landscape beyond**

experienced painters are never sure. The best way of judging your own work is to put it face to the wall for a few weeks and then look at it afresh. Camille Pissarro described in a letter to his son how difficult it was to form an opinion on some paintings he had recently completed. Sometimes he understood them and on other occasions he found them 'horrible' and was afraid to look at canvases piled against the wall of his studio in case he found 'monsters' where he had believed there were 'precious gems'.

Drawings as Works of Art

In describing ways in which working drawings and studies for paintings can be produced, I have stressed that you have to disregard whether they are well-considered, complete artistic statements and ask yourself whether they include all the information you will need when you paint. The selection process starts at the drawing stage. There are always many things I can see in the subject that I know I won't want later, but where I am in doubt, I put them in my working drawings and defer the decision about whether or not to include them in the painting until it is under way.

Even though their working drawings have not been made with exhibiting in mind, artists sometimes find that they turn out to be much better

statements than the paintings subsequently produced from them. The spontaneity which comes from working from direct observation is often an important factor and in the initial encounter with the subject there can be a vivid first impression which is lost as the painting develops.

Drawings and studies which have been made as functional preliminaries to a painting can therefore be exhibited as 'works of art', although I would not describe this practice as widespread. Constable's sketches are exhibited and preferred by some to his finished paintings, and among the artists interviewed in this book John Piper also exhibits his studies. If a working drawing or study turns out, by chance, to be worthy of being exhibited, this possibility should, I believe, be seized upon. For most artists, however, working drawings have served their purpose once the painting is finished.

There are as many ways of painting as there are artists. Each person has to decide what is right for him or her. I have described in this chapter my own approach to painting landscapes in the studio, but Keith Grant's approach, which is described in the next interview, is very different from mine. He is much less concerned with a visual experience and more interested in the re-creation of a total feeling for a particular place.

PHOTO: RACHEL HEWITT

Interview

Keith Grant

'My paintings are about space and light – earthly light but with hints of the extra-terrestrial.'

Keith Grant describes painting from direct observation as 'almost a waste of time'. With few exceptions he paints in oils and watercolour, using drawings as reference and inspiration. Painting on the spot, he finds, has little value as the work produced is more descriptive and lacks the atmosphere of paintings made in the studio. For him his best paintings grow from memory or out of rapidly made observational drawings. Grant has to make a connection between his feelings for the landscape and the painting medium. This demands going through a process of searching out the images he wants through the paint itself. Total concentration is required with no distractions. His imagination and invention can transform the slightest of drawings into one of his best full-blown paintings. He sometimes listens to music in his studio, but once the act of painting is really under way he finds it totally absorbing. Losing all sense of time, he often leaves the record silently spinning on the turntable, unnoticed for hours.

Occasionally a sense of puritanical guilt makes him feel that he should paint outside, to suffer something uncomfortable and perhaps frustrating. However, experience has taught him to struggle on and resist such impulses. A need to be free from distraction is not all that compels Grant to paint 'removed' from the subject. His painting, while true to his feelings for a particular place, is never a view from a single position. He amalgamates many memories and drawings to make the picture evoke a sensation of the place. These 'places' in his work can't be identified in the same way we respond to the view on a picture postcard, but people frequently do recognize them nevertheless.

Working Methods

Some of Grant's paintings change radically on the canvas, even the initial subject being consumed by new inventions. One canvas, for example, started out as a tree-filled landscape but evolved into a painting about a volcano. A typical start to one of Grant's paintings, however, usually involves a clear dominant image, perhaps the triangular silhouette of a mountain, centrally placed on the canvas. Parts of the picture progress through several transformations as he searches for different ways to support the main pictorial feature. Any fortuitous effects are harnessed to help the subject, allowing full exploration of the paint itself. The techniques of painting have never really concerned him, though he has consciously developed a stable and consistent method of working.

Sketch for Mountains near Reykjavik, **1973, pencil, 18 x 24 cm (7 x 9½ in)**

Mountains near Reykjavik, **1974, oil on canvas, 91 x 122 cm (36 x 48 in)**

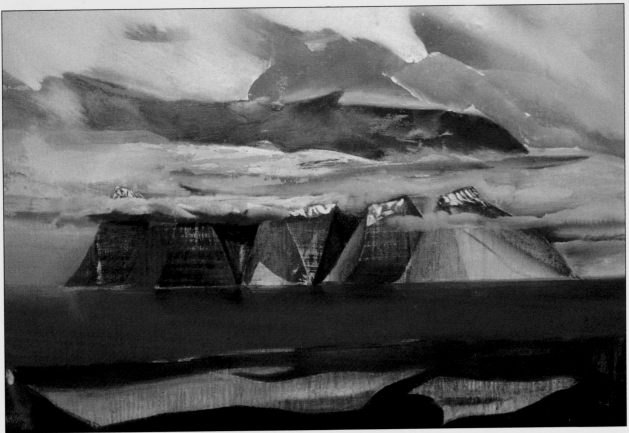

Grant is also a superb photographer. His dramatic photographs show an excellent eye for 'the view' yet while features of the photographs can appear in his pictures, the paintings are never based on his photographs and he never works directly from them. When Grant lectures about his work his photographs are extensively used to give the audience an idea of the place that has been the stimulus for certain paintings. These occasions give him an opportunity to reconsider his subjects. They rekindle his enthusiasm and in talking about the photographs he sees new things and new possibilities for painting. However, he believes photographs are always ultimately disappointing. Although sometimes an inspiration in that they show aspects of the subject not noticed previously, they are always dispassionate and inescapably from a single viewpoint.

During his early experiments with oil painting Grant made full use of his experience with watercolour. He thinned the oil paint with medium to produce transparent washes. The rest of the painting was then built up on this initial foundation. He has utilized this technique for over thirty years, with a palette he describes as simple. By my standards he uses a wide range of colours: three yellows (lemon, cadmium and yellow ochre), raw and burnt sienna,

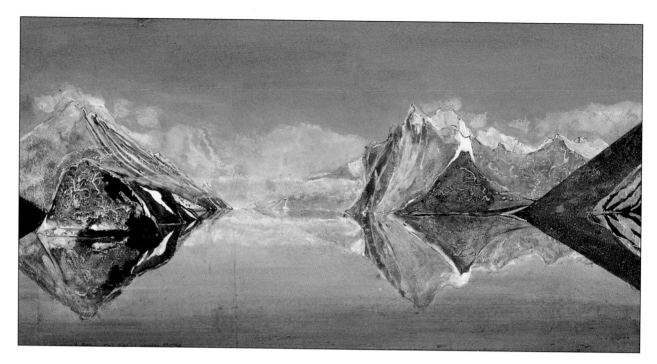

raw and burnt umber, vandyke brown, four blues (prussian, ultramarine, cobalt and cerulean), two greens (viridian and emerald), four reds (vermillion, cadmium, indian and alizarin), black and white. On occasions other hues will be added to obtain particular colour effects.

White primed hardboard is the usual support on which the initial drawing is sketched with charcoal. As the first layers of paint are applied the charcoal smudges into them, 'dirtying' the colours. Grant doesn't see this as a problem because they will be overpainted as the picture develops. He has recently painted on some coloured grounds and is keen to develop this in the future. Another recent experiment has been to paint directly over drawings done on paper, or even over photocopies of them so that the originals can be preserved.

Grant looks forward to the end result as he paints. He is anxious to get the painting completed and in starting a picture will often visualize it, from the outset, in a frame of a certain type or even a particular frame. He found a source of frames probably made in the 1930s and produces pictures to fit these frames.

He wants to sell his paintings and therefore uses dimensions which are suitable not just for galleries and museums. He finds 122 x 91 cm (48 x 36 in) a comfortable size (though this might be thought large for most domestic interiors) and he tends to prefer broad heavy frames which give the effect of looking through a window into another world. Grant has painted some very large pictures, up to 6.5 m (21 ft) long, often in two or three panels. He observed that the long process of production necessary for these inhibits immediacy and that possibly his smaller paintings get nearer to the truth.

Approaches to Landscape Painting

Grant states very firmly that his lack of concern for technique and his straightforward approach to the presentation of his work reflect the fact that he never came to painting 'to be an artist'. He wanted to make landscape images as symbols for 'a cosmic order of things'. He describes his landscapes as 'not pastoral' but relating, within the history of English landscape painting, to Paul Nash, John Piper and Graham Sutherland. They are paintings about space and light – earthly light but with hints of the extra-terrestrial. Grant describes his approach to nature as being 'as a lover' and the act of painting as secondary to that. Making a painting is an 'act of gratitude' for what he gets from his experience of the landscape. 'I have never thought of man small before nature except when he is ignorant of his dependence upon her.' He describes this experience not as one giving feelings of inadequacy but as one producing a desire to become part of the landscape. When considering one of his spectacular volcanoes in Iceland, Grant describes himself as being in the middle of it rather than merely looking at it. He does not see the volcano from a fixed position; the many different views he records allow him to imagine what the volcano is like from the inside, as well as the outside. Turner, he feels, was the ultimate painter of this kind of experience. In a different way van Gogh used his manic determination to portray similar strongly felt sensations about a particular subject.

Grant sees his attempts to distil his feelings for a place and to produce images that will communicate

LEFT: Still Morning, Lofoten, 1987, acrylic, 29 x 62 cm (11½ x 24½ in)

Volcano in the North, 1976-82, oil on canvas, 213 x 152 cm (84 x 60 in)

The Launch of Ariane, French Guyana, 1983, acrylic and ink, 101 x 56 cm (40 x 22 in)

them as being in sharp contrast to artists like Cézanne and Gauguin, for example. He describes Cézanne as 'too much of a schoolmaster' who imposed his view on the landscape, while Gauguin painted idealized landscapes of Tahiti which it is difficult for other artists, faced with the same subject, not to imitate. One reason for Grant's attraction to the North is that it is, for an artist, virgin territory. He went there with no preconceptions; his reasons for going were not related to painting but because

The Sun, **1980, oil on canvas,**
228 x 198 cm (90 x 78 in)

he was fascinated with the landscape itself. He likes snow and, while he is uninterested in self-analysis, he considers his 'pure early upbringing' may be responsible for his search for something simple. Snow simplifies the landscape, forming a natural camouflage, making everything appear to be made of the same material, reducing uneven contrasting planes to simple rounded undulating surfaces.

Weather has a tremendous influence on how Grant responds to a particular place and is highly significant in determining what will eventually appear in his paintings. This is one reason why a number of his paintings have such a low horizon. The large area of sky allows the light and the weather to become major features. Referring again to the order Cézanne superimposed on landscape, Grant remarked that with a single exception neither the weather nor the seasons consciously appear in Cézanne's work. Grant paints what he describes as the 'dome of space', the feeling that everything radiates outwards and that the horizon is curved. The light he paints is not the light falling on objects but the light glaring from the sun which is the focus of everything.

A distinguished critic stated some years ago that everything that could be said about landscape painting had been said and that there was nothing left for landscape artists to paint. Grant disagrees. He maintains that the conditions which sustain life are not infinite. Factors such as atmospheric pollution affect both the landscape itself and how we feel about it. The fact that we have seen pictures of the earth from outer space gives us a new and different sensation of our planet. Damage to the ozone layer, Grant feels, is a vivid reminder to everyone that we can destroy life on the earth. The landscape speaks of this threat and in some way landscape painting of the present must refer to a last chance of survival, in a way which has not been necessary for artists to do in the past.

James Horton, Late Afternoon – Salute, **1988, watercolour with white on toned paper, 15 x 23 cm (6 x 9 in). Using opaque white with ordinary watercolour increases the flexibility of approach enormously in a scene like this. Being able to add the sun sparkling on the water was essential given the speed at which the picture had to be painted**

Focus

Painting Water

Water acts as a mirror, but one with hidden depths where it is possible to see stones, plants or even fish. It reflects the sky, sometimes changing what are actually browns and greens to blues, and the movement of water can transform the images it reflects into corrugated forms or radiating circular shapes.

Ian Simpson, Coastal Landscape, **oil on board, 76 x 91 cm (30 x 36 in). What first attracted me about this subject was the way the view of the sea was framed in a triangular shape of rocks. The painting was made in the studio and I selected those shapes that would exploit this unusual composition. I also featured the dark khaki green sea which had immediately struck me as so important to the subject**

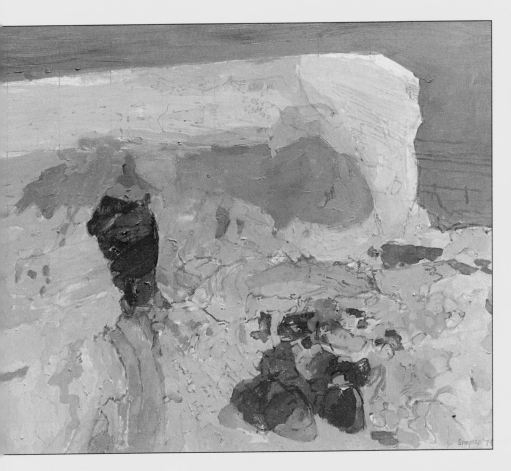

Ian Simpson, Coastal Landscape, **oil on board, 76 x 91 cm (30 x 36 in). This painting was made from drawings. The abstract qualities of the landscape were explored by silhouetting the pale rectangular block of the cliffs against a brilliant blue area of sea and by flattening the foreground. Several patches of contrasting colour break up the foreground, over which some selected details of rocks have been drawn in thin paint**

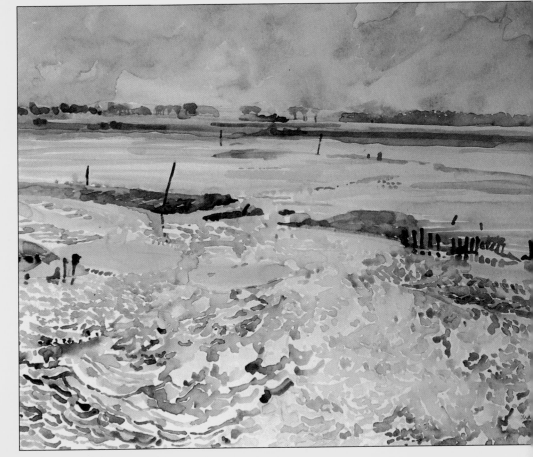

Mary Fox, Incoming Tide, **1988, watercolour, 40 x 53 cm (16 x 21 in). Here lively, colourful brush strokes capture the display of changing reflections and prismatic light effects on the surface of the incoming tide**

'I like a painting which makes me want to stroll in it.'
(Pierre Auguste Renoir, 19th century)

Chapter 5

Three-dimensional Space and Form

I believe a feature common to paintings of all kinds, whether they are representational or abstract, is that they contain an illusion of three-dimensional space. A painting has in itself only two dimensions – height and width – but certainly in the Western world, where painting has been primarily concerned with depicting what we see, artists have developed several ways of making paintings seem to have depth. We expect objects in paintings to look solid and appear to be in their correct places in space. This chapter examines some of the ways in which this can be achieved.

John Blockley, Pennine Winter, 1988, watercolour, 15 x 19 cm (6 x 7½ in). In this landscape there is little in the way of definite features and the interest lay in finding some way of suggesting the emptiness and the subtlety of the undulations created by the covering layers of snow. A process of introducing streaks and spots of water into the drying washes was used, and as these washes dried the painting was plunged into water and the still-wet parts vigorously washed away

Creating an illusion of depth beyond the picture surface is the essence of Western painting. This doesn't usually rely solely on one device, but often depends upon a number of different spatial indicators. To re-create what they see in the visual world, artists have to observe with great concentration and translate the visual sensation they experience into paint. At its most fundamental, painting combines three main activities: looking, drawing, and using colour.

Lesley Giles, Seahouses, 1987, **pencil and coloured pencil drawing, 15 x 23 cm (6 x 9 in)**

The Importance of Looking

Looking is the most important of these activities because all the clues about drawing and using colour are there to be seen if you use your eyes to search for them. We look only in a very generalized way as we go about our everyday lives and we hardly look at all when we see something which is familiar to us, but this kind of looking is useless once we start to draw or paint. To see as an artist you have to become completely engrossed in the subject. You have to see things with a fresh eye, as if you had never seen them before. You must see things as they really are, not as you think they are. This ability to see beyond the obvious is one of the things that distinguishes artists from other people. It is something which can be learned and which needs to be constantly developed. When we draw or paint we have to sharpen our visual awareness so that we can move on to a plane of awareness and sensitivity which is completely different from the one we normally occupy. D. H. Lawrence, who is best known as a writer but who was also an artist, described this state as 'a form of supremely delicate awareness . . . the state of being at one with the object.'

Lawrence is not being fanciful in describing the way an artist sees the world. Scientific studies of artists' behaviour have revealed that when an activity, such as painting, becomes for someone the habitual mode of expression, merely taking up the painting materials can act suggestively and evoke a flight into a higher state. Artists make their discoveries while they are in this state because it is then that they become clear-sighted.

In a sense, artists live in two worlds: the ordinary world and also another one where they are more visually receptive. Henri Matisse (1869–1954), in a conversation with the writer Gertrude Stein, put it more simply. She asked him whether, when eating a tomato, he looked at it in the way an artist would. 'No,' he said, 'when I eat a tomato I look at it the way anyone else would. But when I paint a tomato I see it differently.'

Drawing

In most forms of representational painting, drawing is just as important as colour in creating the illusion of solid forms in three-dimensional space. Strictly speaking, drawing and painting cannot be separated – every mark made with a brush constitutes drawing – but I believe it can be helpful on occasions to think of drawing as a separate element of painting. If you think of drawing as the boundaries of the shapes that the colours will occupy it becomes easier for you to consider it separately, as one of the main ways by which an illusion of forms in space can be created.

Drawing determines the size and shape of the areas of colour which, in a representational painting, will re-create solid objects and three-dimensional space. Drawing objects so that they look right in relation to their distance from you and from each other is of fundamental importance in re-creating this sense of solidity and space. Seeing the relationship between the objects in the first place is crucial.

The drawing above was made with a painting in mind, condensing information for later interpretation in the studio. It was done on the spot and the artist has carefully selected and drawn only the most important shapes and scale relationships in the subject. Back in the studio, memory, imagination, experience and on-site information were combined to paint the atmospheric *Seahouses*. The composition and tonal pattern remain very similar to those of the initial sketch as these structural elements were thoroughly examined and resolved at that stage. Within this framework, individual elements have been elaborated and more 'naturalistic' homogeneous colour established. The contrast between the solidity of the land mass and the floating gaseous

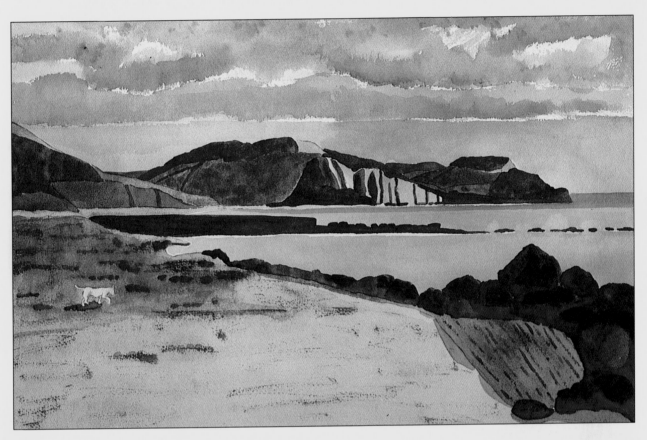

Lesley Giles, Seahouses, 1987,
watercolour, 33 x 51 cm
(13 x 20 in)

clouds is now more apparent. This painting avoids the more usual formula of distant objects being depicted as paler and bluer than those closer to us. Despite the distant hills being strong in tone and rich in colour, there is still a beautiful sense of spatial recession from the foreground beach.

When we draw we tend to take for granted the 'drawing systems' that are available to us, but an examination of the main ones will make you more conscious of their possibilities.

Linear perspective

'Getting things in perspective' has become an expression used about life in general and practically everyone knows something about this system of drawing, which establishes the scale of objects at different positions in space. The best way to remind yourself of how linear perspective operates is to imagine looking through a window and, with a fine brush and some suitable paint, tracing onto the glass the main outlines of what you see outside. If you were actually to do this you would find it impossible unless you closed one eye while making the tracing. You would also discover that it would be difficult to keep your head still enough to prevent the objects you were tracing from seeming to move in relation to the window. This experiment is most effective if you have a distant view from your window with well-defined receding planes and objects both near to you and far away.

In a perspective drawing your paper surface becomes the equivalent of the window and assumes a viewer with a single eye whose head is fixed in one position. Providing you accept these limitations, perspective helps you to draw the receding walls of gardens, the shapes of fields, or a road running into the distance, and calculates the height of someone standing by a stream, perhaps, some distance away.

Obviously we don't keep our heads in a fixed position, or see with just one eye when we draw or paint, and so the rules of perspective will re-create only a limited view of what we actually see. Artists nowadays do not follow the rules of perspective closely, but these rules still remain as a mathematical system for re-creating the visual world, and a basic sound knowledge of perspective can help you to translate what you see.

In my interview with Keith Grant we touched on drawing and whether the drawing skills required by an artist who worked mainly with the figure as a subject were also a prerequisite of the landscape painter. Grant considers that linear perspective needs to be learned if only to be later dispensed with. He contrasted Canaletto's mathematical depiction of space with the way Picasso and Chagall had broken

RIGHT: **Laurence Quigley,** View from Chirk Castle, **1986, oil on canvas, 20 x 30 cm (8 x 12 in)**

LEFT: **Ian Simpson,** Wimbledon Park Tennis Courts I , **pencil, charcoal and wash, 16.5 x 35 cm (6½ x 14 in)**

LEFT: **Ian Simpson,** Wimbledon Park Tennis Courts II, **pencil, charcoal and wash, 16.5 x 35 cm (6½ x 14 in)**

BELOW: **Ian Simpson,** Four Posts on a Common, **pencil drawing, 30 x 38 cm (12 x 15 in)**

the rules. Perspective is a system of measurement and a practical means of establishing the relative scale of objects, but if necessary its laws must be sacrificed, Grant feels, if they get in the way of the 'expressionist, emotional, or the sheer elemental' reasons for the painting.

The simple rule on which perspective is based is that lines which are actually parallel in the visual world appear to meet at a single point on the horizon if you extend them. This is a fact that can be seen, for example, if you look along a straight length of railway track. Landscape painting presents many drawing problems which are similar to this. For instance, you might be drawing a receding foreground roof and a field in the middle distance which runs parallel to it but is some distance away. If you cannot get these two planes to look convincing you can call on your knowledge of perspective and check that the lines describing the road and the field are receding to the same vanishing point.

Often, problems with getting things 'to look right' are related to your eye level. A slight change in eye level can make an enormous difference to what you see. The two drawings above of Wimbledon Park tennis courts look quite different but were made from two similar positions on a bank, one just slightly higher than the other, thus changing the eye

level. By looking up at the background and down at the foreground, you can often incorporate without realizing it two views like this in the same drawing. If the resulting drawing doesn't then 'look right' you can establish where you want your eye level to be and use your knowledge of perspective to make the main lines in the drawing re-create a single view of the subject.

A knowledge of perspective has many possible applications in helping to re-create what you see. It can assist in making planes in your painting recede convincingly and it can be very useful in establishing

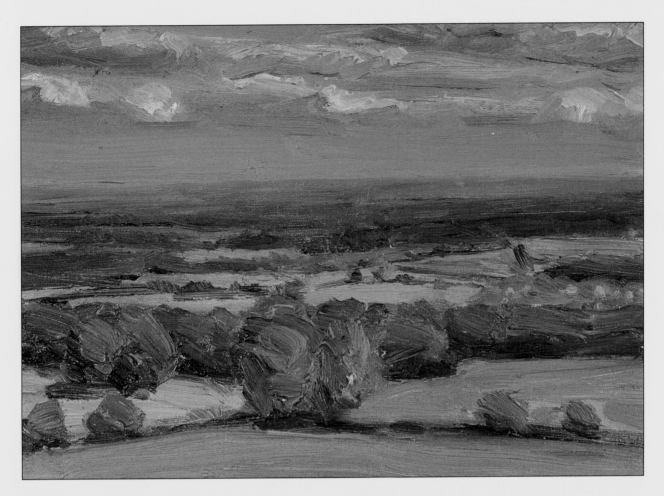

the right sizes of objects at different points in space. In *Four Posts on a Common* perspective has been used to make these posts the right scale, but it works well only when the objects are not very far apart. When they are widely separated, perspective creates something which our eyes tell us is false. What actually happens, in this case, is that when we look at distant objects we see them larger than perspective constructs them. Our brains make an adjustment to the diminished size of the objects. I have already mentioned this factor, called scale constancy, in relation to photography (see page 83).

Perspective can, therefore, on some occasions be a help and on others a hindrance, and there are many different ideas amongst artists as to whether perspective is important or not. Many twentieth century painters have disregarded it and drawn what they felt they saw rather than what perspective told them should be there.

Perspective is a drawing system which can create a convincing interpretation of the visual world, but it does not depict what you actually see. Artists have to decide how they are going to communicate their vision and perspective can play a part in this, particularly, as I have indicated above, when it is used as a means of checking the visual logic in a painting when things look wrong.

Aerial perspective

Aerial perspective is to an extent an observable feature of the atmosphere of northern Europe and was made use of by the Impressionists. It is another means of creating a sense of space in a painting. This form of perspective is based on the fact that the tones and colours of objects change as they recede from us. With aerial perspective tonal contrasts become reduced and receding colours become colder. Distant mountains, for example, would be painted blue, and dark tones would only appear in the foreground of the painting. *View from Chirk Castle* demonstrates very clearly the effect of aerial perspective and diminishing scale. As the hedges and trees recede from us they appear smaller, merging together and losing the strong contrasts of tone visible in the foreground. Colours also become less distinctive until at the horizon the land mass becomes a continuous pale neutral grey, almost blending into the sky. The prominent clouds and the impasto paintwork on the large central tree also help to convince us that these objects are closer to us than other elements of the picture.

Unfortunately, like linear perspective, the laws of aerial perspective will only re-create in part what you see. Certainly you can make your landscape painting look spatial if you paint the background

tones lighter and the colours cooler, but what you actually see in the visual world is not so ordered and predictable. There can be dark tones and warm colours in the background, and light tones and cold colours in the foreground. What matters in painting is what you see and feel, and what you judge to be important. Aerial perspective can play a part in re-creating this vision, but only if it is used selectively and not as a formula.

Making objects appear solid

It is important to draw objects so that they look correct in scale when you are trying to re-create space in a painting, but the objects must also appear to be solid and three-dimensional. Sometimes it is possible to overlook the fact that the view we take of the objects is important in explaining their form. For example, if you imagine a box seen from above, it reveals its three-dimensional form easily; but if you can see only one side of the box, it becomes imposs-ible to explain that it is solid. If you painted the box seen from above it would become more convincing as a solid form if you used colour to describe the light falling on it. Generally light falls on objects from one particular direction, illuminating some parts and leaving others in shadow. Selective translation of the way objects are lit is the means by which form is usually created in both drawing and painting. In painting, this translation makes use of the ways colours contrast with each other, a topic I will be discussing later.

The cube and the sphere are the basic underlying forms of everything we see. These simple geometric forms are, for example, the essential forms of trees, walls, buildings, mountains and rocks, and a sound understanding of how they can be drawn and painted is of fundamental importance to the land-scape painter. The roundness of a tree in full foliage may be obscured by patterns and textures made by the leaves, but its basic form may not be far from that of a sphere and will pose the same basic painting problem to the artist. Taking time off from landscape painting to make studies of simple still life forms like eggs and boxes, for example, can therefore be instructive and rewarding.

Using Colour

Painting is predominantly about colour and the way colours contrast with one another. They can do this in a number of ways and the result helps to create a feeling of space and solidity in a painting. There are books devoted entirely to colour theory and although you may have learned from them

George Rowlett, *St Margaret's Bay, Hazy Afternoon Sunshine*, 1988, oil on canvas, 58 x 94 cm (23 x 37 in). Looking from a high viewpoint out to sea always provides spatial drama. In this case it is made more breathtaking by the powerful handling of the paint. The large brush strokes and warm colours of the right-hand cliff thrust it forward towards us, whereas contrasting cold colours and smaller brush strokes help to establish a more distant cliff behind this

about the properties of colour and colour contrasts, you may also, in the end, have wondered how this knowledge could be applied to the actual practice of painting. If this is so, I can sympathize, because while I regard a knowledge of colour theory to be important, I am not at all certain about the precise part it plays in making someone a good painter. Many artists in the past had little knowledge of colour theory, but this is less true of artists working now since for at least the last quarter of a century it has been taught in many art schools.

It seems to me that knowledge of how colours respond to each other may have a direct relationship with some forms of abstract painting, but there is an enormous chasm between painting a colour circle or carrying out colour-mixing exercises and trying to re-create the colour relationships you have seen in the landscape.

Colour theory has, however, obsessed some art-ists who were not abstract painters – for example, Georges Seurat. We now know that the scientific

theories on which his ideas were based were flawed, but this does not detract from the importance of Seurat's paintings. In my view this is because, although he wished to base his paintings on an intellectual premise rather than an emotional response, in the end he relied on his visual judgement to make his pictures look correct. Now, a century later, we find his theories interesting, but it is his visual judgement which makes him a great artist.

Without doubt, many artists have learned about colour by finding out what will work in practice. Knowledge gained as a result of 'doing' is the artist's most significant method of learning, but theory has a rôle as well. Just as a knowledge of perspective is important, so, too, is an understanding of colour theory. It forms, I believe, an important reservoir of knowledge which is particularly helpful when things go wrong; but it is a reservoir in which you can become submerged.

Knowledge of colour mixing can, for example, determine the range of colours you decide to have on your palette. An appreciation of the principle ways in which colours contrast with each other can also be of inestimable value when you get a colour 'wrong' and can't see how to get it 'right'.

Theory in itself, however, will not make you even a competent painter, because it is judgement which matters in the end. Your painting has got to look right. This is what all artists strive for. I am convinced that even the great colour theorist Seurat put his theories to one side at some point as he painted, and aimed for this 'rightness' that worries and obsesses all artists but is impossible to put into words.

Colour contrasts

I mentioned earlier that colours can contrast with each other in a number of ways. Obviously, colours can have different hues, different tones, and different degrees of intensity (usually referred to as 'chroma' or 'colour saturation'). When we use the word 'colour', it generally refers to the contrasts of hue, tone and chroma collectively. You can paint

without being aware of these contrasts. However, if you are conscious of them, rather than simply feeling that a colour is not quite right you can identify exactly which aspect is wrong and this will help you to mix the colours you want with greater precision.

Yet colour mixing in painting is not just a matter of seeing a colour in nature, mixing the same colour on your palette and transferring it to your painting. As soon as the colour has been placed in your picture it is affected by the other colours already there and often has to be re-adjusted to take account of this. It is a question of how it contrasts with the other colours present, and there are four important kinds of contrast to note.

The first of these contrasts is between different-sized areas of colour. If you place a bright green area of paint in your picture it can be made to appear dull in comparison with a larger area of a similar green.

The second kind of contrast is between different paint textures. An area of colour where the brush strokes are prominent can look quite different from another area of the same colour painted smoothly with no obvious brush marks.

The third contrast occurs between a colour and its complementary colour. Colour theory tells us that the colours directly opposite each other in the colour circle, called complementary colours, produce the most vivid contrast; or, to put it another way, are most violently discordant when placed next to each other.

The fourth contrast is of the utmost importance in creating an illusion of three-dimensional space in painting. This is the contrast between warm and cold colours. The degree to which colours tend towards red or blue determines their relative warmth or coldness. This is sometimes referred to as their 'colour temperature'. Generally, warm colours advance in painting and appear to be in the foreground, and cold colours recede. The extent to which colours contrast with each other through their 'temperature' significantly affects the illusion of depth in most paintings.

The contrast of warm and cold colours is also important in making objects look solid and three-dimensional. I said earlier in this chapter that solidity is created in most paintings by describing the way in which light falls on objects. This sense of the third dimension can be further enhanced by translating the colour of an object so that it is warmest on those parts of the form which are nearest to you.

I have only touched on what I regard as the most important colour contrasts, but even this amount of theory may seem to you too mechanistic to be relevant to painting, which, as several quotations in this book testify, is not only about placing objects in space but is also concerned with our emotions. Before I leave colour theory, however, for those who

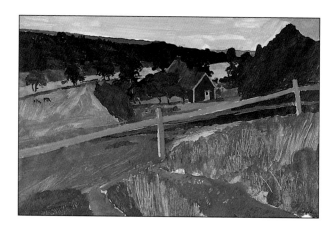

may still be sceptical let me illustrate its relevance to landscape painting.

Using complementary colours

The painting entitled *Swedish Landscape with Red Farm* is mostly green with a red farm in the middle distance. The contrast between red and green is basically a contrast of complementary colours. Every colour, in fact, has only one absolute complementary colour, so although any red placed next to any green does not produce the most violent discord, in general, reds excite greens.

An easy way of making the red less of a contrast with the green and therefore less likely to 'jump out' of the painting would be to reduce its chroma; but you may not want to do this. You may have seen the red in the middle distance as a bright colour, which you want to feature in your painting. Many careful adjustments, by trial and error, may be needed to get the relationship between the red and green exactly right, but in making these adjustments you will know from colour theory that the nearer these colours come to being absolute complementary colours, the more the red will tend to 'jump'. Your knowledge of colour contrasts will also tell you that if the red is too prominent, it may not be the actual colour that is wrong. The area of red might be too large, or it could be the paint texture that is making it advance.

When I painted this particular picture I was aware of the potential problem of the red building and the green fields. From the start, although the red is a bright colour, I made certain that it would be able to survive against a vivid green. I began with this strategy in mind, but so far as I am aware I continued after this without any predetermined plan, mixing and remixing colours, and positioning and repositioning them until the picture looked right.

Colour theory in practice

At certain points in almost every painting I make, I find that something 'doesn't work' and then I stop to take stock. This is when it is important to step

back and see your painting from a distance. When I do this I use my knowledge of theory, and probably my experience as a teacher, to develop a strategy for putting things right. I am not sure how much of my teaching experience comes into it, because as Roger de Grey said in his interview, it is difficult to see your own work as you would a student's. You have to be self-critical, but not to the point of destruction. A student can easily shrug off an over-critical remark. It is much harder to dismiss something you have told yourself.

Painting is not only about using colour to re-create forms and space; it is also about emotions. Colour plays a major part in re-creating atmosphere and expressing the artist's feeling for a particular subject. Emphasizing the contrast between colours or reducing colour contrasts can both create different moods in paintings and we need only to remind ourselves of the way colours are used in our verbal descriptions to realize how much colour is associated with a state of mind, or a kind of day. 'He saw red,' we say, or 'It was a grey day and I was feeling blue.'

Further Ways of Depicting Space

We sometimes forget that perspective and colour temperature are not the only ways in which an illusion of space can be created in painting. There are other means, some which tend to be taken for granted and others which are overlooked. Another problem for landscape painters now is the recognition that we do not actually see a single view, but a number of different ones which somehow have to be combined; this too affects the way in which space is depicted.

Overlapping objects

I have already mentioned that the view taken of an object can either reveal its form or conceal it. Similarly, selecting a particular point of view can help to enhance the feeling of space in a painting. One of the most obvious ways in which objects can be shown to be behind each other is when they are seen overlapping. Making a feature of overlapping objects is another way of creating a sense of space, as can be seen in *Vale of Stock Ghyll, Ambleside*. This quirky landscape breaks most of the so-called rules by which painters create the illusion of space. However, we can still weave our way down the hillside, across the valley, and start climbing the other side. This is primarily because we can follow the logic of overlapping objects, assuming one to be in front of the other and vice versa. By not introducing a horizon line, the spatial recession is limited but the two-dimensional qualities of the work are amplified. This ambiguity between pattern and the illusion of space helps to create the excitement in this painting.

Cubist space

Cubism developed from the attempts of Pablo Picasso (1881–1973) and Georges Braque (1882–1963) to give painting a more intellectual concept of form. It was an extension of Cézanne's wish 'to make of Impressionism something more solid and durable'. Picasso and Braque combined and super-

ABOVE LEFT: **Ian Simpson,** Swedish Landscape with Red Farm, **acrylic on paper, 40 x 58 cm (16 x 23 in)**

Andrew Waddington, Vale of Stock Ghyll, Ambleside, **1988, pencil and ink on tinted paper, 23 x 35 cm (9 x 14 in)**

Raymond Spurrier, View from the Terrace, Villa Stamatis, **1983, watercolour, 23 x 28 cm (9 x 11 in). This painting is a statement about modern buildings embedded in a natural landscape, showing how separate buildings have combined into a simple shape that might almost have been pasted onto the landscape like a collage**

imposed several views of the same object. They wanted to represent the total object rather than a single view of it. The first phase of Cubism, called Analytical Cubism, excluded any interest in colour and concentrated solely on the analysis of form. However, later phases of Cubism incorporated colour and the tactile qualities of paint and collage.

In the interviews in this book Keith Grant refers specifically to Cubism and some of the other artists state that they do not try to present an actual view from a single viewpoint. The Cubist concept of how form and space can be re-created in painting has strongly influenced artists in this century. The departure from having a single viewpoint and the ways

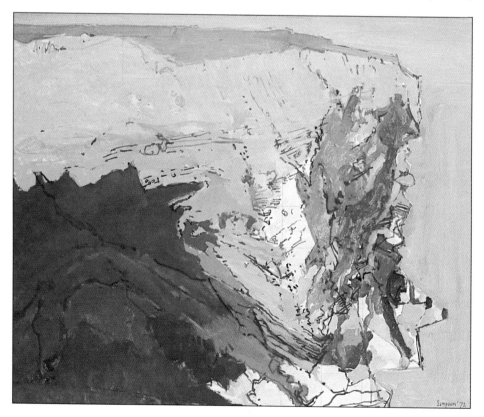

Ian Simpson, Coastal Landscape, **oil on board, 76 x 91 cm (30 x 36 in)**

in which we now represent and rearrange objects and space are mostly derived from this source.

Extending the view

When we look at a subject we intend to paint, we do not take the one-eyed view of perspective or see views simultaneously from all angles, as in Cubism. Our natural way of looking at a subject lies somewhere in between. When we look at something we don't normally have just one viewpoint. Our heads and eyes move constantly and if we actually paint what we see, the picture is constructed from a number of separate views. These multi-viewpoints are what often make paintings appear to include distortions. Allowing your eyes to scan the subject and then joining together what you see from a number of different viewpoints can have the effect of flattening or stretching the subject. If you move your eyes across your subject, from one side to the other, the width of the objects becomes exaggerated and the illusion of depth is reduced. The effect is similar to that of a photograph taken with a wide-angle lens. The photograph looks distorted, just as a painting made from a number of viewpoints produces distorted images even if you try to paint exactly what you see. Distortions of this kind are not as obvious in landscape paintings as in paintings of other subjects, but I am very conscious of them in my own work. *Coastal Landscape* shows an example of this. There are also references to the ordering and reorganization of space in some of the interviews with other artists.

Paintings from two or more viewpoints

Landscape near Stockholm was developed from three paintings made on the spot from the windows of a house on the edge of the city. Each painting is a view from a particular window and was máde separately. The paintings were then joined to make a panoramic view. Paintings of different views can each be painted in their own right and don't necessarily have to look as if they have been worked on at the same time. Pictures brought together to represent a particular place can give indications of the passage of time. Another painting, *A Swedish Landscape on Two Days*, made on the spot on two separate days, shows the different kinds of weather that were experienced and their effect on the landscape.

The next interview, with Derek Hyatt, refers to new ways of seeing which have developed not only from Cubism and our recognition of the way we see the visual world from different viewpoints, but also from the speed at which life moves in this century.

BELOW: **Ian Simpson**, Landscape near Stockholm, **acrylic on paper, each section 38 x 45 cm (15 x 17¾ in)**

BOTTOM: **Ian Simpson**, A Swedish Landscape on Two Days, **acrylic on paper, 49.5 x 118 cm (19½ x 46½ in)**

Interview

Derek Hyatt

'The idea comes and goes. It's really a mental exercise; you test how far your mind can discover yet another variation.'

Derek Hyatt's paintings are almost all concerned with two particular landscapes which he has known for many years. Bishopdale and Langbar Moor in Yorkshire have provided him with material for literally hundreds of paintings.

At Bishopdale he draws and paints from a farmhouse perched high above the steep-sided valley. The view takes in an intimate area of garden before the land suddenly falls away into the valley, rising up steeply to a high horizon on the other side. 'Hanging a painting' from this high horizon has intrigued and motivated Hyatt for the last thirty years. He has never been interested in what he describes as the 'stock landscape image', which might have a carefully positioned tree, a foreground figure, perhaps mythological, an abundance of background trees and the horizon crossing the middle of the picture.

Gauguin's paintings of Brittany, with their high horizons, Hyatt says, were a real discovery to him. The idea that you could suspend a painting from a high horizon, with rock forms and figures making symbolic shapes, was inspirational. He found Gauguin's particular colours, such as dark reddy browns and purples, similar to the dark moody colours he experiences in the Yorkshire valleys. 'Gauguin,' Hyatt says, 'was the beginning for me as an artist.' His paintings demonstrated how it was possible to avoid having perspective 'hurtling to the horizon'. They showed Hyatt the way to making paintings that he describes as 'a hanging vertical spread across your vision'. Hyatt regards this 'hanging vertical spread' as a feature of a great deal of modern painting, especially abstract painting.

Hyatt's love of the particular Yorkshire landscape and his interest in twentieth-century painting provide dual elements in his work. A tension exists between his memories of the landscape and his desire to produce unmistakably twentieth century paintings. In his pictures an agreement or balance has to be reached between those two conflicting elements of description and abstraction.

Working Methods

Hyatt's first paintings were in gouache, a medium he rarely uses now. He usually paints in oils, although it took him some time to learn to use these effectively. Initially he worked in oils with long stiff hog's-hair brushes, but used in this way the medium seemed to be wrong for expressing his feelings for the landscape: it was 'like trying to dance in splints'. Later he found that by using soft brushes with gouache he could work in an experimental way

Grouse Moor, **oil on hardboard, 40 x 38 cm** (16 x 15 in)

Paul Gauguin, La Bergère Bretonne, **1886, oil on canvas, 61 x 74 cm (24 x 29 in)** (Laing Art Gallery; reproduced by permission of Tyne & Wear Museums Service)

which produced the textures and splashes his paintings needed. After ten years of trial and error he eventually found he could use oils in the same experimental way.

He keeps a selection of primed boards of different dimensions ready for painting so that there is as short a time as possible between seeing something he wants to paint and making a start. Having the boards handy means that he can pick one up and start drawing 'ahead of thinking', with one shape automatically leading to the next.

The Dark Furrow, **oil on hardboard, 28 x 33 cm** (11 x 13 in)

The Challenge of Landscape Painting

'Another delight,' Hyatt says, 'is when I am sitting at my window and something clicks – a wall shape and a cloud shadow – and with felt-tip pen and pad I can work through twenty or thirty variations. The idea comes and goes. It's really a mental exercise; you test how far your mind can discover yet another variation. Into the unknown. A game for one.'

His paintings are almost always nearly square. He has worked with this format for years and says he now automatically sees the landscape in terms of square pictures. He finds many of the conventional watercolour block and paper sizes the wrong proportions. Recently he has been commissioned to paint a landscape using a traditional rectangular format and he has found it almost impossible to work within it. He feels a need to make paintings that rise up and confront the viewer: 'not a space that's running off at the sides but space that is self-contained, holding a moment of time, not a detail of a horizontal event which goes on outside the edges'.

Many of Hyatt's paintings have been based on views from one particular vantage point high above Bishopdale – 'a simple white room, one large window a thousand feet above the valley. You look down on the curlews gliding by.' Hyatt starts a painting by quickly drawing the simplified shapes he identifies as being significant to his subject. There is a mental image which comes from looking at the

landscape and Hyatt describes his first task as fixing this image in the right place on the board. He knows that when he begins to paint he will be able to remember enough about the colour and details of the landscape, but he cannot retain the main shapes of the painting and their position in the picture. His initial drawing is made in blue or brown felt-tip pen, which must have dissolvable ink. This is because once the drawing is complete he will paint over it. When he does this he withdraws from the window, painting in the same room but not referring directly to the landscape. It remains outside the window as a kind of security. Yet although this presence is important to him, he says that in a sense he can't go back to it because he knows it will have changed since his initial drawing.

When this drawing is made, colour notes, such as red, brown, yellow and cold yellow, are often written on it. Hyatt intends these to be as simple as possible, like the images of the landscape he has drawn. He recognizes that everything is going to change once he begins to paint and the painting will become complicated of its own accord. Hyatt explains that he uses a limited palette of six colours – vermillion, cerulean, cobalt blue, yellow ochre, cadmium yellow and chrome lemon – plus white, and cites Turner as another artist who used only a few colours. Hyatt considers his palette to be probably unsuitable for what he describes as 'descriptive

Gate to the Fell, **oil on hardboard, 27 x 29 cm (10½ x 11½ in)**

painting', where a wider range of colours is necessary. Sometimes he adds a colour to his basic palette for a particular painting, just as a musician might change to another key or bring a different instrument into the orchestra. This introduction of another colour, Hyatt says, needs to be approached with caution as it starts a new range of problems: by including it all his tried and tested colour harmonies and contrasts will have to be readjusted. He does not like synthetic colours, which is one reason why he never uses acrylic paint. Many acrylic colours are synthetically produced and Hyatt feels that as substances they are at odds with his tactile experience of landscape.

Hyatt uses colour symbolically or to describe the seasons of the year, and this non-literal use of colour can lead to a particular colour becoming significant and being used more than all the rest. For him, browns and reds symbolize earth; blues, the sky and water; and yellow and white symbolize light. He does not use black and for white he always uses Winsor & Newton's oil painting primer, which he also uses for priming his boards. Looking back over a number of years he has asked himself why he repeatedly uses the same selected colours. 'It's partly because you know how to handle and mix them, but mainly because certain colours become almost symbolic of certain times of year, certain places and certain effects of light.'

Interestingly, he does not use a conventional painting medium such as turpentine but mixes white primer with the oil paint. He mixes primer with almost every colour, even the darks, 'to give them body'. He says he had heard turpentine described as a paint remover and he agrees with this view. 'It de-natures the paint' and he maintains that his painting technique, while giving the paint 'body', still makes transparent paint possible. Personally, I am convinced that Hyatt's oil painting technique is based on his experience of using gouache, which tends to dry lighter than when wet and has a slightly 'chalky' character. In a sense, Hyatt has found a way of creating these qualities using the more permanent medium of oil paint.

Hyatt likes to work on his pictures with the paint at different stages of drying. Simultaneously some areas will be dry and remain untouched, while other dry areas will be overpainted with thin glazes of colour. Some parts of the painting will also be sufficiently wet to allow fresh colour to be added and mixed in. The tough ground provided by the primer allows him at any time to remove paint, with razor blade or solvent, right back to the white ground. His working method is a matter of trial and error. 'Experience may give me more choices but it doesn't produce "sure-fire" answers. I have to come up with some sort of surprise – otherwise it wouldn't be worth the bother.'

Views on Drawing and Composition

In talking about making drawings Hyatt observed that his practice of drawing directly onto the board and not making preliminary drawings came in part from an early dislike of working on cheap paper as a student. 'Board is tough,' he says, 'and you can easily erase.'

The kind of draughtsmanship required by the landscape painter, Hyatt considers, needs to be appropriate to the artist's vision. A tree can be described in a highly detailed way, as in a Ruskin drawing, or it may be expressed by a few or even just one brush stroke, as with Ivon Hitchens. You can't possibly draw every leaf on a tree and so the problem is the degree to which you decide to simplify it. If you believe the tree to be a creation of God, if you see it as related to the tree of life or the tree which provided the cross for the Crucifixion then that will surely influence the way you draw it. If you see the tree as part of world ecology or world mythology, you will see it differently. There are as many ways of drawing, Hyatt states, as there are attitudes and therefore you can only make a value judgement about a drawing in relation to the artist's attitude to the subject. Hyatt does not believe it is helpful to think that there is such a thing as 'classical' good drawing to which all other forms of drawing relate. A child who has an idea about a tree can draw this idea. It may be a tree full of magic or full of sunshine or birds. The tree might be drawn badly in terms of conventional draughtsmanship, but nevertheless might be an excellent depiction of what the child wants to say about that tree.

Composition, Hyatt thinks, is perhaps the most important single aspect of painting. The positioning of elements must be expressive and there must not be a discrepancy between what you know and what you can see. He referred back to the hidden part of the valley which he paints. It is necessary to give clues in a painting which will reveal what can't actually be seen but is known to be there. Much modern art, according to Hyatt, is concerned with revealing and opening up, laying out and presenting. Paradoxically, much figurative art uses excessive detail to cover up, to make things more dense and to deny space. When we look at things around us our eyes don't go into so much detail. Hyatt feels that Pre-Raphaelite paintings are so detailed that we back away from them because detail to this extent is very unlike how we see things today. Realistic painting, Hyatt says, is a fallacy. People of this century move about rapidly; we drive on motorways and dash around cities. We haven't the time to see in detail. Our vision is based on scanning and on reorganizing information quickly. To ask someone to stop seeing in a modern way and to see sequentially, in intense detail, would be to ask them to look at things in an abnormal way. Composition, therefore, must be concerned with a twentieth-century way of coming upon things visually.

Hyatt takes photographs of the landscape, not for direct use in painting but because looking through the lens helps him to see things he may not otherwise notice. The camera, he asserts, sees differently from the human eye. He recalls the first time he used a polaroid camera to take pictures of snow shapes on the ground. Peeling off the prints in the shelter of a wall and comparing them immediately with what he could see, he was amazed at the difference.

Searching for Subjects

Hyatt believes that there is an instant in time when you see something which strikes you as a possible painting subject. You might be driving past a field with a stone trough in it, for instance. You stop and go back. The field and the trough don't look the same. The faded mental image which made you stop the car may have been partly the view and partly the association of certain symbols with the subject. You might recognize this consciously or subconsciously. All these things are triggered once you think that you've found a painting subject. When you begin to observe it more carefully, new information might direct your interest from the initial snap-shot view of the field and the trough to some other feature of the landscape. The frozen trough is full of ice shapes which are echoed in the snow shapes on the hills beyond. The trough itself is a stone and ice 'model' of the whole winter landscape. The mind's eye computer sees and recognizes these

LEFT: Malham Mirror, **oil on hardboard, 28 x 33 cm** (11 x 13 in)

Snow Clouds: Grey, Red and Blue, **oil on hardboard,** 28 x 33 cm (11 x 13 in)

metaphors way ahead of conscious thought! The view is only one ingredient. When the view has been translated into a drawing another ingredient has been added. Then the drawing becomes a painting, and so on. You could paint a series of pictures of the same subject with each succeeding painting becoming a new subject, with the original view of the field long since discarded.

Hyatt described seeing, on a visit to Yugoslavia, a view which he imagined Cézanne would have loved to paint. It was a view through trees with the distance hidden by a rock face. Hyatt described this experience as like looking into Cézanne's mind. He also recalled seeing French landscape paintings in Paris and being impressed with their openness and sense of space. On returning to England and looking again at Constable's work, he had suddenly realized that Constable's landscapes were not free and fresh as they were supposed to be but neurotically intense and frightening.

Hyatt compares searching for his subjects with climbing to the top of a mountain and suddenly finding a particular space which you discover you need. His preoccupation with a particular landscape suggests that, as with Cézanne or Constable, for example, he is trying to paint a certain kind of picture and the actual subject acts as a sort of 'releasing agent'. He considered this idea in our interview and

agreed that something must make one view strike an artist as being more significant than all the rest.

Hyatt also paints subjects other than the landscape of Bishopdale. He has made drawings, photographs and sketches on holiday, but he rarely paints these first impressions of new places. He has, however, made some watercolours of archaeological sites in Yugoslavia. It was the happy coincidence of a holiday visit relating directly to an existing interest. He has also made paintings on a journey to Norway. These were principally based on a sea-plane flight which was so exciting that he felt compelled to make some kind of record of it. He has visited other parts of Britain as well, such as Cornwall, the Lake District and Pembrokeshire, which have traditionally provided subjects for artists and have been painted by Turner, Sutherland and many others. However, it is the places he has known intimately since childhood that Hyatt says work best for him. They are packed with associations and in almost any visit he still finds them charged with meaning.

'There are places, just as there are people and objects…whose relationship of parts creates a mystery.'
(Paul Nash, 20th century)

Chapter 6

The Importance of Composition

Composition is possibly the single most import-ant element of any picture. No matter how well realized and well painted individual areas of a painting might be, if the composition is inadequate, the picture will not be successful.

Any good painting, however free and spon-taneous it might appear to be, has a firm underlying structure. If a painting is to convey satisfactorily the artist's vision, the shapes, forms and colours have to be contained in a format which is the correct size for the subject and within which they have to be combined to provide a satisfying visual whole. This art of picture organization, which we know as com-position, begins as soon as the first mark is made on the painting surface. You could, in fact, say that it starts earlier than this, at the point where you decide on the position from which you are going to draw or paint your subject; or perhaps even before that, with the 'idea' of the painting and the decision on its format and basic proportions.

Ian Simpson, Coastal Landscape, Cornwall, **oil on board, 51 x 61 cm (20 x 24 in). This painting of a rough, foamy sea was painted on the spot in one session**

Good Composition

In a good composition the shapes, forms and colours are arranged so that the painting makes an initial impact and continues to hold the viewer's interest. The various dynamic forces created in the painting rectangle have to be held in equilibrium. When you look at a picture you should feel that everything is held in balance and that the composition is not weighted in one direction or another. In the painting *Billesdon Coplow*, for example, the balance of the underlying composition is a perfect backdrop against which the colourful calligraphic elements can dance.

The painting rectangle

Before we start a painting, the empty rectangle of the picture surface is static, but anything that we introduce into this rectangle – even a single mark – affects how we see it. If we put a mark on the top right-hand corner of the picture surface, for example, our eyes go straight to this point and the equilibrium of the rectangle is disturbed. For the composition to look right, we then have to introduce something which will counteract this first mark and restore the balance of the rectangle.

Artists often become interested in certain kinds of composition. Derek Hyatt, for example, saw in the paintings of Paul Gauguin (1848–1903) how it was possible to suspend a painting from a high horizon, and this suggested to him how he could paint pictures which he felt were compatible with his interest in the most progressive forms of twentieth-century art. Hyatt has also developed an interest in painting square pictures. He therefore doesn't really allow his subject to dictate the shape of his paintings. He looks for a landscape that gives him a suitably high horizon and one which will fit the square format which he likes so much.

You might find a particular kind of composition which appeals to you by chance, or from another artist's work. You could also find new ways of organizing your paintings by trying out different ways of dividing the painting rectangle. A good way of doing this is to draw a number of 'picture' rectangles of varying proportions and experiment by placing in them lines, shapes, tones and colours. The lines and shapes should not be intended to represent objects. You could start with a number of small squares and rectangles placed at random in one of your picture rectangles. Next, you might introduce lines linking the squares and rectangles, and then add tones to some of the shapes that have appeared. Notice the way that the introduction of new elements changes the balance within the picture rectangle. Try adding curved shapes, textures and colours until you feel you have produced a balanced and satisfactory composition.

You don't need to think of this as making abstract paintings; rather it can be seen as a way of exploring pictorial structure, which you can put to direct use in your landscape painting. Just as Derek Hyatt looked for, and found, Gauguin's compositions in nature, so you can discover exciting structures by your own experimentation and find these in nature in the same way.

Michael Hoar, Billesdon Coplow, **1985, watercolour, 61 x 91 cm (24 x 36 in). Transverse divisions of the foreground and the line of the tree tops form parallel dissections of this image. Crossing these at 90 degrees, the white fence posts, telegraph poles and dangling branches suggest a grid-like, measured order. In relation to this the lively washes and flecks of foliage appear all the more spontaneous and animated**

Trevor Burgess, *Snowdonia*, 1987, oil on canvas, 76 x 94 cm (30 x 37 in). Energetic handling and luminosity create a strong initial impact in this painting. There seem to be no quiet passages anywhere across its surface and our gaze, swept into the picture by the curving track running from the bottom right corner, darts around until arrested by the stability of the strong dark mountain centrally placed on the high horizon

BELOW: **Mary Fox,** Near Nuolini di Triora, 1988, watercolour, 40 x 53 cm (16 x 21 in). Unlike those in many landscape paintings, the large tree in this watercolour is not contained by the edges of the paper, as if standing inside an imaginary box. It breaks the top and bottom edges of the rectangle and sprawls over the picture, flattening itself into a beautiful decorative series of curves

Approaches to Composition

Most artists working today, and all the landscape painters I interviewed for this book, decide on the composition of their paintings by a process of trial and error, changing elements of the picture until it looks 'right'. Although the tree in *Near Nuolini Di Triora* happens to be placed on a 'golden proportion', this was not necessarily pre-planned. Compositions like this evolve as the artist works, perhaps preoccupied with other elements of the painting. When successful, this can produce, as in this painting, a wonderful informality that is often impossible to repeat consciously.

Keith Grant regards composition as an intermediary between the frame and the picture content. It is of supreme importance to him and involves transformation of the subject through distortion and abbreviation in such a way that a balance is achieved in the painting between orderliness and unpredictability. Grant used to think there were fundamentally two kinds of painting – representational and abstract. Now he believes that there is only one kind – abstract.

I have already offered a definition of good composition and although it is an imprecise one, I do not think it is possible to be more specific. Ernst Gombrich wrote in *The Story of Art*: 'What an artist worries about as he plans his pictures, is something

. . . difficult to put into words. Perhaps he would say he worries about whether he has got it "right". Now it is only when we understand what he means by this modest little word "right" that we begin to understand what artists are really after.'

I have used the word 'right', in this context, several times already and in a sense we have an instinctive feeling for what it means. If you forget about painting for a moment, you will realize that making things look visually correct in other contexts is something we do frequently without ever thinking about it. Choosing curtains for a room, arranging flowers, even picking the right tie for a particular shirt, are all everyday examples of things we want to get 'right', and usually after looking at a range of alternatives we decide on one. In all these examples, to

quote Gombrich again, 'however trivial, we may feel that a shade too much or too little upsets the balance and that there is only one relationship which is as it should be'. When we paint we are looking for this same balance and this single relationship.

Some artists don't worry about composition when they start a painting, leaving it until a later stage to decide on the precise shape and size of the picture. I have already suggested extending working drawings and I have demonstrated through my own paintings where I have had second thoughts about how much of the subject to include. Pierre Bonnard is an example of an artist who often painted on a canvas much larger than he knew the final painting would require; he would cut this down later as the painting developed. Olwyn Bowey describes in her interview how she doesn't commit herself to the size of her painting before she starts. Even though she makes a well-considered preparatory drawing, she is not sure until she starts to paint whether the canvas she has chosen will eventually need to be enlarged slightly. She paints on a piece of canvas which is bigger than her stretcher and only loosely attached to it, so that if necessary she can attach it to a stretcher of a different size. Even then the canvas is not properly fixed, because she may yet decide to alter the size of her painting.

If you start a painting on canvas, board or paper it is possible to make your painting surface smaller, but unless you work on canvas in a way which is similar to Olwyn Bowey's painting method, or on paper, it is not easy to make it larger. Even if you choose to work in a way which allows the size of the picture to be changed, in the end the painting has to relate to the shape you have decided for it. It is not until you have determined the final shape that the composition can be fully considered, and in all probability many alterations will then be necessary to hold everything in balance within this rectangle. I think there is much in favour of the more practical approach of painting in a rectangle of a predetermined size, so that you consciously compose your painting right from the beginning, although I do not always do this myself.

A successful composition depends on a delicate balance. Nowadays, this is usually decided by a judgement of eye, but many artists in the past have used a formal underlying geometrical construction for their paintings, and a knowledge of the way such predetermined abstract designs have been devised can give useful insight into composition.

Artists and geometry

In the history of painting many pictures have been based on simple geometric designs. Artists divided the picture surface in ways similar to the experiments I was advocating earlier in the section on the painting

Ian Simpson, tracing from Pollaiuolo's *The Martyrdom of St Sebastian*

rectangle (see page 114), but rather than their picture divisions being a free form of composition, they were often quite rigidly geometrical. The composition of a painting might be based on an equilateral triangle, for example, with its base at the bottom of the picture and its point at the top. This geometric structure was devised first and then the realistic components of the picture were arranged later to suit the predetermined structure.

The illustration above shows a simple line drawing traced from a painting, which includes a number of figures. You can see that the painting is based on a triangular division of the picture, with the figures posed so that they conform to this symmetrical structure. This method of picture construction can be very effective and can provide a solid composition, but the objects have to be arranged to suit the predetermined design. Here, this would have been planned to help the picture tell its story. The painting in question is *The Martyrdom of St Sebastian* by Pollaiuolo and the saint is placed in the picture at the point of the triangle with the soldiers arranged along the sides leading up to him. The viewer's eyes follow these lines to the saint who, as the most important person in the story, is placed at the most significant point in the composition. There is a beautiful landscape in this painting but it is only small in scale and in the distant background. It is quite incidental to the story the painting tells. Once artists began to be more and more concerned with making their paintings mirror reality, predetermined geometrical designs such as this were not so useful, because they relied entirely on the subject being invented and arranged in a particular way.

Since the fifteenth century geometrical compositions have been in general use, particularly in paintings which include a number of figures. Usually such pictures were painted in 'the studio' and the subjects were invented rather than mirroring reality. Victorian painters, for example, who to a great extent revived the story-telling tradition of painting, made great use of geometrical compositions.

Ian Simpson, Landscape from a Summerhouse, **charcoal and acrylic drawing, 40 x 58 cm (16 x 23 in)**

Ian Simpson, Landscape from a Summerhouse, **acrylic on paper, 40 x 58 cm (16 x 23 in)**

However, these have not been used only by story-telling artists. Seurat, whom I have already labelled as a theorist, was not only a colour theorist; he also developed a formal type of composition. He placed particular emphasis on the precise positioning of horizontals and verticals, and on the proportion and relationships between the objects in his pictures and between these objects and the picture as a whole. The painting by Seurat on page 22 shows the careful way his landscapes were composed. As preparation for his paintings, he made numerous drawings and colour studies on the spot, from which he selected and modified those features which suited his theories of composition. The horizontal and vertical divisions of his paintings, which were so important to him, were based on the 'divine proportion' of the golden mean, or golden section, which has provided the underlying mathematical basis for many kinds of artefacts, including buildings, as well as paintings.

Seurat demonstrated that a formal type of composition could be used to give a structure to landscape painting. He started with a preconceived idea of the pictorial framework for his painting and then adjusted nature to suit. I believe that you can establish in your mind the kind of formal composition you want to paint and then actually find it in nature. You need to be selective and you will have to make adjustments, just as Seurat did, but these can still be made while preserving a feeling for the actual place. *Landscape from a Summerhouse* was painted on the spot, at a time when I was interested in compositions based on inter-related rectangles, and I saw in this subject a series of rectangles which were already there, waiting to be used. The right-hand side of the painting has square and rectangular divisions made by the trellis and the windows of the house behind, and the landscape on the left is framed by a large rectangular structure, partly hidden by foliage.

Keith Grant sees composition as trying to create a type of cubistic architecture to give his paintings a solid, sculptural feeling; he also has an interest in geology. He thinks that picture structure can be implicit, as in Turner, as well as more obviously geometrical, as in Cézanne.

The golden section

The formal compositions of many paintings, like those of Seurat, have been based on the golden section. This was believed by some artists to be a 'divine proportion' bringing art and nature into harmony. The golden section was first set out by Euclid in the third century BC and is defined as the division of a line into two parts, so that the ratio of the smaller part to the larger is equal to the ratio of the larger to the whole line. In the diagram below, the line AC has been divided in this way: the ratio of AB to BC (approximately 8:13) is equal to the ratio of BC to AC. A line has been extended vertically from B to divide the rectangle into two sections. A similar procedure has been used to divide the line CD, with a line extended horizontally from this point to divide the rectangle further. The sections within the rectangle can also be subdivided using the golden section and the lines and areas produced as a result can be used as the underlying grid of a painting.

The golden section

The golden section proportion was used extensively by Renaissance artists (and architects), but it is interesting to note that many paintings by other artists, when analysed, display this same proportion even though, so far as we know, the artists concerned did not use the golden section consciously. The golden section will not in itself ensure a good composition, but while it is not something I use deliberately when I paint, it seems important in achieving a dynamic balance in painting, particularly where there are strongly emphasized horizontals and verticals in a picture. Many landscapes have these features. One horizontal could be the horizon line itself and trees, for example, can make emphatic verticals which have to be placed in a picture with great care. If the golden section serves only to remind us of the care with which we must relate such features both to each other and to the picture as a whole, it will have proved itself a powerful factor in helping us to produce well-balanced compositions.

Landscape painters working today do not generally use an elaborate preconceived system of proportions for their paintings, but they may have, in their mind's eye, a kind of composition they are looking to find in the visual world. The golden section can be considered as a 'theory' about composition and as with the other theories we have considered in this book, it can be useful when things go wrong. If the main divisions of your painting do not seem right, check their proportions and see whether adjustments which bring them closer to the 'divine proportion' will solve the problem.

Rules of Composition

The fundamental rule of composition is that the picture surface should not be divided symmetrically. It would be easy to produce a balanced composition by echoing a line on the left side of a painting with an identical line, the same distance from the edge of the picture, on the right. This, however, would only produce a balance like that of a repeating pattern; pictures require a form of equilibrium which is much more subtle and complex than this. The balance must not be too apparent. As I said at the beginning of this chapter, a painting must first be arresting. The British art historian Kenneth Clark once said that the initial impact of a good painting was so noticeable that you could spot it, in a gallery window, if you were passing in a bus travelling at some speed. After this first encounter, the picture has to continue to offer the viewer information. Looking at a painting is rather like peeling the skin off an onion. Each layer reveals a new one.

ABOVE: **Ian Simpson**, A Garden from a Window, **oil on board, 61 x 51 cm (24 x 20 in)**

ABOVE RIGHT: **Ian Simpson**, A Landscape from a Swedish House, **acrylic on paper, 58 x 40 cm (23 x 16 in)**

For many years I worked near the National Gallery in London and sometimes at lunch time I would choose one painting to go and see. No matter how well I knew the particular painting it never ceased to reveal something new to me. In part, it is the composition of a painting that enables it to be of continuing interest, for in a well-composed picture the information is not presented in an obvious and predictable way.

The basic rule of composition – to avoid the obvious by not dividing the picture symmetrically – can be broken down into more specific rules for landscape painters, such as not placing the horizon in the centre of the picture and not positioning a tall tree so that it divides the painting into two equal parts. Similarly, sub-divisions of the picture should not be equal either. Placing a fence so that it runs horizontally across a painting, equally dividing the distance from the bottom edge of the picture to the horizon, can be a way of courting disaster.

There are no rules of composition that cannot be broken, however. If you look through the pictures in this book you will find some examples of symmetrical compositions – for example, *A Garden from a Window* and *A Landscape from a Swedish House*. The rules of composition, like all rules in painting, are something to be aware of and to respect, but following them does not ensure success. Even Pollaiuolo,

Andrew Waddington, *Starlings, Rose, Cornwall,* **1988, watercolour, pencil and gouache, 30 x 38 cm (12 x 15 in). There are virtually no vertical or horizontal lines in this painting. Everything seems to slope and move with a life of its own, and yet the whole picture feels to be in balance. Careful changes in direction, such as the palm tree leaning the opposite way to the greenhouse, help to retain the equilibrium. The playful anarchic activity of the animals' world is vividly portrayed through correspondingly unconventional composition**

working with his formal geometric plan, was careful to ensure that the figures in his painting of St Sebastian, while following his basic design, did not adhere to it too rigidly. It is the quality of judgement that is exercised in interpreting (or bending) the rules which determines the success of a picture. This is dependent on something I keep returning to: the ability which all artists strive to attain, that of getting things 'right'. This 'rightness', which has to be judged intuitively, is what decides the quality of a painting.

Three-dimensional Composition

In considering the formal and informal divisions of pictures so far in this chapter, I have put the emphasis on a two-dimensional structure. I have drawn attention to the pattern of shapes in painting, and shown how these can be balanced and made interesting. It is equally important, however, that

Raymond Spurrier, *Cretan Hillside I,* **1986, watercolour, 26 x 35 cm (10¼ x 14 in). This shows natural elements formalized into a more or less abstract composition in which design is more important than descriptive realism**

Ian Simpson, Delabole Quarry, drawing in pencil, ink and acrylic, 40 x 58 cm (16 x 23 in). This quarry provided a subject very similar to a coastal landscape. The simply treated foreground gives way to a more detailed treatment of the rock formations of the quarry with, beyond it, a green landscape. The painting has a feeling of space and drama

the painting is balanced in depth. The intervals of space between foreground, middle distance and background are just as important as the surface pattern. A knowledge of perspective and the spatial properties of colour can be very useful aids in creating an illusion of space which is composed in as careful and unpredictable a way as the picture's two-dimensional structure.

The importance of the three-dimensional organization of a painting should not be underestimated. It is one of the features which distinguishes painting from other kinds of representational art. The difference between a good landscape painting and the representation of a landscape in a poster or an illustration, is that the painting has to have greater depth, in both senses of the word. Whereas the poster and illustration are painted for easy comprehension, the painting must take the viewer into depth beyond the picture surface. This needs to be organized and controlled: you do not want the viewer's eyes to shoot up uncontrollably to the top left-hand corner of the picture, nor do you want them to zoom straight into the horizon. The dynamic three-dimensional forces of perspective and colour have to be balanced just as subtly as the two-dimensional forces.

Italian Renaissance painters sometimes planned their paintings using ground plans, on which the main objects in the composition were geometrically placed in a similar manner to the way the surface pattern was organized. Landscape painters have not, to the best of my knowledge, used maps of the areas they painted to help give their paintings a three-dimensional structure, but nevertheless the intervals leading into the pictorial space of a painting have to be considered just as carefully as the two-dimensional shapes. In a sense, you explore them as you paint, almost as if you were making a topographical survey.

Difficult compositions

Although interesting intervals of depth are essential to a well-balanced composition, there are some subjects which make this almost impossible. A typical example is a close-up view of the façade of a building. In experienced hands, it may be possible for the small intervals of depth – say, in the recession of doors and windows – to be used to offset the flat face of the building, but for most painters this kind of subject is almost certainly doomed to failure. It is very difficult to create an interesting composition in depth, even if a satisfactory arrangement of two-dimensional shapes can be selected.

Monet painted some twenty views of Rouen Cathedral, many of them of the main façade. However, this cathedral has a much greater variety of shapes and intervals of space than most buildings and Monet, in any case, was mainly concerned with painting the light patterns, which in his pictures seem to flicker just as if the sun were exploring the features of the building.

A landscape subject where the main interest is in the middle distance or background can be equally difficult. It is necessary to find a means of organizing the foreground so that the eye is led through unusual intervals of space into the picture.

Most subjects, approached thoughtfully, can be used to make a picture, but you need to be on your guard for problems such as those described above. It can be very demoralizing to struggle with a painting which offers little possibility of success.

I have referred to Olwyn Bowey already in this chapter. She always works on the spot and tackles the problems of composition by making a detailed drawing before she paints and then by delaying a decision on the final shape of her painting until it is well advanced. Olwyn Bowey drew my attention to the extracts from Ford Madox Brown's diary which I have quoted earlier (see page 53). His account of the perils of painting outdoors is verified by what Olwyn Bowey told me, but the interview with her reveals something which the other artists interviewed in this book have tended to minimize: the importance of the particular landscape itself.

PHOTO: IAN SIMPSON

Interview

Olwyn Bowey

'I look for something…geometry…a perspective that fascinates me, the colour, a certain set of things; it all falls into place.'

Olwyn Bowey always starts by making a drawing of her subject on the spot. If the drawing is promising it is likely that she will be able to make a successful painting from the same place. If she decides to make an oil painting she then transports her painting equipment, including several stretchers and a large radial easel, to the spot. This usually requires two trips. She deliberately leaves the drawing at home, for it has served its purpose and enabled her to see 'the bones' of the painting.

The first stage of the painting is to decide exactly what to include in it and what shape and size it will be. She is never sure when she starts whether the painting, which is initially perhaps 91 x 71 cm (36 x 28 in), will need to have a few centimetres added to the side or the bottom once she begins to draw in the subject. She takes out with her a piece of canvas larger than her stretcher and only loosely attached to it. She starts drawing in charcoal. When she is more sure of the size the painting will be she attaches the canvas roughly with a staple gun to an appropriately sized stretcher. She continues drawing and working out the painting, perhaps adding a bit to one side or another until it begins to take shape. Even then she may decide to take a few centimetres off one side. She carries on drawing and making these adjustments, finally applying thin washes of colour so that she gets an idea of how the finished painting might look. The composition of the painting is now established. At this point she takes the canvas home and stretches it properly.

That is how Olwyn Bowey spends a typical first day working on a painting. It might seem that the next day would be a more straightforward one, spent developing the painting, but it is often not at all like that. Sometimes when she goes back to her painting spot to continue the painting it 'goes all wrong'. She may find that if she moves her easel to a slightly different position the new view will be better, which means that adjustments have to be made to the picture. She is never sure whether the composition is absolutely right until the painting is well under way. Bowey says she hates both starting paintings and finishing them. At the beginning there is all the uncertainty of not knowing what will make a good painting and at the end often the sense of an opportunity missed.

She described working on what eventually turned out to be one of her best paintings. At one point, as she was painting, she thought that everything was changing so much in the landscape, that it had become too difficult to paint. 'In another fit of rage and self-pity, I ripped [the painting] off the stretcher and threw the bloody thing away.' In fact, she threw it on a bonfire in her garden, which she says her mother lights with great enthusiasm as soon as there is anything there to burn. On many occasions

LEFT: Sapling Trees, **pencil,**
35 x 46 cm (14 x 18 in)

BELOW: After the Storm, **1988,**
mixed media, 78 x 119 cm
(31 x 47 in)
(Royal Academy of Arts, London)

Bowey's rejected paintings have been burned before she could have second thoughts. In this instance, however, she retrieved it from the bonfire and later, when her rage had subsided, she looked at it again. She found that a corner looked 'quite possible'. She says that if she finds a tiny part which looks possible, she has another go. 'What else is there to do but try again?' she asks.

Bowey says she gets terribly depressed about painting. 'I think I can't do it . . . the subject is too difficult and impossible. I can't handle the paint. It gets out of control. But then I look at the subject. I think it's beautiful and if it looks all right, surely I can do it – that keeps me going.' She identifies as her greatest asset her ability to seize on something which will make a painting.

Formative Years

Bowey believes she is an artist purely by chance. 'I never thought I had a true interest in art,' she says. 'I felt I got into it by accident, because it was an opportunity at the time. I never felt I had an instinctive talent, which a lot of people have.' She concedes that other artists may have had the same doubts about their natural ability. At the age of seven she wanted to be a naturalist. If she had been brought up in West Sussex, where she now lives, instead of West Hartlepool, she might, she says, have written and illustrated the 'Nature and Garden Notes' in the *Petworth and Midhurst Observer*, her local newspaper. The idea of working as a journalist appeals to her – she is an enthusiastic letter writer.

West Hartlepool offered her no opportunity to pursue her first interest. She left school at fifteen, with no obvious way of indulging in her passion for wild flowers and collecting frog spawn, and it never occurred to her to do the things her school-mates were going to do, such as hairdressing or working in a shop. She didn't know how to be a naturalist. She feels that if she'd studied biology, things might have been different. If she'd been born in Sussex she might even have found a job as a horticulturalist.

Instead she went to the small art school in West Hartlepool. She had an ability from the beginning, which she recognized and which she feels has sustained her as an artist. She discovered she was good at finding subjects which would make pictures, and which were more original than those of the other students. But although she had a talent for choosing subjects she had little skill, she judges, for painting them, compared with her fellow students at West Hartlepool and at the Royal College of Art, where she started in 1955 and where she feels she belonged to a year of outstanding students.

Attitudes to Painting

She says she doesn't really know how to paint and works almost literally with her fingers crossed. She finds painting difficult. It requires a superhuman effort and if whatever it is that guides her (an imaginary Svengali-like figure) were to collapse, then she feels she would be finished. It is hard to imagine this happening, however. In spite of her anxiety she paints almost every day and feels irritable if she isn't working. On a more confident note she also acknowledges that she has done better than many others at art school with more talent than her. Painting, which she calls her 'job', has given her a freedom and a way of life she would not wish to change and she is now dedicated to it.

Bowey is absolutely certain about what is important to her as an artist. It is the subject itself. 'I look for it very carefully,' she says. 'I wander around and look . . . a great panoramic landscape looks beautiful at a certain time of day . . . I say, that's wonderful, but I couldn't make a picture out of it. It's beyond

RIGHT: Coultershaw Mill, **oil on canvas, 101 x 127 cm (40 x 50 in)**

Rowner Mill, **oil on canvas, 63 x 76 cm (25 x 30 in)**

me, so I look for something . . . geometry . . . a perspective that fascinates me, the colour, a certain set of things; it all falls into place. It could be a stile, an old railway line, something beyond that and something beyond that. All the components are there. I think, I can make something out of this.' She says that if someone were to go to a place where she had painted they would easily be able to recognize the view in her painting. 'I understand only what I see,' she says. 'I am incapable of making anything up.' She has become good at placing herself, she says, so that her subjects are interesting and avoid being commonplace.

Working Methods

Some years ago, when she lived in London, Bowey used to work from drawings, mainly because she disliked painting in public, but now she always paints from direct observation. She has never liked being observed. As a student she didn't like painting with other students in the life room and now she is happiest painting outside during the week when there is seldom anyone around to see her. She paints outdoors all the year round. A typical working day would be from about 9 a.m. to 4 p.m. She always works standing, and although she finds this tiring, together with the concentration demanded, she works for as long as the elements allow. If the sun is bright the light changes so much that her painting time may be restricted to half a day, but sometimes she gets one of those 'calm days with a constant light', when it's bright but the sun isn't out. These for her are perfect days. In the winter she wears thick socks, Wellington boots and gloves, and she paints until her fingers are too numb to hold the brush. When she finds it impossible to go out (which isn't often) she paints still lifes – 'everything I like I gather round me'. Occasionally she paints from the windows of the cottage where she lives.

When she isn't painting, she is worrying about it. She might take out a sketchbook and find something she thinks will be a good subject for a painting, and

she is then able to enjoy thinking about it. She is nevertheless nervous about returning to start the painting. Sometimes she paints in oils and sometimes in mixed media, a combination of watercolours, gouache and soft pastels. The subject determines the medium for her. If it's complicated – an area overgrown with grasses, tangled plants and shrubs, maybe, or a big bramble bush – then she uses oils, which allow flexibility and can be altered. Subjects requiring more precise drawing and perhaps including architecture are painted using mixed media. For these Bowey usually works on half imperial (39 x 57 cm) or double elephant size (102 x 68 cm) heavy watercolour paper, which is dry-mounted on thick card. She starts in watercolour but this medium is used only to make an underpainting. She says she is not fond of the Great British watercolour tradition, which she describes as being 'beautiful in its own way' but which does not allow her to make things 'rich and lovely'. She achieves this by building up layers of colour, first in gouache painted over the watercolour, and then in pastel. She is enthusiastic about the range of colours available in pastels, saying that 'there is a pastel for every kind of colour'. Sometimes a well-advanced mixed-media painting is washed off and she starts again.

When she paints in oils she always uses the same range of colours, mostly earth colours, for each painting. She is still looking for the perfect green to add to them. She rarely uses blue, frequently choosing Payne's grey for skies. She also makes great use of sepia, a colour she has discovered recently. 'Black doesn't come into nature,' she says, and she only uses it to mix a particular dark green. Sap green and charcoal grey, together with sepia, are used for mixing most dark tones.

Her oil paintings usually have 91 cm (36 in) or 122 cm (48 in) as their longer dimension. A painting measuring 127 x 101 cm (50 x 40 in) is the largest she feels able to cope with outside. She can't find subjects to paint on a small scale, although she says she likes other artists' small paintings.

Subjects for Painting

Bowey likes to have had long familiarity with the subjects she paints. She never paints if she goes away from home, although she might make drawings and discover a particular view which she feels,

LEFT: Cows Returning to Pasture, **1986, gouache and pastel, approx. 56 x 76 cm (22 x 30 in)**

Overgrown Greenhouse, **1988, oil on canvas, approx. 91 x 91 cm (36 x 36 in)**

on longer acquaintance, could have made a painting. She never paints landscapes from photographs either, describing them as having no relation to what she has seen. The only things added to her landscape paintings back in the studio are occasionally animals or perhaps a small figure. Even these are often painted on the spot and she sometimes takes carrots out with her to attract an animal she needs as a model. Usually she adds cats, dogs and human figures from drawings, and sometimes figures are taken from magazines.

I mentioned earlier a start to one of Bowey's paintings when things did not go as she had hoped. After her nervousness about making a start, and the first day spent working out the composition, her paintings generally proceed more smoothly. She described one of those occasions: 'I think that it is going to be all right,' she said. 'I get 15 cm (6 in) right. I think if only I could take that across the whole picture I might get near to the great Constable *Haywain*, but I never can carry it through.'

Recently Bowey has found a marvellous new subject – some dilapidated greenhouses attached to a grand country house, West Dean, which is now a college. The greenhouses offer a subject which is part interior and part landscape; painting there is half-way between painting outside and painting in a studio. Bowey says this subject has revived for her an internal debate as to whether painting outside is preferable to studio painting. Working outdoors, she says, never leaves you relaxed, but in the greenhouses she can work more slowly and she wonders whether in contrast her landscapes painted outdoors are 'too sketchy, due to the elements'. She also wonders whether perhaps the only way to paint landscapes on the grand scale is in the studio from sketches, like Constable. Painting the greenhouses, she feels, is almost like painting a landscape indoors.

'I am fascinated by the picture plane,' she says, 'just like any abstract artist, and fascinated by the geometry of the subject, which holds it together.' Her reference to abstract painting prompted some observations on a period in art which she feels has now passed. She says that she was never involved in Modernism in the way that some artists, particularly those in education, had to be, and she couldn't imagine being stuck in a studio trying to make paintings which had no external reference. She could never, she says, have rejected 'that wonderful power of feeling you can describe something with pencil. Fancy not being able to go out and see a fantastic overgrown greenhouse.'

Laurence Wood, Moorgreen Colliery, Eastwood, 1985, watercolour and ink, 46 x 56 cm (18 x 22 in). Buildings age and weather just like the landscape they exist in, especially industrial ones. This colliery is set into the surrounding hills and spoil heaps almost as if it is a 'natural' feature

FAR RIGHT: Raymond Spurrier, Stogumber, 1980, watercolour, 27.5 x 37 cm (10¾ x 14½ in). Here a few elements in an English village are simplified and arranged with the aid of distant hills and sloping fields into a composition which suggests a sense of enclosed space

FOCUS

Painting Buildings

Even in the most remote areas we come across man-made features in the landscape. These can be obtrusive, but they can also provide extremely varied subjects for the landscape painter. They can be utilized simply to create a sense of scale in a picture or to provide a particular focal point of interest. An artist might be inspired either by the way a building blends into its environment or by the clash between man-made and organic forms.

Andrew Waddington, Crows in the Valley, 1988, watercolour and pencil, 30 x 38 cm (12 x 15 in). Buildings can present an interesting contrast between man-made and 'natural' shapes. In this quirky, colourful painting the regular architectural shapes seem to jostle for position with the curved rhythms of the wooded valley

RIGHT: Edward Chell, River Tyne, 1985, oil on canvas, 152 x 213 cm (60 x 84 in). The complex matrix of forms and lines evident in a modern city provides stimulating subject matter. Here the artist conveys all the noise and clatter of an urban panorama with sweeping gestural brush strokes

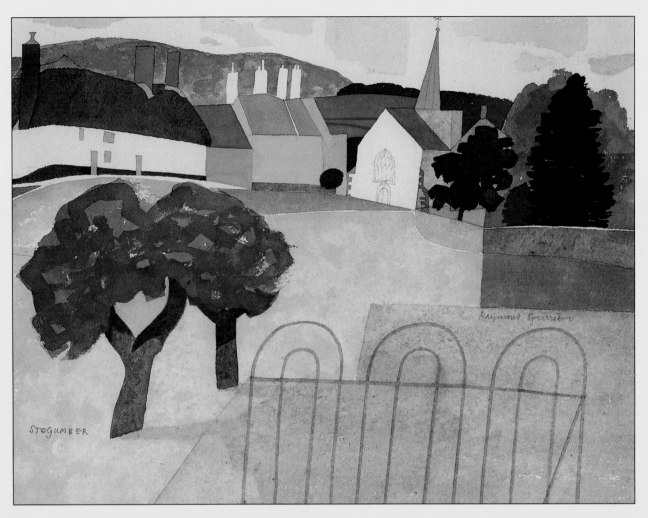

'...almost everything, if one keeps one's eyes open, is potential material for painting.'
(Graham Sutherland, 1962)

Chapter 7

Translating What We See

In considering the problems of re-creating the solidity of objects and a feeling of space in landscape painting, I have stressed the significance of 'looking'. To me this is all-important, but I hope that when I use the word in this context you will already appreciate that what I mean by it is a combination of seeing, feeling and analysing, which is only possible when we are operating on a plane of visual awareness very different from the one we use in our everyday lives. On this higher plane, we find that we can see the landscape in thousands of different ways and from all these alternatives we have to select a way that is personal. There are equally thousands of ways in which we can translate what we see into paint and in this chapter I will be considering some of these.

George Rowlett, Cornfield, Wet Evening, **1988, oil on canvas, 30 x 40 cm (12 x 16 in). Here the artist has produced a bold statement that goes beyond the purely visual experience of the landscape. The subject is simplified into major shapes and planes. Colour's expressive potential becomes the prime element in the artist's translation of his response to this subject**

The Visual Language of Art

The word 'translation' implies that there must also be a 'language' and the visual language of painting is one which, like our verbal language, is being constantly changed and extended. While the conventions, or pictorial codes, which constitute a visual language change and develop, there has nevertheless usually been at any one time in history a consensus amongst artists about which visual code to adopt. If we had been painting in Italy during the fifteenth century we would have constructed our paintings using linear perspective and have planned the composition with the help of the golden section. The style of representation in our paintings would equally have been dependent on the conventions of the day and we would have belonged to a united group of artists, intent on creating a new art which would be more faithful to nature than had ever been seen before.

Particularly during the twentieth century, there have been no universal conventions for artists to follow. There have been groups of artists working in similar ways and international movements like Modernism, which I mentioned in Chapter 2, but in general, diversity and non-conformity have flourished. Landscape painters now have an unlimited number of visual conventions from which to select those that will best present their version of visual truth. Nowadays there is no prescribed way to paint and so artists must take visual language systems from the past and adapt these to develop their own visual language.

It has been a popular belief in art education in the last twenty years that a personal visual language could somehow be developed independently of history. Students have been considered as artists already and encouraged to believe that they should find what they have to say and that they will then automatically discover a means of saying it. Yet finding what to say in part comes from having a means of communication. The past can be both a hindrance and a help but we cannot ignore it no matter how we try. The visual conventions of the past have to be used selectively and need to be modified in order both to help us to see and to help us to translate our visual experience.

For most of this century the visual language of painting has developed at a great pace and in many different directions. We have been bombarded by images from television, film, photography, advertising, books and magazines, and some artists have developed highly personal visual languages which are incomprehensible to all but a few. Nevertheless, most developments in the visual language of art, however radical they may seem at the time, become

RIGHT: **Laurence Wood,** Blossom, **1986, oil on canvas, 122 x 152 cm (48 x 60 in).** This painting is based upon a number of studies made at the site of a disused coal mine. The painter has explored the subject of regeneration in the landscape, contrasting the redundant, industrial piping with the living blossom

BELOW: **Paul Nash,** Battle of Britain, **1941, oil on canvas, 122 x 182 cm (48 x 72 in)** (Imperial War Museum, London)

BELOW LEFT: **Sally Hargreaves,** Black Peat Field, **1985, acrylic, 101 x 152 cm (40 x 60 in).** Here the artist has observed and then revealed to us the beautiful simplicity of a large fertile field. She has translated the subject's two-dimensional qualities into a subtle tension between the shape of the large field and the edges of the rectangular canvas. The landscape may be only a starting point for a painting like this: shapes, colours and textures become the subject themselves

absorbed into the language and are used subconsciously by many artists afterwards.

Recent developments in technology have not only created new kinds of visual images but also enabled us to see the landscape in a new way. Derek Hyatt has referred to the way travelling at speed by car has changed our perception of landscape, and a picture such as Paul Nash's *Battle of Britain*, with its aerial view of the Thames, could not have been painted before the invention of the aeroplane.

Translating Visual Experiences

For the contemporary landscape painter there are, therefore, many systems of communication to choose from and a bewildering number of ways in which it is possible, for example, to paint a tree. Trees are very important components of many landscape paintings and it will be helpful to look at the variety of ways that trees have been painted in the illustrations in this book. A tree at the height of summer is a mass of thousands of leaves. It would be possible, but tedious, to try to paint it leaf by leaf, but it is unlikely that the result would turn out to be a successful translation of your visual experience.

The painter Joshua Reynolds (1723–92), who was the first President of the Royal Academy, stated in one of his famous Discourses that complex objects were not best re-created in painting by including masses of detail. He explained that 'the general effect', presented 'by a skilful hand', expressed the object 'in a more lively manner than the minutest resemblance would do'. Derek Hyatt refers to the practice of putting in excessive detail as 'covering up' and obscuring the object. He maintains that when we look at things we don't see them in detail because we are so used to moving about quickly and absorbing visual information at high speed.

If the leaf by leaf approach to painting a tree is rejected, we then have the problem of producing a shape for the whole tree, one which suggests its complexity and which also gives a feeling of the tree's solidity. A child who paints a symbol for a tree, rather than a translation of something seen, reduces the tree to a green 'lollipop', and our efforts to produce something more descriptive can easily lead to an abstraction which results in a cut-out effect, as if the tree were taken from a stage set. With all organic forms such as shrubs, plants and flowers a sense of their three-dimensional quality is essential. It is important to remember that a clump of foliage and a bush or a plant are basically simple rounded forms, even though they may not be solid and are in fact made up of thousands of leaves.

In the painting on page 19, John Sell Cotman carefully observed the shapes made by clusters of leaves and noted how these overlapped and related to the tree's overall silhouette. He avoided hard, cut-out edges and made certain that the tone of his trees related to the sky, thereby preventing the

ABOVE LEFT: **Trevor Burgess,** Great Yarmouth I, **1986, oil on canvas, 66 x 76 cm (26 x 30 in). Although this painting provides considerable detail of a particular place, especially along the horizon, the detail is never allowed to dominate. Physical detail is incidental to the real subject, which is the quality of light and the beautiful fresh and airy atmosphere it produces**

LEFT: **Ian Simpson,** Bathers at Getterön, **acrylic on paper, 40 x 58 cm (16 x 23 in). This was painted on the spot on a warm but particularly windy day. The angle of the little boat in the background and the swell of the sea in the nearest bay give an indication of the movement of the sea. The paint has been used freely and thinly, giving a feeling of the blustery wind**

stage-set appearance. He carefully overlaid simple patterns of foliage, which were used to give the tree a sense of three dimensions and also to suggest the texture by its leaf clusters.

Cotman's approach was to see and translate the landscape in a rather detached way. The process of selection and abstraction which he used doesn't look unfamiliar to us now, but it was a development of the visual language of art which was not wholly acceptable at the time Cotman was painting. His system of translating trees was unkindly described as his 'bunches of bananas' technique, but more accurately and sympathetically his trees have also been called 'enchanting bath sponges'.

It is interesting to compare Cotman's 'bath sponges' with the swirling, agitated marks with which van Gogh describes the trees in *Landscape near Montmajour* (see page 23). Van Gogh's approach is not that of the detached observer. His paintings are full of passion and his obsession with the emotional effects of colour is emphasized by his gestural painting technique in which the paint was applied to the canvas using energetic jabs of the brush. This drawing has been jabbed and dotted with his pen in a similar way, so that one senses his visual excitement by the way he has translated this visual experience.

Different Interpretations

Trees are extremely difficult to paint. Roger de Grey reminded us earlier that Constable had problems with them, and told us how he himself sometimes found it hard to make his trees look

Mary Fox, Baths of Aphrodite, Cyprus, 1988, oil on canvas, 91 x 71 cm (36 x 28 in). Shrubs, plants and flowers provide inexhaustible variations of colour and form, and do not always have to be relegated to playing the supporting rôle in landscape painting. Here the exotic shapes and vivid colours of Mediterranean foliage fill the canvas to bursting point

Ian Simpson, *Suffolk Landscape*, 1988, oil on board, 91 x 76 cm (36 x 30 in). This painting was made after the hurricane in Britain in 1987. It features the angular shapes and forms of trees after their upheaval and has a feeling of things having been twisted and disjointed

rooted convincingly to the ground. De Grey likened the way a tree stands to the way a standing figure balances itself.

These different ways of seeing a tree – as a shape, as life and growth, or as a balanced standing form – demonstrate again that there are two broadly different approaches to painting what we see. One way is as a detached observer, like Constable, Cotman and de Grey, reconstructing nature as they see it 'through the glass of art'; the other way is as a passionate observer, like Van Gogh painting his obsessive visual excitement.

Whether you paint the landscape as a detached or passionate observer, however, a tree still has to be seen as a *particular* tree. Painting a tree as a generalized shape, for example, may be perfectly suitable as an illustration for a book on tree identification but it is not specific enough for landscape painting. Roger de Grey compared trees with human beings; like people, trees have an individuality which makes each one completely different. You can search out the personality of a tree and find a way of translating it, or you can discover a means of translating your unique response to a particular tree. However, these are not the only possible alternatives. There are limitless combinations of objectivity and emotional responsiveness which can be used to express each artist's personality.

I have used trees as examples so that I could illustrate some different ways in which the visual experience can be translated. From this you may be led into thinking that I see landscape painting as a number of elements which are painted separately and then put together to make a complete picture, but this is not the case. Searching for the personality of a tree or expressing your feelings about it must not be at the expense of the picture as a whole.

If I were actually painting a tree, I would consider it from the start in relation to the rest of the painting. The way the tree is painted, its colour, and the degree of emphasis to be placed on it would depend on its relationship to the total picture. The trees in Victor Pasmore's *The Park* must have been totally integrated into the picture from the moment he started painting. Pasmore has reduced the trees to simple shapes and textures. He has used the same treatment for the ground, which is broken by a simple pattern of paths, and the foreground is textured in a similar way to the clusters of foliage in the trees. This picture was painted in the transitional stage between Pasmore's period of representational painting and his later work as an abstract painter. In this painting Pasmore is less interested in the trees themselves than in their potential as abstract shapes, but nevertheless the trees are well observed and each has its own distinctive shape and character.

RIGHT: **Victor Pasmore**, The Park, 1947, oil on canvas, 109 x 78 cm (43 x 31 in)

Skies

Skies are often a most important feature in land-scape painting and can give pictures atmosphere and mood. This is particularly so where the ground plane is relatively flat and the horizon low. Cloudy skies pose special problems of seeing and trans-lation. There are many types of cloud formations and different kinds of skies, and they change con-stantly as you try to paint them. It helps to remember that the sky has similar features to the ground. It isn't simply a flat backdrop against which objects are silhouetted, but is something which recedes from above your head until it appears to meet the ground at the horizon.

The problem of painting skies is similar to that of painting the sea or anything else which is in motion. Skies demand keen observation if you are to capture their particular shapes and forms. It is often useful to make rapid drawings as well as colour studies so that these can be used as references for your painting once the sky has changed.

Visual Conventions

Ernst Gombrich, in his book *Art and Illusion*, uses the word 'schemata' to describe the visual con-ventions that artists have used to translate what they see into appropriate images. It can be very difficult, in practice, to arrive at the schemata which satisfy you. Looking at how other artists have dealt with a particular problem is a useful means of stimulating your own ideas, but in my view learning through trial and error, in direct contact with the subject, is just as important.

Many great artists have adopted the schemata of a mentor. Turner, as we have seen, studied Claude, while Monet and Pissarro studied Turner. The use of other artists' work in this way should not be confused with superficial copying. The intention is not to imitate their paintings but to find out the artists' approaches and the visual language on which their schemata are based. By using this knowledge selectively when you paint, your own visual vocabu-lary will gradually emerge. Some of the information from other artists' languages will help, while some may be a hindrance; you will have to decide for yourself what is of assistance to you and what you should discard.

When our paintings go wrong there is a tendency to think that our technical skill is at fault. We believe that either our inability to draw the subject has produced the problem, or that the cause is a lack of technical skill in painting. Whatever the medium, the technical skill required to manipulate it is not very great, although of course you need practice to achieve a degree of fluency. So far as drawing is concerned, however, it is generally our inability to see clearly that is the problem, rather than a lack of drawing skill. I believe that you can draw anything you *really* see. The drawing you make may not necessarily be particularly elegant, but if you have really observed the subject you will be able to make a statement describing your visual experience even if the result is crude and is created entirely by trial and error.

Painting, I believe, relies in a similar way on seeing clearly. If you have developed a particular approach to landscape painting, this will turn your attention to those things in the landscape which you need to include in your painting. Having said that, it is true that there are many artists who work by trying different alternatives and by changing their painting until it looks right. This method can be equally successful.

If something won't go right in a painting the solution is to return to the original subject and try to see with greater clarity what you are aiming to re-create in paint. Sometimes in these circumstances it can be helpful to put down your brushes and, instead of struggling with paint, make a separate drawing of the subject. You might, for example, make a charcoal or pencil drawing which helps you to rediscover what interested you in the subject and enables you to re-establish the significant elements in the landscape which you want to re-create in your painting.

Although this chapter has focused on particular landscape forms and features, I must emphasize that you cannot naturally do this when you start to work on a painting. Then, all the forms and features have to be considered simultaneously and they must all work in the context of the painting as a whole. I must also underline the fact that the basic problems of painting are the same whatever the subject may be. There are no special techniques for painting trees or clouds, for example, just as there is no predetermined way to paint the human figure. Land-scape painters develop their own personal ways of seeing but they do not approach each feature of the landscape differently.

Norman Adams, whose interview follows, has de-veloped a distinctive personal visual language which seems to relate closely to his verbal descriptions of his subjects. He describes 'the explosive effect' of the sun and 'chinkling water like broken glass' and these images are very effectively translated into paint in his pictures.

Andrew Waddington, Pigs
Get Longer and Longer, 1988,
watercolour, ink, pencil
and gouache, 38 x 25 cm
(15 x 10 in). For this artist the
'landscape' is not a subject
that we are meant to observe
or analyse with detachment.
He is more concerned with
the antics of life going on
amidst it. Lively, almost
cartoon-like schemata
introduce a note of humour,
an element often ignored
by landscape artists

Interview

Norman Adams

PHOTO: MARTIN CHARLES
(REPRODUCED FROM
R.A. MAGAZINE)

'I am not interested in the landscape in the topographical sense. I am only interested in painting one's feelings…'

Norman Adams paints landscapes in watercolour. Most of his recent landscapes have been painted in the South of France, in Provence. He was inspired to go there after re-reading van Gogh's letters, which Adams describes as being 'so marvellously, so powerfully, so passionately' written that he desperately wanted to try to discover the places van Gogh mentioned.

Adams vividly describes his Provençal experiences. He feels that the countryside, buzzing with insect life, is like a kind of city. He is 'tremendously excited, just sitting in a field, feeling the effect of the sun, enjoying the life, even the insect life; it all comes into it as far as I am concerned. It's part of the landscape . . . On a cool, overcast day it's totally different. Then the sun comes out, everything starts to move, jumping into your water bottle, existing, being part of this great city in miniature.'

Adams' awareness of the sun's energy, of its powerful, life-giving force, is why he finds landscape so stimulating. He describes the subject itself as 'important but not as a portrait subject'. What is most important for him is 'the place – sitting on a hillside on a sultry evening; to see the sun going down, to see it descending into a tree – the explosive effect. All these things, which are so visual, are terribly exciting.' Adams says that the sense of distance experienced outdoors is very important, to 'actually feel space' and 'to see in landscape how solid masses disintegrate into texture'. Part of this excitement is that all kinds of things come into his mind; abstract thoughts and ideas are generated, which can't happen in the restricted cell of the studio. The landscape is so full of variety and inspiration. The enclosed 'womb-like' feeling of crouching down under great towering trees is just as stimulating as the vast space of a hill-top view with a distant pattern of fields.

'I am not interested in the landscape in the topographical sense,' Adams explains. 'I am only interested in painting one's feelings, strong feelings, passionate feelings. One paints in order to try to understand a bit about life and about oneself.' However, he thinks the actual places he has painted could possibly be identified, for the paintings sometimes contain some specific references to the place even though these are not important to him.

Working Methods

When painting out-of-doors he does not take an easel. He carries a stool but says this is soon discarded as he works on the ground, sometimes on two paintings at a time but often three or

Study at Provence, **1983,**
watercolour, 28 x 33 cm
(11 x 13 in)

Cherry Orchard, Evening, **1983,**
watercolour, 28 x 33 cm
(11 x 13 in)

four. His working method requires the watercolour to dry at interim stages in the development of the painting and so he moves from one painting to another while this drying takes place. He goes out day after day to the same place, starting early in the morning and staying until sunset. Four, five, even six watercolours might be completed in a day, but sometimes he will return to the landscape and continue a painting which was started on a previous day and which he now feels is incomplete.

Earth Mother and the Stars,
**1987, oil on canvas,
180 x 182 cm (71 x 72 in)**
(Royal Academy of Arts, London)

Field of Sunflowers, **1984, oil on
canvas, 117 x 137 cm
(46 x 54 in)**

He doesn't need to discard many paintings although he feels his view of his work sometimes changes once he has left the heat and biting insects and returned to the quiet of his base. When painting he is 'always working on the edge . . . never quite sure it's going to work . . . trying things'.

Adams does not think of himself as a landscape painter and his landscapes in watercolour are only one part of his work. He describes himself as a religious painter, though he is not conventionally religious, and as well as his religious pictures he also paints still lifes, usually with flowers. The landscapes are intended, at least in part, to help the larger religious pictures which he paints in his studio. As he works there, the landscapes are displayed all around him on the walls. The religious pictures, which are sometimes painted in watercolour and sometimes in oils, may not have obviously religious subjects. For example, Adams thinks of a field of sunflowers as a mystical and compassionate subject.

Sometimes a religious painting is largely based on a landscape experience. One of Adams' biggest paintings, *A Soul's Journey*, was painted after the death of two close friends, one himself a landscape painter. The painting was conceived as the ascension of a dying man's soul from the body to an infinite

A Soul's Journey, **1988, oil on
canvas, 335 x 244 cm
(132 x 96 in)**
(Royal Academy of Arts, London)

vision of life. Adams had started the painting before a visit to France, but the sight of a little stream there made him completely change the painting on his return. The stream, Adams says, could have been in Wales; the place was nothing like the usual Provençal landscape. The sunlight filtered through the trees onto soggy green vegetation. A little stream flowed down the hill-side and at the bottom there was 'chinkling water, like broken glass, like stained glass windows, like bits of glitter' as it 'trickles, wriggling lines of bright colours.' This stream runs right through the middle of *A Soul's Journey*, sometimes sharply in forms with clean, hard lines, at other times out of focus. The same stream has appeared in several other paintings as well.

Adams believes that an artist should study nature because in this way it may be possible to discover something of the divine. This study of nature is very important for his own work and he explains that the only way he knows to discover form is 'in nature, through looking'. He is fascinated by the epic themes of redemption and resurrection, but he finds them as much reflected in the landscape as in the literature of Christianity.

143

Adams recalled another visual experience similar to the 'stream of life' and one which had equal impact. He used to paint in the Hebrides and had a crofter's cottage right by the sea. There were many misty wet days with a turquoise sea and muted colours; but there was almost every day a rainbow, 'its primary colours shrieking through' like the stream of life.

Adams has a large studio at the Royal Academy in London and an even larger one at his permanent home in Yorkshire. He makes paintings from subjects in his garden there, but rarely paints the views from his studio, which looks out over a valley. However, he has a good view from his studio window of crows and gulls. He finds their black and white contrast inspiring and these birds often feature in his paintings.

He never paints in oils outside, only in his studio. Mostly he makes his own paint, grinding up the pigment with a little oil, usually to a fairly dry consistency. Sometimes the paint looks as if it has been mixed with sand, as he varies the degree to which the pigment is ground.

Although a Londoner, Adams has had his home in Yorkshire for thirty-two years and has taught in the North for many years. When he first went to live in Yorkshire and was more interested in painting the northern landscape, the severity of its dark, sombre greens led him to use a very austere palette, which he has since extended. He uses roughly the same wide range of colours in watercolour and oil painting but does not have all his colours on the palette at the same time. He keeps his low-key colours and high-key colours separate.

The Importance of Composition

Adams is a very experienced teacher but almost all his teaching has been with post-graduate students, which allows for more of a person-to-person discussion rather than a master–pupil relationship. He is, he thinks, infinitely more severe in his criticism of his own work than he is of work by the students, to whom he feels he is rather kind. He finds talking to students about composition more effective than anything else. He describes composition as his major obsession in painting and also in music, with which he draws parallels. 'Painting things together, creating rhythms and movements, composing in depth,' are concerns which he spends a great deal of time working out in his studio. These abstract problems are tackled directly on the canvas. 'I don't want the distraction of nature,' he says, 'but I have my watercolours all around me when I'm

doing it.' He feels you have to invent your own kinds of composition and that any rules are of little use. You can do anything, he maintains, and you can develop your own systems and methods. All that a systematic method ever does, Adams argues, is to give you more confidence in your 'hunch'. It makes you feel you have your feet on the ground and are 'not absolutely in space'. He sees composition as 'contrary directions . . . a dialogue, a kind of discussion. A kind of balance but not necessarily a harmony. It must mean something.' Adams insists that you can't ignore your intuition and sensitivity. Composition is about 'unusual relationships, ways of pushing the emotional force to the limit, without going over it'. He regards composition as related to abstraction, but he is not interested in painting abstract pictures, despite the fact that he considers his work to be on the edge of abstract painting.

Drawing and Interpretation

He spends a good deal of time drawing, but his drawings are almost never framed or exhibited. They are a back-up to his paintings. Taste and proportions, he believes, come into drawing. 'It's a matter of character why one shape is not like another.' He described drawing a view down a street which was exciting and unusual: 'You draw it. It's not a bit like it seems – you've got it all wrong – little bits of measurement here and there are out of character. It's not always a matter of accuracy, although sometimes it is.' You can draw a figure, Adams says, with the head too big so that it looks ridiculous, but a Gothic figure can be all out of

LEFT: Hebridean Landscape,
**c. 1975, watercolour, 28 x 33 cm
(11 x 13 in)**

Christ's Cross and Adam's Tree,
**1989, oil on canvas,
124 x 150 cm (49 x 59 in)**
(Royal Academy of Arts, London)

proportion and yet look marvellous – the same kind of distortion can look like Mickey Mouse or like God the Father. Adams used also to draw in the life room but doesn't any longer, as he feels it wouldn't relate to anything in his painting and would be artificial.

Adams thinks the ways in which artists can interpret the landscape are limitless, not only because of the great variety of possible landscape experiences but because the experience of other artists can be drawn on as well. When young he was inspired by van Gogh. Recently his interest has been renewed, as mentioned earlier, and he feels he enjoys him much more. He has always thought the work of James Ensor (1860–1949), Constant Permeke (1886–1952) and the Belgian Expressionists wonderful and he loves the work of Emil Nolde, particularly his watercolours. 'Soaking in those late Turners', in the Clore Galleries at the Tate, also influenced Adams and inspired him to rush to work outdoors. Provence, where he paints, is always associated with the landscapes of Cézanne but Adams has mixed feelings about him. He feels he isn't close to him and he has never been able to learn from him, which is the reason for preferring the work of some artists to others.

Adams admires Graham Sutherland. He considers him an Expressionist and one who is very under-rated. He particularly likes his religious paintings and the earlier landscapes such as *Entrance to Lane* in the Tate Gallery. He feels Sutherland gets a very poor showing compared with Francis Bacon, for example, whom he thinks is over-rated. Adams is 'anti most of the stuff from America' and says that rather than being influenced by American art Britain should have had closer artistic links with Europe and formed an Art Common Market before the EEC was set up.

Although, as we have seen, Adams does not consider his work abstract, neither is it figurative. He feels that making this distinction is a red herring. He knows what he wants to do as a painter, though his pictures don't always turn out as he initially envisaged them. They are, he says, based on something he sees, interpreted in a form which moves towards abstraction, but a painting loses its roots at its peril. When he was appointed Professor of Fine Art at Newcastle University, his inaugural lecture was about the idea that some artists have of working towards a picture that sums up their whole life – a single picture to put on the walls in Heaven. He used van Gogh and Gauguin as examples of such artists and this idea of the ultimate painting is one which appears to intrigue Adams.

He feels that he is 'not desperately confident' and that however many successes you have had in the past, if your present painting is a disaster, then the whole world's a disaster. On these occasions when depression strikes, he considers it most important to continue working. Painting is, Adams says, a 'terrible masochism and a tremendous privilege.'

145

Focus

Painting Trees

Very few artists try to record every leaf or tiny branch of a tree as this so easily produces a tedious, lifeless image. Trees are three-dimensional living forms, not flat 'cut-outs'. It is far better to explore overall proportions, shapes and masses and to exploit rhythms, colours, textures or movement.

ABOVE: **Laurence Wood**, *Still Night*, 1987, **watercolour, 76 x 91 cm (30 x 36 in). In this painting a strong back light throws the trees into dark, silhouetted shapes, interpreted with calligraphic brushwork. Flecks of light on the glossy summer leaves were created by scratching through the watercolour with a scalpel**

ABOVE RIGHT: **Laurence Wood**, *Oak*, 1988, **watercolour, 43 x 51 cm (17 x 20 in). Trees become exciting 'colour subjects' as the seasons change. Bold watercolour washes, ignoring details, capture the progression from summer to autumn foliage in this painting**

RIGHT: **Laurence Wood**, *Trees, Summer*, 1987, **watercolour, 46 x 56 cm (18 x 22 in). This rapid, on-the-spot painting was made at the height of summer. To re-create the feeling of light breaking through the translucent canopy of leaves, washes were applied thinly and areas of white paper were left unpainted**

146

Ian Simpson, Cumbrian Landscape, **oil on board, 51 x 61cm (20 x 24 in)**. This was painted in one long session, with the paint applied directly to a white ground. Particular emphasis was placed on the pattern of the branches against the sky and the foliage. The latter was painted in clusters in some places but assembled from individual leaves in others

BELOW: Ian Simpson, Winter Landscape, **watercolour, 40 x 58 cm (16 x 23 in)**. This picture was painted from a window, with the paper kept constantly wet so that the soft colours and blurred shapes of the landscape could be translated into simple washes of colour. The painting has been given vitality and a feeling of recession by the use of occasional sharp accents which describe the construction of the trees or shrubs and their location on the ground plane

'The Sun is God.'
(J. M. W. Turner, 1851)

Chapter 8

Depicting Atmosphere and Weather

A sense of atmosphere can be the most personal and important aspect of a picture. Painting as a means of expression can convey the feeling for a particular place or a particular kind of day in a way that is impossible in words. The manner in which this feeling is described can also reveal a great deal about the artist. Some artists in this century have tried to deny their own particular ways of applying paint and have attempted to make statements which were more impersonal. Once an artist uses paint expressively, however, the brush marks are as revealing as a person's handwriting.

Joy Girvin, Autumn at Bellosguardo, **1987, oil on canvas, 61 x 78 cm (24 x 31 in). The rich colouring and strong brushwork not only record the profound beauty of this place, but also charge the painting with the artist's intense feelings for the subject**

RIGHT: **George Rowlett,** Showery Spring Day, **1987, oil on canvas, 61 x 99 cm (24 x 39 in). This strident interpretation of falling raindrops shows subtle nuances of colour within an animated paint surface. The dynamic brushwork in this painting conveys not only the atmosphere of the location, the weight and passage of raindrops, but also the artist's excitement**

BELOW RIGHT: **Rowland Hilder,** Anglers, **watercolour and chalk, 19 x 27.5 cm (7½ x 10¾ in). The artist saw this dramatic sky – with the sun barely appearing through a dark storm cloud – from his studio window and he made a hasty note of it, using smudged pastel on tinted paper. Later, when he was reviewing some sketches, this particular scene evoked memories of fishing trips made on a lake in Rutland, and by combining a number of sketched ideas the artist was able to produce this atmospheric composition**

Ian Simpson, Tregardock Beach, **acrylic on paper, 40 x 58 cm (16 x 23 in). This picture, painted on the spot, has a feeling of a grey day with rain threatening. The immediate** foreground was painted first and the rocks were used to articulate the space reaching to the sea. As the eye moves in this direction it is met by the narrow waves

The Mood of a Landscape

Some landscape painters become totally involved in trying to describe their visual sensations. They wish to translate into paint not only the shapes, forms and space they can see and feel, but also the less tangible mood of the subject. Alfred Sisley, the French Impressionist painter, wrote to a friend: 'Every picture shows a spot with which the artist has fallen in love. . . .The animation of the canvas is one of the hardest problems of painting. . . . Everything must serve the end, form, colour, surface. . . .And though the artist must remain master of his craft, the surface, at times raised to the highest pitch of loveliness, should transmit to the beholder the sensation which possessed the artist.' Sisley's description of painting reveals how important 'the sensation' was to him and how the paint itself should be used to help transmit this sensation.

Sisley's paintings, to our eyes now, do not appear to depart much from recording what we imagine he saw. For some artists, however, the landscape stimulates them to go far beyond description and to express not only the mood of the landscape but their own mood as well. A particular visual experience might be seen by a painter as symbolic. Norman Adams described a stream flowing down a hillside as symbolizing the 'stream of life'. Once something has been seen as having some kind of association, this must affect the way it is painted. The subject has been given a meaning which has somehow to be expressed in paint, and to some artists this expression matters more than accurate representation. If you look through the illustrations in this book you will find that in all of them, to a degree, description has been less important than the artist's relationship with the subject. It is perhaps impossible to describe this relationship, although there have been a number of attempts in this book to do so.

Striving to harness this sensation, the artist might emphasize certain aspects of the subject. A painter may exaggerate or distort shapes and forms. Colours can be adapted to express widely different feelings. The gestures recorded by the brush as the artist paints can also vividly reveal his or her excitement.

The degree to which artists transform elements of the landscape to express their relationship with it varies. Sutherland's landscape paintings relate less directly to the actual landscape than Sisley's, but this departure from the subject is more apparent in the work of artists labelled as Expressionists. With these artists (the most famous example of whom is probably van Gogh) the objects in their paintings may be unrecognizable. The landscape is used as a starting point from which a painting about the feelings the subject invokes is developed. The Norwegian painter Edvard Munch described the overpowering feeling of a particular landscape thus: 'I was walking along a road one evening – on one side lay the city, and below me was the fjord. The sun went down – the clouds were stained red, as if with blood. I felt as though the whole of nature was screaming – it seemed as though I could hear a scream. I painted that picture, painting the clouds like real blood. The colours screamed.'

Not all artists are in the disturbed emotional state that Munch was in, nor do they exist in his highly charged world. Nevertheless, even the least

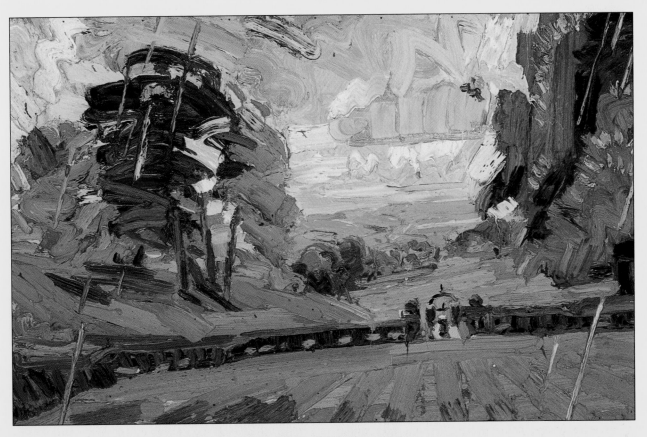

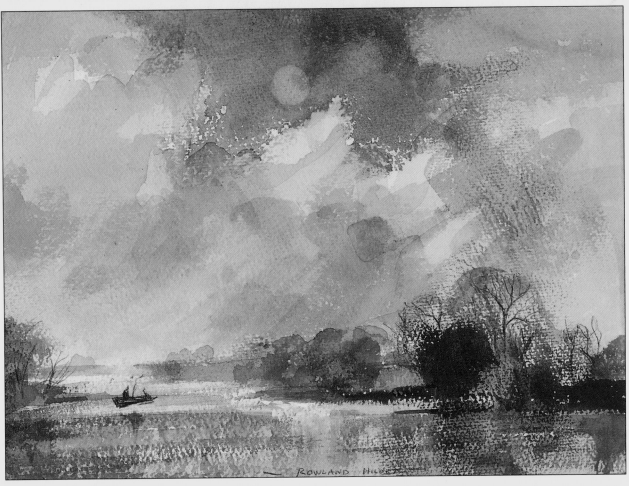

emotional of us does not need to be reminded of how we respond to places. When we go to familiar places which we love, there is a raising of our level of consciousness as we approach them. Nostalgia, as I mentioned in Chapter 2, is a strong driving force in much landscape painting. Our own moods and our personality are revealed in our painting whether we wish it or not. It is often said of portrait painting that it reveals as much about the artist as about the subject and this is equally true of landscape painting. I have said previously that a beautiful view does not necessarily produce a beautiful painting. The beauty of the painting comes from your perception of the landscape and the way you relate to it. As you paint, you project yourself into the landscape and you find it reflects back something of yourself. This elusive 'self' is something that has been mentioned in the interviews in this book, but it is only in the paintings themselves that it can be truly identified.

The Effects of Weather

So far, in attempting to describe atmosphere I have referred to it as 'feeling', a feeling the artist receives from the landscape and one that the landscape draws from the artist. A landscape never looks the same on different days; in fact, it changes from minute to minute. This is because we constantly see things in different ways and also because the landscape itself is made up of constantly changing organic forms. The weather, which particularly in northern Europe varies so much, is another powerful factor both in providing a 'landscape mood' and provoking powerful responses in us.

The kind of light at any particular time determines how we see. Strong sunlight clearly reveals some forms and camouflages others in shadow. Poor light reduces the distance we can see, and rain can turn surfaces into mirrors and produce visual phenomena, as shown in *The Rainbow Landscape* (see page 16). Pictures of rainbows or sunsets are now considered by many artists to be subjects which are too sentimental to consider, but paintings by Rubens, Turner and Norman Adams (see page 141), show how spectacular effects such as these can make pictures that are powerful and not in the least trite. A stunning effect doesn't necessarily make a marvellous painting, but it can do if the artist is able to see beyond the obvious.

The interviews with different artists in this book have shown that for some landscape painters the heat of summer makes them feel more at one with the landscape. However, strong sunlight changes the appearance of the landscape so rapidly, as the earth and the sun change their relative positions, that it does not provide ideal conditions for all artists. I much prefer those days when there is an even light and no dense shadows. On such days you can draw or paint the same subject for a longer period of time than on very bright days. I suspect there is also something else about the subdued light on these grey days that appeals to me. Perhaps it is because my formative years were spent in the north-east of England, where this kind of weather is present for much of the year, that I respond to it so positively.

LEFT: **Sally Hargreaves,** Dusk in the Fens, **1985, acrylic on canvas, 101 x 193 cm (40 x 76 in). To convey the quiet beauty of the dusk this landscape was reduced to essential horizontal elements painted with subtle colour harmonies**

RIGHT: **Trevor Burgess,** Great Ghyll No. I, 11 a.m., **1986, 56 x 71 cm (22 x 28 in). Light conditions and atmosphere change continuously, especially in mountainous regions. This picture captures these transitory atmospheric effects**

BELOW: **Michael Hoar,** Landscape (D. H. Lawrence), **1984, oil on canvas, 101 x 127 cm (40 x 50 in). Middle distance and foreground detail are fused together into calligraphic shapes by the strong lighting in this landscape. Powerful brushwork re-creates the moment of strongest tonal contrast as light conditions alter with the passing storm**

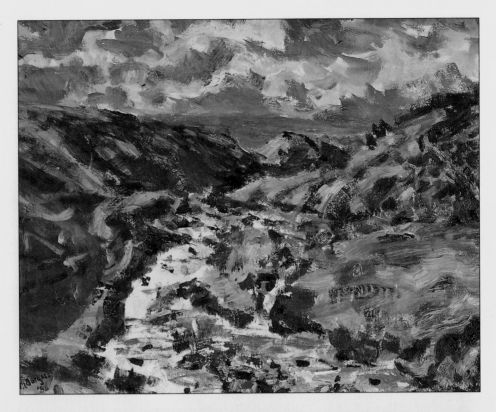

There is not a great deal of evidence of weather conditions in many artists' paintings. Cézanne's paintings, as Keith Grant observed, show no sign of the changing seasons. In contrast, Grant's own interest in dramatic effects has led him to paint volcanoes, spectacular weather effects and even the sun itself (see page 91). There are several illustrations in this book of paintings clearly made at different times of the year, such as *Winter Allotments, Broughton Astley* illustrated here, and others showing effects of storms, rain and mist, such as *Vale of Llangollen, Snowy Landscape* and *Winter Landscape, Sweden*.

ABOVE: **Alan Welsford,** Winter Allotments, Broughton Astley, **1982/3, oil on canvas, 107 x 152 cm (42 x 60 in). Seasonal change transforms the landscape, especially in terms of colour. Here the canvas seems to shiver with the stark chill air of a winter's day, conveyed with lively brush strokes of blue, cold grey and sepia**

RIGHT: **Laurence Quigley,** Vale of Llangollen, Snowy Landscape, **1988, oil on canvas, 30 x 40 cm (12 x 16 in). Snowfall can produce the most radical alteration of a well-known view, obscuring details and reflecting light in all directions. This energetic sketch seems full of the artist's surprise and delight in rediscovering a familiar subject**

Ian Simpson, Winter Landscape, Sweden, **ink and watercolour, 40 x 58 cm (16 x 23 in). This was painted from a window, just after a snowfall. The background is lost against the sky but the foreground trees** weave intricate patterns against the white background. The picture has an atmosphere of cold and the trees give a sharp, spiky feeling which conveys a sense of winter

All these effects of weather rely on the artist either being able to make quick studies from which to paint later or being able to paint from memory. It is no coincidence that an artist like Keith Grant, who works mainly from memory, puts a special emphasis on weather in his paintings. On the face of it, photographs should be useful in catching and painting a rapidly changing sky or the shadows of dark clouds passing over a landscape, but I find this is not the case. Photographs of something you have found exciting are invariably disappointing. This is because when you look you do not merely record what you see, like a camera, but emphasize and enlarge it. The quickest, crudest drawing made from observation or from memory is always, in my experience both as artist and teacher, more interesting and more informative than a photograph. When a particular cloud effect has been important to me, I have painted the sky with great speed from direct observation, or made rapid studies in colour, as in *Sky Studies*, and used them later to complete my painting.

Ian Simpson, Sky Studies, **1989, gouache, 59 x 42 cm (23½ x 16½ in)**

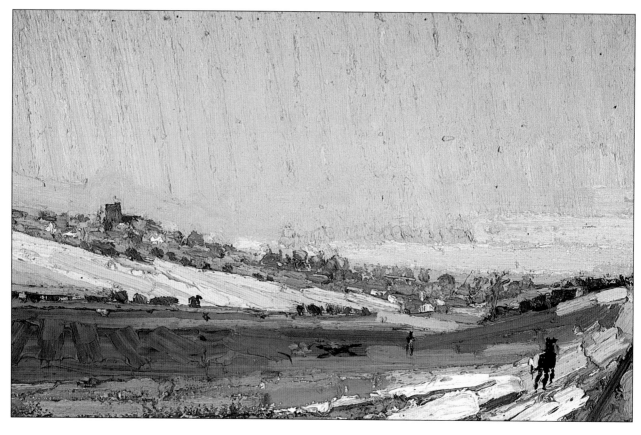

George Rowlett, Advancing
Mist, 1987, oil on canvas,
61 x 99 cm (24 x 39 in). This
artist is particularly concerned
with creating powerful
expressions of different
atmospheric conditions. Here
he has recorded the beautiful
contrast between the pale,
uniform veil of mist and the
rich, dark, yet colourful tones
of the foreground fields

BELOW: **Sally Hargreaves,**
Sunset, 1984, oil on canvas,
13 x 18 cm (5 x 7 in). Dawn and
dusk have always attracted
the artist, providing a moody
transformation of the
landscape. Here the artist
shows how a simple study of
the warm, mellow tones can
produce a restful,
contemplative yet robust
painting, with no trace of the
sentimentality often
associated with sunset
paintings

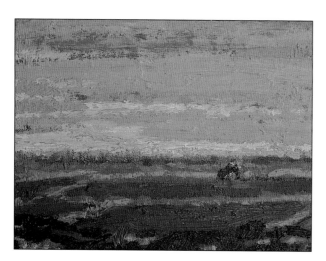

Conclusion

Throughout this book I have returned several times to the significance of seeing. I believe this is of the utmost importance, no matter how experienced a painter you might be. The ability to see provides an endless supply of visual material. Joshua Reynolds said that it was 'vain for painters . . . to endeavour to invent without materials on which the mind may work, and from which invention must originate. Nothing,' he added, 'can come from nothing.'

By touching on the more subjective, emotional aspects of painting here and by making passing reference to photography, I hope I have reminded you that seeing means 'seeing like an artist' and that this form of seeing is not as a camera sees. Artists look with great concentration, but they don't take what they see at face value. They are looking for things which no-one has seen, in things that everyone has seen. They are seeking to make associations between objects not usually believed to be related. They are trying to find the odd in the ordinary. This kind of looking involves their feelings for the landscape, the way in which they relate to it, and the associations they bring to it.

Particularly at this point in time there is no 'right' way to paint the landscape, and because there is so

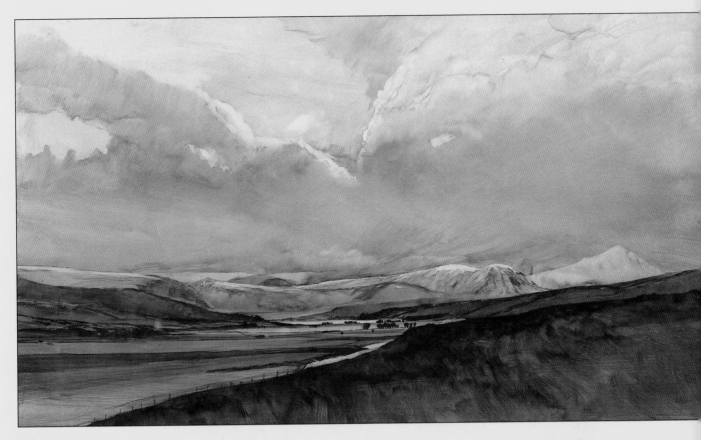

ABOVE: **James Morrison,** From Barravourich I, **1988, oil on gesso-primed board, 91 x 152 cm (36 x 60 in). The vast scale of a wild, open landscape and the awesome beauty we sense before it have an instinctive appeal, and one that artists will always continue to celebrate** (The Scottish Gallery, Edinburgh and London)

Julia Hope, Clouds Over the Amstel, **1987, watercolour and gouache on card, 18 x 23 cm (7 x 9 in). The dark clouds of this painting seem to form a proscenium arch through which we gaze in wonder at the infinitely varied scenes of nature**

much emphasis on individuality, artists are striving to find new ways of seeing and new ways of communicating their experience of it. Everyone is different and the way each person responds to the landscape is different. Searching for this difference is like searching for the truth. I hope this book helps you to find it.

Select Bibliography

Bouleau, Charles
The Painter's Secret Geometry: Study of Composition in Art
(Thames & Hudson, London, 1981)

Denvir, Bernard (ed.)
The Impressionists at First Hand
(Thames & Hudson, London and New York, 1987)

Gombrich, Ernst
The Story of Art
(Phaidon, London, 1950; 14th edition 1984)

Hollis, H.F.
Perspective Drawing
(Hodder & Stoughton, London, 1955)

Janson, H.W.
History of Art
(Thames & Hudson, London, 1987;
Harry N. Abrams, Inc.,
New York, 1987)

Murray, Peter and Linda
A Dictionary of Art and Artists
(Penguin, London, 1959; 5th edition 1983)

Poore, Henry Rankin
Composition in Art
(John Constable, London, 1976; Dover
Publications, Mineola, N.Y., 1977)

Spalding, Frances
British Art Since 1900
(Thames & Hudson, London, 1987)

Terrasse, Michel
Bonnard at Le Cannet
(Thames & Hudson, London, 1980; Pantheon
Books, New York, 1988)

Various authors
John Sell Cotman 1782–1842
(Arts Council of Great Britain, London, 1982)

Various authors
Turner 1775–1851
(Tate Gallery, London, 1974)

Wark, Robert R. (ed.)
Reynolds' Discourses on Art
(Yale University Press, London, 1975)

White, James
The Birth and Rebirth of Pictorial Space
(Faber & Faber, London, 1987; Harvard University
Press, Cambridge, Mass., 1987)

Index